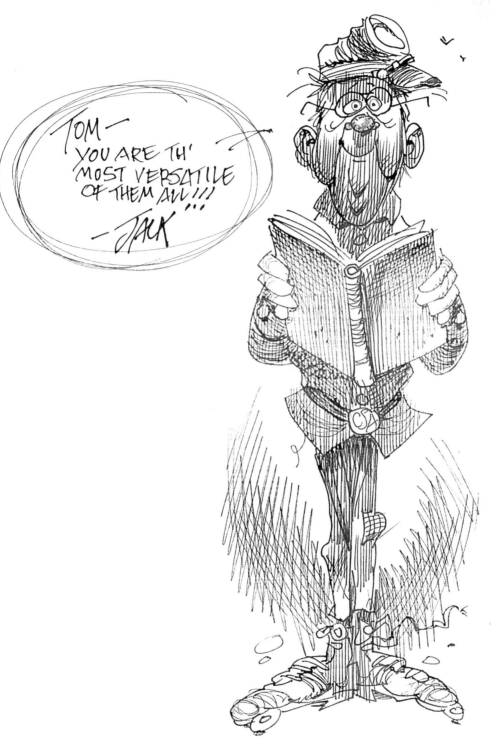

— JACK DAVIS, legendary *MAD* Magazine caricaturist, cartoonist, and illustrator

THE Mad Art OF CARICATURE!

A Serious Guide to Drawing Funny Faces

by TOM RICHMOND

DEADLINE DEMON
PUBLISHING

First published in 2011 in the United States by Deadline Demon Publishing,
a division of Richmond Illustration Inc.
3421 East Burnsville Pkwy, Burnsville, MN 55337-3464
www.deadlinedemon.com

1 2 4 5 6 7 8 9 10

Library of Congress Control Number: 2011929003

ISBN 978-0-9835767-0-9

741.51
RIC
7/11/13

Written, illustrated, and designed by Tom Richmond

Printed in Korea

This book is for my wife,
The Lovely Anna, without whom I am utterly
and truly lost . . . and not just on road trips.

CONTENTS

FOREWORD BY NICK MEGLIN

TOM RICHMOND—AN ARTIST WHO NEEDS NO INTRODUCTION, BUT I WROTE ONE ANYWAY . . .

At a recent panel discussion at the North Carolina Museum of Art that focused on the Lighter Side of Norman Rockwell as part of their wonderful retrospective exhibit of that beloved artist's work, the speakers fielded several comments from the large, appreciative audience alluding to the paradigm of where "fine art" ends and illustration begins. Inasmuch as criteria for judgment is arbitrary at best, few can offer much in the way of clearly defined resolution. In the broadest analogy, it's highly probable that Da Vinci himself would have painted Saturday Evening Post covers if the publication existed in his day, and King Solomon, cutting a Rockwell painting in half, would only be destroying a brilliant piece of art while satisfying neither side of the would-be label makers.

I plead guilty for engaging in similar folly. In one of my earliest books, *The Art of Humorous Illustration*, I suggested that there was a clear distinction between humorous illustrator and cartoonist. Long after the need to be more definitive in my text had passed, I realized that a singular aspiration—to elicit a comic response through a piece of art—reduced categorization to meaningless wordplay. Norman Rockwell was as proud of his gag attempts as he was his serious themes and didn't compromise his strong representational approach to achieve them. Except for slight exaggeration of expression or gesture, it was business as usual for the famed Illustrator's Illustrator whether solemn or slapstick. Other notables in that same edition, Sergio Aragonés, Johnny Hart, Paul Coker, Arnold Roth, Al Jaffee, and Jules Feiffer—classic cartoonists all—share exactly that same goal. So much for definitions.

Caricature is unique in that it incorporates a blend of both the representational and humorous approaches. At the core is the need to depict a known subject, no different a result than that of serious portrait artists who will also take liberties with clinical accuracy to achieve a deeper likeness. They will exaggerate, condense, shift, or whatever they feel necessary to achieve a desired effect.

Just as a well-conceived and executed portrait often says more about the person than physical features alone, caricature, especially in political cartooning, will exaggerate qualities to help carry a slanted editorial message be it positive or negative, reflecting the opinion of the artist and/or the publication in which it appears.

What has become more important about caricature to me personally is that even after a long, professional career in publishing, I remain in awe of artists who can draw lines on a two-dimensional surface and transform them into a graphic statement that travels far beyond three-dimensional realities. As a consummate sketchbook artist (and sometime freelance illustrator), my omnipresent fountain pen responds to the visual stimuli that inspires me. There's no magic to this approach, a basic eye-to-hand process—I draw what I see. But the mind's eye-to-hand is something else entirely, to me a process bordering on witchcraft, and those who engage in the practice more sorcerer than artist, especially when their drawing looks more like the subject than the photographic reference used to achieve it. Beelzebub, be gone!

The successful caricaturist employs the reader's image memory entirely; another difficult feat brought about by capturing attitude and/or other significant visual at-

tributes coupled with a sense of the inner being that serves to remind us of that individual despite our visual memory often being more distorted than the drawing.

The major easily recognizable difference in approach to caricature is the "lollipop school" (wherein a large head is jammed onto an interchangeable body as in most cameo pieces, political cartoons, etc.), and the narrative continuity (in which the physical proportion, body language, and action are all utilized to help capture the complete representation as in a *MAD* Magazine satire, for example).

While most artists of this latter approach also master the former, the reverse is far less typical and serves as one of the two major reasons Tom Richmond was invited to join *MAD* Magazine's Usual Gang of Idiots. His ability to combine "old school" solid drawing with "new school" technology, especially in areas like colorization and special effects heretofore not at the artist's disposal, made him a welcome addition to the magazine's transition into full color and a more current design. Traditionally a black and white presentation (other than covers), *MAD* entered the full-color world of modern publishing full throttle by 2001, including the intrusive and compromising advertisements it had scrupulously avoided since its inception but now accepted in order to survive in the economically fragile publishing world.

The other reason Tom was accepted into the fold was far more important in that the ability to serve the writing in a faux realistically drawn panel-to-panel narrative is what *MAD* satire is all about. Clooney, Gaga, Downey, Paltrow, Brad and Angelina have got to look like who they are from all

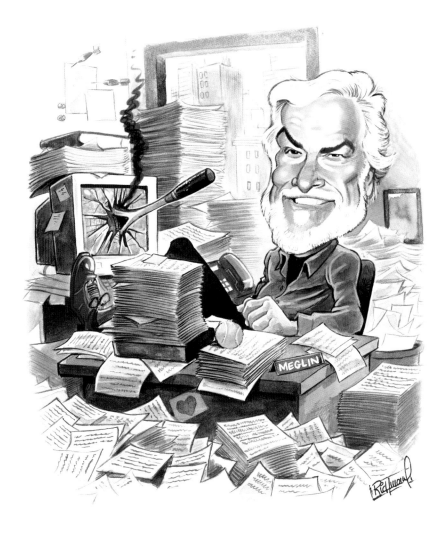

angles and lighting effects throughout 30 or more frames, and very few artists can sustain the level the magazine requires from issue to issue, let alone year to year. A film director has it easier in comparison—the actors already look themselves from scene to scene and not created by a facile artist with pen, brush, and ink.

My earlier mention of being "in awe" of such talent is obviously not an overstatement and those who can do it are a rare, scary breed. See for yourself over the following pages as one of these talented devils shares a wealth of insights, knowledge, and instruction from his formidable experience in that Dark Side art form, caricature. Ladies and gentlemen, I give you Tom Richmond . . .

Nick Meglin
Tom's friend and former MAD editor

PREFACE AND ACKNOWLEDGMENTS

You can blame this book on Mr. Chilson and the Fasen brothers.

When I was a young man, drawing caricatures for a living never struck me as something I was interested in doing. I never opened a magazine and saw a great caricature of some celebrity and realized in a forehead-slapping moment of epiphany, *that's what I want to do!* In fact, I wasn't even aware caricature was an art form. The whole thing kind of snuck up on me, and those aforementioned gentlemen are to blame.

Mr. Chilson was my seventh-grade art teacher at Longfellow Middle School in La Crosse, Wisconsin, in 1979. The school was so small that we had our art classes in the same room they held the shop classes, sitting on barstools at tall worktables, while another grade's art class was going on at the same time on the other side of the large workshop. One day Mr. Chilson started a lesson on caricature. I was sitting in the back, not paying attention, as usual, and drawing in my notebook. While Mr. Chilson was explaining what a caricature was, I was drawing one of the other teacher, who was only a few dozen feet away from me . . . except I didn't know it was a caricature. To me, it was just my drawing of the other teacher.

"RICHMOND!" Mr. Chilson yelled in my ear. "You are in THIS class, not THAT one!" He was standing next to me. One of the drawbacks of being absorbed in a drawing at the expense of paying attention in class was that I never heard the teacher coming. That resulted in many startling yells in my ear. He snatched away the notebook, glanced at it, glared at me, and then instructed me loudly in front of everybody to see him after class as he returned to the front of the room with my confiscated notebook in hand. Resigned to getting detention at the least, I meekly hung back and watched my schoolmates shuffle out following the bell.

Instead of giving me detention, Mr. Chilson sent me around the school over the next several days to draw about two dozen of the teachers, and then he displayed my work in the glass case at the top of the stairs right in front of the art/shop room. I guess he liked my drawing of the other art teacher—or maybe he hated the guy and sent me around to draw all the other teachers he disliked so they could be ridiculed publicly and I'd be to blame. I was never sure. Regardless, that was my first exposure to the art of caricature, as well as my first understanding of what caricature was.

I then promptly forgot all about caricature for about six years.

In 1985, I was at the University of Minnesota in Minneapolis, attempting to study commercial art. It had been a year or so, and I'd had only one art class as they were impossible to get into as an underclassman, and the one I was "lucky" enough to get into was a complete waste of time. "Alternative Sculpture" was one of those art classes that was 99% pretension and 1% actual, useful art instruction. I was skipping it one day, hanging about the commons area, when I spied a flyer on the wall asking "Can You Draw?" It turned out to be an ad seeking caricature artists to draw at the local amusement park for a company called Fasen Arts. I suddenly recalled Mr. Chilson and my seventh-grade show and thought this would make a great summer job. I secured an interview and dragged an overflowing folder of drawings I'd done from some magazine photos with me to meet with Steve Fasen, an accomplished caricaturist and the owner of Fasen Arts.

I didn't get the job.

Some weeks later Steve called and offered me a spot at a different theme park near Chicago, about 450 miles southeast. I was later told this opportunity opened up only because someone else had backed out, but that hardly would have mattered to me

at the time—nor does it matter in hindsight. I packed up my things and moved to Waukegan, Illinios, where I spent the summer drawing caricatures with a group of very talented artists headed by Steve's brother Gary, a brilliant caricaturist and illustrator. There I learned a great deal about drawing and cartooning, discovered the realities of making a living as an artist, renewed my appreciation for a certain magazine that would later become an important part of my life, and, most importantly, fell in love with the art of caricature completely and for good.

For better or for worse, Mr. Chilson and Steve and Gary Fasen have much to answer for . . . and they have my eternal thanks.

Additionally, a very special thanks to the following:

The folks at DC Comics / E.C. Publications for the permission to include some images from *MAD* in this book.

The editorial and art staff at *MAD* Magazine, who refuse to stop overworking and underpaying me, thereby continuing to give me the privilege of being a part of a genuine piece of cartooning, humor, and pop culture history—and for making me feel like part of the family. Specifically, thanks to John Ficarra, Charlie Kadau, Joe Raiola, Ryan Flanders, Dave Croatto, Doug Thompson, and those past *MAD* men and women staffers I miss working with.

All the people who lent me their faces to use as examples for demonstration. Especially to my fellow National Cartoonist Society member Mark Simon, who gave me permission to borrow some of the faces from one of his excellent *Facial Expressions* books. I highly recommend Mark's books as a source for facial references. You can find them all at www.expressions-books.com.

The generous friends and colleagues who contributed blurbs for the back cover of this book (and Jack Davis, whose contribution is on the first page). One of the greatest benefits to being "in the business," that is, doing humorous illustration and cartooning for a living, is meeting some of the most awesomely talented cartoonists, writers, and artists in the world—and then discovering they are equally awesome people.

My deepest gratitude to Celestia Ward, who worked tirelessly editing my babbling blather and somehow making it not only readable but preserving my voice—only with good grammar and punctuation. When she offered years ago to do this for any book I cared to write in the future, I thought she was kidding. It turns out she wasn't just serious about doing it, she was seriously brilliant at doing it. It is no exaggeration to say this book would never have happened without her—not just because she worked so hard on it, but because she motivated me to finish it so I wouldn't disappoint her.

Finally, a heartfelt thanks to Nick Meglin and Sam Viviano. Not just for the terrific foreword and afterword, but for the encouragement, support, and instruction they have generously shared with me over the years. The word "mentor" doesn't begin to describe their impact on me. I owe them much . . . especially Nick because of that twenty bucks he loaned me once.

Spies like us. *All the actors who have officially played British secret agent James Bond in the 007 movies (right to left): Sean Connery, George Lazenby, Roger Moore, Timothy Dalton, Pierce Brosnan, and Daniel Craig.*

ABOUT CARICATURE AND THIS BOOK . . .

Caricature is an artform with a multitude of different applications. You see caricatures of politicians every day in your local newspaper's editorial pages. You see caricature illustrations of celebrities in magazines, and more simplified caricatures are used in animated TV shows and movies. They appear in advertising on billboards, on the sides of trucks, and in your local phone book. They illustrate articles promoting or reviewing books, films, plays, or TV shows. You see them being drawn right in front of your eyes by artists at amusement parks, fairs, and festivals, on city streets, and at events ranging from the largest corporate trade show to the neighborhood kid's birthday party.

Each of these different applications requires its own type of execution. With editorial cartoons, the caricatures are necessarily simplified in line form, like the work of Pat Oliphant, Jeff MacNelly, or Mike Luchovich. Magazine illustrations can vary from the very painterly realism of Sebastian Krüger or C. F. Payne, to the cartoony, linear style of Mort Drucker and Jack Davis, to the more stylized work of artists like John Kascht, Steve Brodner, or Anita Kunz. Street artists have a variety of styles, but most depend on a simple, linear form of drawing that lends

itself to speed and spontaneity. Simply put, the art of caricature has as many different commercial applications as it has different stylistic approaches.

In this book I have tried to avoid discussing style-specific details and instead describe drawing caricatures in a way that can be applied to almost any style of drawing. In theory, this would mean any caricature artist, from the most realistic of painters to the most simplified and linear of cartoonists, should be able to apply the information and ideas from these pages to their own work. That is a nice theory, but in some ways it is also an impossible one. My specific style of drawing caricatures invariably will color my commentary and observations about the art form, if for no other reason than it is my

central perspective on caricature. So, when I talk about drawing specific features, I inevitably approach them from my own style of drawing no matter how hard I try not to. For those looking for a focus on some particular application of caricature, I have included several chapters that are more style specific. In these chapters I discuss some of the unique challenges of drawing caricatures live at a party or a theme park, as well as drawing them for publications and, in particular, for *MAD Magazine,* which has its own set of unique considerations.

It's my hope that no matter where in the art of caricature your interests lie, or in what avenue you want to express them, you'll get something from this book.

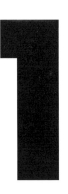

1 WHAT IS CARICATURE?

THE THREE ELEMENTS OF CARICATURE

I've heard caricature described many different ways, from the grossly misunderstood:

"Caricature is where they pick one thing on your face and make it bigger."

to the overly simplified:

"Caricature is where they make you into a cartoon."

to the downright incorrect:

"A caricature is supposed to be funny . . . it's not supposed to look like you."

The best definition I've ever heard is from caricature illustrator John Kascht:

"A caricature is a portrait with the volume turned up."

That is a perfect way to think of it. A good caricature captures more than the likeness of the subject, and it does more than exaggerate their features. A good caricature captures some of the personality, attitude,

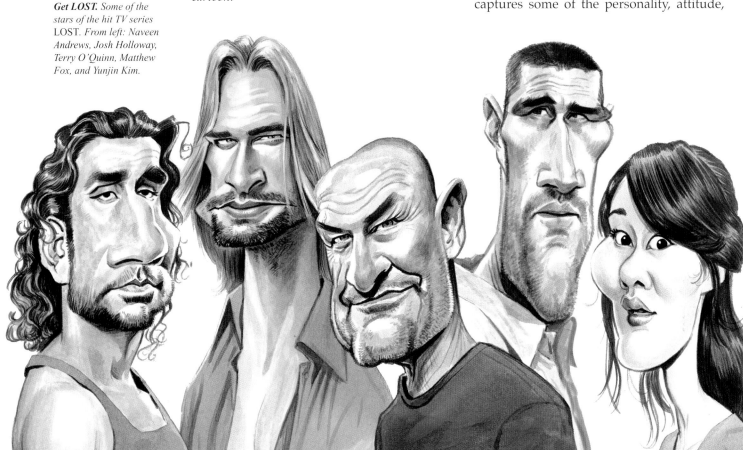

Get LOST. Some of the stars of the hit TV series LOST. From left: Naveen Andrews, Josh Holloway, Terry O'Quinn, Matthew Fox, and Yunjin Kim.

and intangible essence of the subject; it goes where a portrait cannot because it can amplify and accentuate those elements of a person that make them unique. In many ways a caricature can be more recognizable than a portrait because it can go beyond the features. It can capture and describe elements of the subject that speak to who the subject is, not just what the subject looks like.

By my own definition, a good caricature must have three elements in place to be successful:

- **Recognizability**
- **Exaggeration**
- **Statement**

Recognizability

A good caricature must be instantly recognizable as the subject regardless of the level of exaggeration the artist applies to the subject's features. If it doesn't read as the subject, it's not a successful caricature. Notice I did not say it must have a "likeness," meaning it must be recognizable as the subject via the features themselves. The "likeness" can be independent of "recognizability." You can recognize a subject in a caricature in other ways than likeness of features. More stylized caricatures can depend on things like very distinct features represented by more abstract elements rather than by accurately drawn facial details. A caricature can also utilize things like trademark clothing, hairdos, or other well-known and unique aspects of a subject. One example of this might be the "caricatures" of famous people making cameos as themselves on animated television shows like *The Simpsons* or *Futurama*. These must be recognizable as the celebrities they depict but still conform to the rigid style of the animation design—the features are immaterial. The caricature on the right relies on the signature hair, hat, and other elements of rock star Slash for its recognizability, as opposed to any accuracy in drawing the features themselves . . . since there are no features.

Cousin It Rocks. *This caricature of rock star Slash literally has no facial features, but it is unmistakably him. A viewer recognizes a person or personality on more levels than just their face. Body posture, signature clothing or "look," accessories, setting— these all play a part in recognizability.*

While some styles of caricature incorporate other factors to create recognizability, I personally think that likeness is the strongest foundation upon which to build. It is the base upon which the weight of the caricature is supported. If through the features themselves you can capture the subject's likeness in a caricature, then the addition of other trademark elements simply acts as further cement for your caricature's already strong recognizability.

EXAGGERATIONS CAN GO FROM

mild TO WILD!

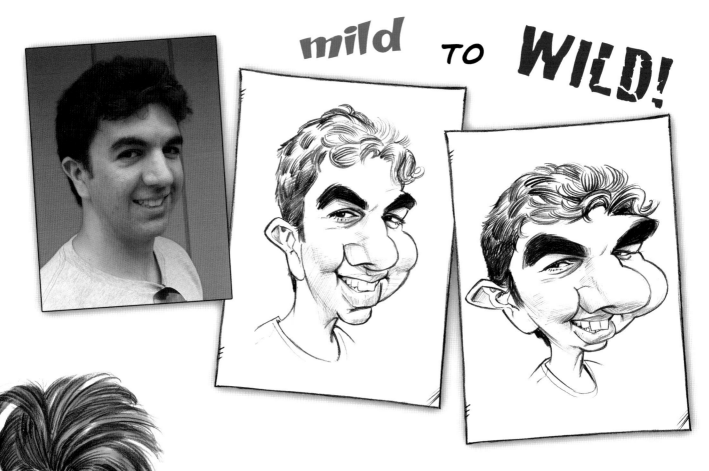

Why the long face?
Actor Adrien Brody has
plenty to work with when
it comes to deciding what
to exaggerate.

Exaggeration

A portrait is based entirely on likeness and technique. There is little room for subjectivity in a traditional portrait. The face being depicted is the face being depicted, and, outside of style of rendering and medium, the success of a portrait hinges on the same conditions in all cases—it must look like the subject. A caricature also should look like (or, more accurately, be recognizable as) the subject, but the added element of how the caricaturist chooses to exaggerate the model makes it a more subjective and personal representation than a portrait. The addition of exaggeration into the equation is what makes caricature the wildly diverse art form that it is.

Exaggeration of a given subject in caricature is not a constant. The art of caricature can encompass everything from the mildly exaggerated "portrai-cature" to the most outrageous, face-melting, extremely exaggerated depiction. The level of exaggeration is only limited by the artist's ability to retain the recognizability. There is a point beyond which further exaggeration would cause likeness or recognizability to be lost, and as a result the caricature would fail. Learning to push that boundary without overstepping it is a goal for any caricaturist.

Exaggeration is also not limited by any single choice about what to stretch in a given face. Each face has multiple elements that can be focused on in the pursuit of exaggeration . . . there is no "one way" to caricature a face. One caricaturist could decide that a subject's eyes are the focal point of their exaggeration, while another might see the same subject's chin as something that needs particular attention. Caricature is forgiving in that way. Since it depends on an

artist's personal observations and decisions about what makes a particular face unique, there are multiple "correct" decisions for any subject. Not just any random decision is "right," however. Each face may have multiple elements worthy of exaggeration, but those elements depend on the subject, and it's the caricaturist's job to perceive which are appropriate and which are not. There are wrong decisions with respect to exaggeration, and it becomes obvious when a decision is wrong: an exaggeration in the wrong direction will cause the recognizability to suffer or to be lost. Giving a little girl with a cute, button nose a giant, potato-sized nose is not going to work.

It all comes back to likeness and recognizability as the measuring stick for the success of a caricature. The best caricatures are those that strike the viewer immediately with a sense of instant recognition of the subject, even amid (or perhaps because of) all the exaggerations applied by the caricaturist.

Statement

I use this term to encompass many different factors that add to the impact of the caricature. *Personality* might be a different word to use; *editorialization* might be another. What I mean by this is reaching past the surface features of the subject and capturing some of the intangibles that make that subject a living, breathing person. It is the way that a good caricature goes beyond capturing the look and enters the realm of describing the subject's personality and essence. Caricatures that capture these intangibles hit their mark so accurately that viewers are almost caught off guard as they exclaim "THAT'S HIM!" or "THAT'S HER!"—a reaction that mere portraiture would not elicit. There are many different ways an artist can accomplish this.

One of the key tools that can help a caricaturist make a statement is expression. Sir Arthur Conan Doyle once wrote, "The features are given to man as the means by which he shall express his emotions, and yours are faithful servants." Sherlock Holmes was

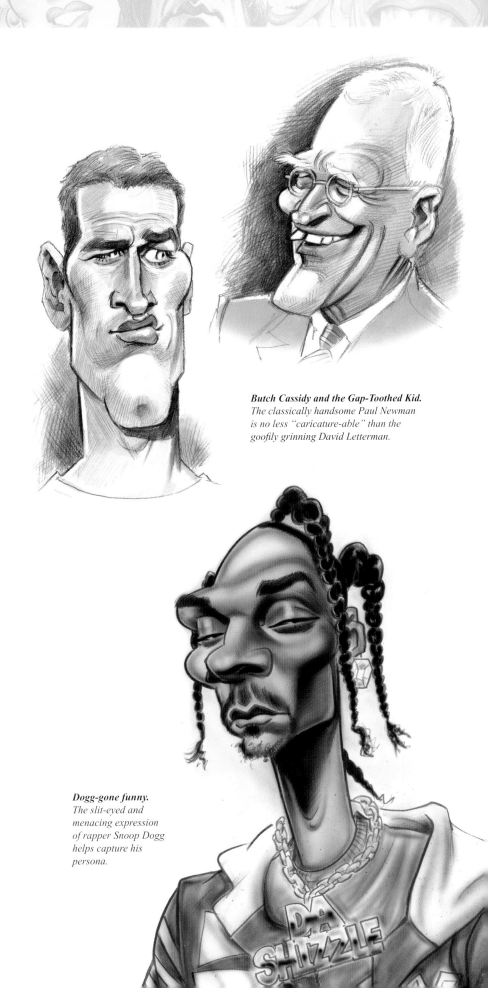

Butch Cassidy and the Gap-Toothed Kid.
The classically handsome Paul Newman is no less "caricature-able" than the goofily grinning David Letterman.

Dogg-gone funny.
The slit-eyed and menacing expression of rapper Snoop Dogg helps capture his persona.

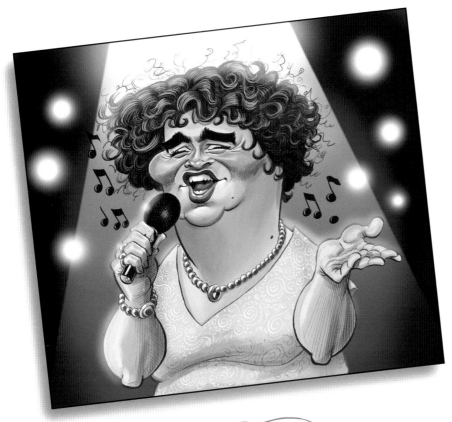

Boyle-ing point.
*British singer Susan
Boyle's expression
when singing is a
big part of her look.*

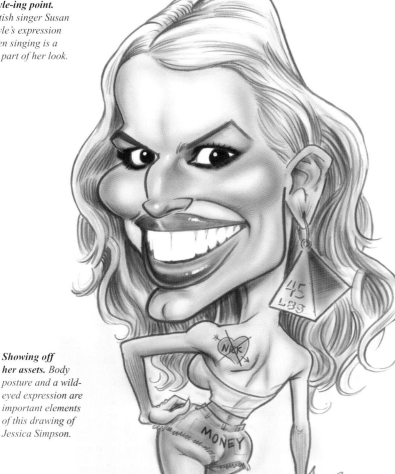

***Showing off
her assets.*** *Body
posture and a wild-
eyed expression are
important elements
of this drawing of
Jessica Simpson.*

explaining to Dr. Watson how he was able to follow the thoughts of his amazed companion as they sat in silence in their rooms on Baker Street. What we as humans see each day in the faces of our friends, family, and acquaintances is more than the sum of the physical parts of the face. Family members often remark at open-casket funerals that the deceased doesn't seem to look like the person they knew in life. The animation behind the features has as much to do with how we recognize people as does the meat and bone that those features are made of. Capturing someone's typical expression imbues a caricature with a life and personality far beyond the features themselves. The raised eyebrow, the crooked smirk, the squinted eyes, or the crinkled nose describes the person rather than just the features. It's by capturing these intangibles that a caricaturist really makes the subject pop off the page.

It's not all about the face either. Posture and body language play an important part in the statement of a caricature. How a person moves, walks, stands, leans, slouches, dances, and so on, is a large factor in their recognizability. Al Hirschfeld once pointed out that a person could spot their best friend from a distance, walking away from them on a crowded street. The silhouette, walk, and posture is all that is required for someone to pick their friend out of that crowd. If a person typically hunches forward and slouches as they walk, then a drawing of them with squared shoulders and an upright posture would miss a great part of their individuality. Observing and capturing that tendency, in addition to their features, makes for a powerful statement in a caricature. How a person leans, cocks their head, looks up from under their brows or down their nose at you—these mannerisms and idiosyncrasies are an unconscious part of the animated human subject. Making observations of these elements and describing them—or, better yet, EXAGGERATING them—in caricature helps capture your subject in ways the features alone cannot.

Caricaturists can also editorialize in their work, something I lump into my rather

broad definition of "statement." Caricatures have a long history as an important element in satire, and incorporating some kind of editorial statement with the caricature lends a touch of storytelling to the image. This mostly applies to caricature used for publication in some form of the media, but what is caricature if it's not telling a bit of a story about the subject? The caricature of Harrison Ford below doesn't just exaggerate his features, it describes the essential silliness of a 60-year-old actor portraying an action hero in the latest Indiana Jones film.

The arena in which an artist is producing their caricature determines the importance of the different elements. For example in the case of live caricature I'd define exaggeration and statement to simply mean humor, because that would be the aim of these two elements for the purpose of the artwork. In the case of a magazine illustration meant to accompany an article criticizing some politician, I'd emphasize the satirical and editorial aspects of exaggeration and statement.

When it's all said and done, a good caricature is pretty easy to see. Either it is successful in capturing the subject, or it isn't. It all comes back to creating and maintaining solid and hopefully undeniable recognizability while applying exaggeration and statement to capture your subject.

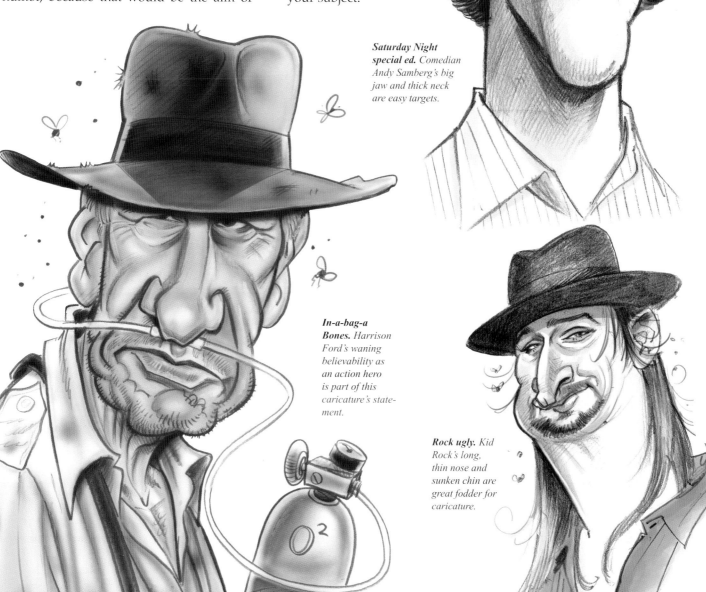

Saturday Night special ed. Comedian Andy Samberg's big jaw and thick neck are easy targets.

In-a-bag-a Bones. Harrison Ford's waning believability as an action hero is part of this caricature's statement.

Rock ugly. Kid Rock's long, thin nose and sunken chin are great fodder for caricature.

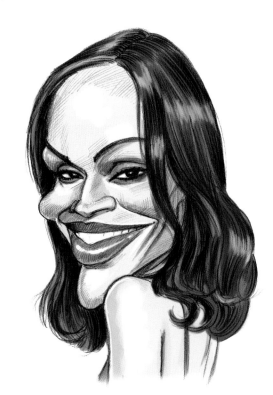

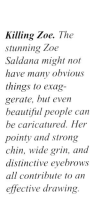

Killing Zoe. The stunning Zoe Saldana might not have many obvious things to exaggerate, but even beautiful people can be caricatured. Her pointy and strong chin, wide grin, and distinctive eyebrows all contribute to an effective drawing.

CARICATURE EQUALS PERCEPTION

We spend our entire lives staring into the faces of our fellow humans. The faces of our parents are the first things we learn to recognize as infants. We interact face to face with tens of thousands of people over our lifetime, from those we meet only once while ordering lunch one afternoon to those family, friends, and coworkers we might see on a daily basis for many decades. As a result, we are uniquely attuned to the subtleties and intricacies of the face. Because all humans have basically the same types of features and we have become intimately familiar with them, we perceive what are really only small differences in the size, shape, and relationships of these features as very dramatic.

Caricature artists, by nature or through training (or some combination of both) are particularly sensitive to a given face's eccentricities. A caricaturist might be casually grocery shopping one morning and suddenly be confronted by a fellow shopper who, to the awestruck caricaturist anyway, looks like he has eyebrows made of two hairy floor mats glued above his eyes. This will distract said caricaturist for some time. It might even bring a quick end to the grocery shopping outing. I have had entire Broadway musicals ruined for me because I could not take my eyes off the enormous, bulbous forehead of one of the chorus members. Let me tell you that can make for a long night at the theater. The odd thing is that the forehead in question probably wasn't really all that much bigger than the forehead of the next chorus member—it's just that I perceived it that way. A combination of things about that subject's face caused me to notice something "out of the ordinary" about it. The way features interact, the slight differences in size and distance between them, the way expression influences the face, the posture, the angle someone holds their head at when they talk . . . all these factors and more change the way we perceive the face.

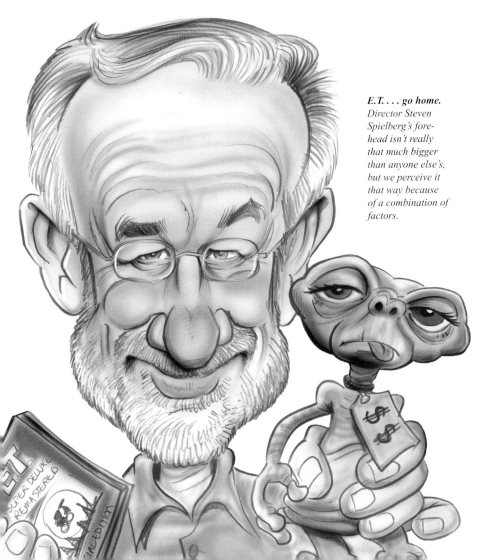

E.T. . . . go home. Director Steven Spielberg's forehead isn't really that much bigger than anyone else's, but we perceive it that way because of a combination of factors.

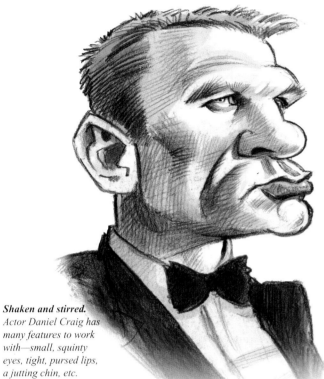

Shaken and stirred.
Actor Daniel Craig has many features to work with—small, squinty eyes, tight, pursed lips, a jutting chin, etc.

Not TODAY, dear. *TV anchor and talk show host Katie Couric has a toothy, uneven smile and a pixie-ish twinkle in her eyes that are great to capture.*

Portrait artists draw what the face looks like. They deal in fixed absolutes. Caricature artists draw what the face *feels* like. They deal in perception. That can be different for each individual caricaturist. It's the caricaturist's job to describe how they perceive the subject to the rest of the world through their caricature, much like telling a story. The language used in this story is the interplay between the artist's drawing skills and the actual features of the subject, and while the story can be told in many different ways, the "reader" must be able to recognize the tale in the end. It's a little like how the same joke can be told in different ways by different comedians. They all might take different paths to get to the recognizable punchline.

What a caricature artist must do is recognize where their perception of a given subject's face diverges from, for lack of a better term, a "normal" face, and to emphasize those differences by exaggerating them. "This person's eyes are close together" or "that person has a large jaw" are observations based mainly on perception; the measurable differences in anatomy are minute. That's what makes caricature such a personal and subjective form of expression.

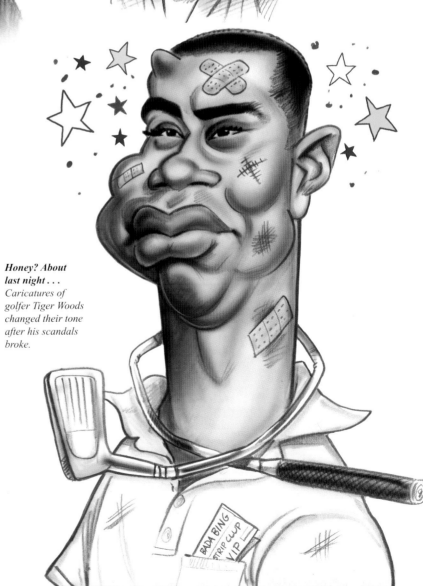

Honey? About last night . . .
Caricatures of golfer Tiger Woods changed their tone after his scandals broke.

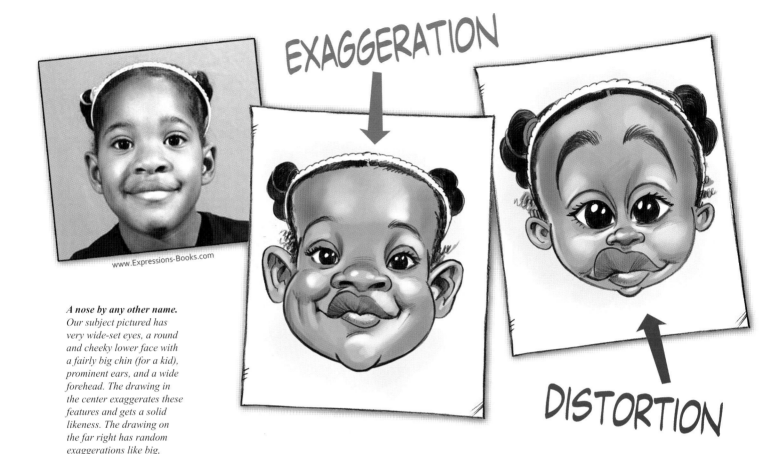

EXAGGERATION

DISTORTION

www.Expressions-Books.com

A nose by any other name.
Our subject pictured has
very wide-set eyes, a round
and cheeky lower face with
a fairly big chin (for a kid),
prominent ears, and a wide
forehead. The drawing in
the center exaggerates these
features and gets a solid
likeness. The drawing on
the far right has random
exaggerations like big,
close-set eyes, a tiny nose,
small chin and jaw, and
tiny ears. This is distortion,
and the result is a missed
likeness.

EXAGGERATION VERSUS DISTORTION

Before we delve into the theories behind seeing and drawing caricatures, it's important to understand the difference between exaggeration and distortion.

Back when I was working as a live caricaturist at various theme parks, I lost count of how many times I heard a person behind me describing a caricature as a drawing "where the artist picks something and makes it bigger." That is far from accurate. It's just as likely that a caricaturist will exaggerate a given feature by making it *smaller* than it really is, or making it a greater distance from another feature, or changing the angle that at which it lies, or a combination of all those decisions and more. Picking one thing and making it bigger might be a correct exaggeration for some particular model, but then

again it might not be. Taking a feature and making it bigger or smaller without a reason isn't exaggeration—it's *distortion*. My previous example of a bad decision, namely giving a subject who has a small, button nose a big bulbous schnoz, would be distortion. Distortion is exaggeration without a reason or a purpose. Caricature is exaggeration for a reason. Caricature is exaggeration with a purpose.

Most people have, at some point, stood in front of a carnival funhouse mirror. These mirrors are warped to make your reflection look short and fat, or tall and skinny, or twisted in some weird way. Some might be more familiar with various types of image software like Apple's Photobooth, which apply filters to create some of the same effects. These mirrors or programs show us examples of distortion: exaggerations applied to every subject in the same way, regardless of their individuality. EVERYBODY

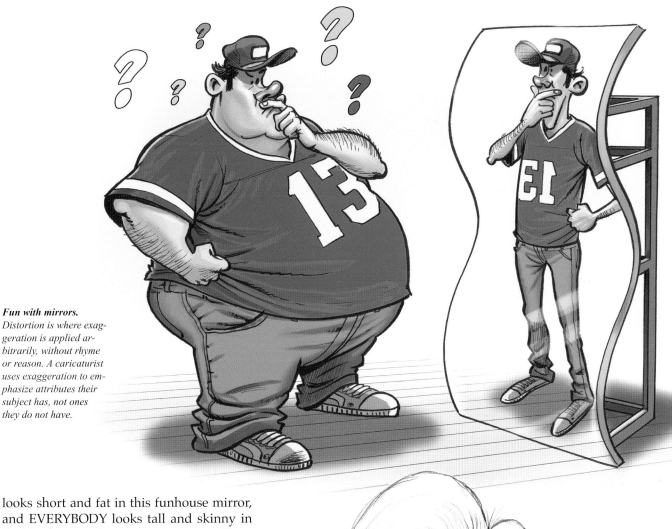

Fun with mirrors. *Distortion is where exaggeration is applied arbitrarily, without rhyme or reason. A caricaturist uses exaggeration to emphasize attributes their subject has, not ones they do not have.*

looks short and fat in this funhouse mirror, and EVERYBODY looks tall and skinny in that funhouse mirror. A caricature is like a funhouse mirror that is designed specifically for one individual. It makes you bigger in places the artist perceives as bigger and smaller in places the artist perceives as smaller . . . or wider . . . or rounder . . . or whatever your individual features demand. A caricature artist must be a funhouse mirror with a purpose.

Arbitrarily applying an exaggeration to a face without reason is the worst kind of caricature. It defeats the entire purpose of the art form, which is taking an artist's observations of what makes a person unique and amplifying them to produce that "portrait with the volume turned up." Keeping with that analogy, exaggeration based on good observations and decisions is like great music with the volume cranked. Distortion is just loud, incoherent noise.

A big head for politics. *I exaggerated the late Senator Ted Kennedy's huge head and jaw. Had I given him gigantic eyes or a long, thin face, that would have been distortion.*

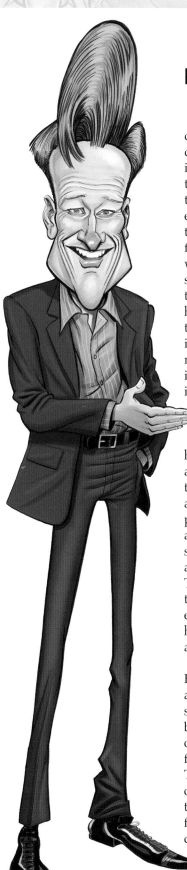

LEARNING TO SEE

I've been working with young caricaturists at theme parks for well over two decades now, and I've learned one very important lesson: it's nearly impossible to teach someone to draw caricatures. I can teach them to draw . . . that isn't so hard given they all have artistic talent—otherwise they wouldn't have gotten the job in the first place. Learning how a face looks and works by learning anatomy, how expression changes the features, how the angle of the face changes the perception of features, how hair grows and falls about the head— those are things that can be taught. Drawing caricatures, on the other hand, is a lot more about *seeing* what makes the person in front of you unique, and your personal interpretation of that uniqueness, than it is about making good, confident marks on the paper. That's hard to teach. For example, I can explain to students exactly how to draw a circle. I can show them what a circle looks like and how to draw curves to create it and demonstrate drawing it at a thousand different sizes. However, if I place a picture of a circle before them and ask them to draw it, and they each draw a square . . . well, the problem lies in how they are seeing and not how they are drawing. The ability to see, and, after that, the ability to exaggerate what you see for humorous effect in a caricature—those are skills that have to be developed. For most that means a lot of drawing and a lot of looking.

Some faces are easier to see than others. Have you ever come across somebody with a crazy, incredibly distinct face that maybe sports a gigantic nose or a Neanderthal brow or some other obviously out-of-the-ordinary features? Caricaturists have a term for that kind of face: it's called a "field day." Those are the ones that you do a double take on, and instantly you see your caricature of that person in your head. Think about it for a second . . . why is that face so ripe for caricature compared to the next guy's? Are the features really that different? If you took a ruler and measured the size of Mr. Schnoz's nose compared to Mr. Normal's, the actual difference would probably be miniscule. So why is that subject so easy to draw? Because your perception of that person's face and its unique aspects are obvious to you, and that is giving you, in turn, an obvious springboard for a caricature. Make just one observation about what makes this person different from "normal," and you are off and running. The obvious features are easy observations. It's Johnny and Susie Normal or, worse yet, Johnny and Susie Supermodel that are the challenge for most caricature artists. That is where fine-tuning your ability to see becomes important. There is no face that defies caricature, you just sometimes have to dig a little deeper. In caricature, the old adage of "practice makes perfect" has never been truer. The ability to see doesn't spring up overnight, and I often tell eager young caricaturists they have about 500 or so bad caricatures in them before they start noticing the subtle things that hide inside the ordinary face.

The encouraging thing is that the more you develop your eye and learn to see, the fewer and fewer faces defy your ability to find something to play with. More and more faces begin to have things that jump out at you—things you may not have noticed before. To be more accurate, these are things you likely saw before but never perceived as unique. A man might walk by the same brick wall every day for years and then one day suddenly notice that one of the bricks is a different color than the rest of them. After that it becomes impossible for him to walk by without seeing that odd brick. It had always been there and he had doubtless seen it many times, but he didn't notice it until just then. He had looked but not seen.

The more a caricature artist's eye develops, the more people fall into that "I CAN'T WAIT TO DRAW THAT GUY!" category. Fewer and fewer flummox or evade the artist's pen. Johnny and Susie Normal become Johnny and Susie Mutant, or they at least become subjects who have things to work with, things that previously went unnoticed.

Seeing red. *Conan O'Brien's tall and lanky form as well as his unique hair are easy elements to see and therefore caricature. Some subjects require looking harder.*

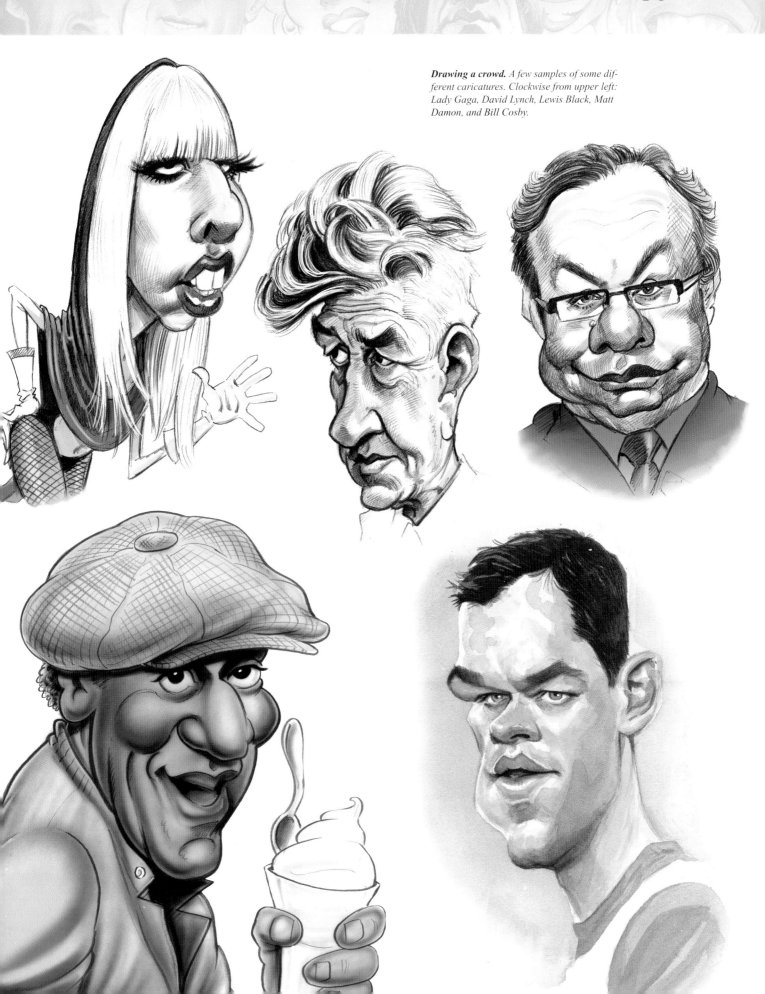

Drawing a crowd. *A few samples of some different caricatures. Clockwise from upper left: Lady Gaga, David Lynch, Lewis Black, Matt Damon, and Bill Cosby.*

2 BASIC CARICATURE THEORY

Although I say it's nearly impossible to truly teach someone to draw caricatures, it's not impossible to help them develop their ability to draw them. There are many techniques that can help an artist develop their ability to see what is in front of them, recognize what makes it unique, and then amplify that uniqueness to create a successful caricature. Over the next few chapters I will share general concepts that apply to the overall approach of a caricature, specific tricks and tips for individual features, and important main concepts.

Most of the specific drawing tips are geared toward line drawing as opposed to value-based techniques like painting, as my style of caricature is a line-oriented extension of live drawing techniques. However, much of what I cover can apply to any style of caricature art.

This is the P[...] Brad Pitt as [...] appeared in [...] role from the [...] film Ingloriou[...] Basterds.

Is there a doctor in the **House?** *Actor Hugh Laurie has a number of features that are begging to be exaggerated.*

Hardly a Paltry model. *Actress Gwyneth Paltrow has a long and narrow face.*

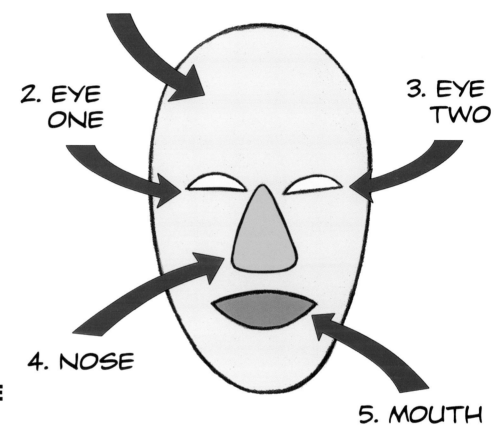

THE FIVE SHAPES

1. HEAD SHAPE

2. EYE ONE

3. EYE TWO

4. NOSE

5. MOUTH

Simple and to the point. This minimalist drawing lacks any detail whatsoever. As basic as this image is, there is still no mistaking what it represents: this is a human face. All the necessary information is there for anyone to make that instant identification.

RELATIONSHIPS AND THE FIVE SHAPES

Many consider the human face to be an incredibly complex object to draw. There are about 52 muscles in the face—the actual number varies depending on your source and its method of categorization. Age, sex, race, expression (the face is capable of about 5,000 of these), weight, and environment can all play a role in the look of, and our perception of, a given face. Sound pretty complicated? Not really. Every building, no matter how complex, starts out with a foundation and framework.

Look at the simple drawing on the upper left of this page. Show this to any human being in the world and ask them what it is. Without fail, they will tell you it is a person's face.

In its most basic form, the human face is made up of only five simple shapes, as shown in the drawing above. Place these shapes in their proper relationship, and you have a human face. It really is that simple.

Drawing these basic shapes accurately, so they recognizably represent the subject's features, is the basis for a good likeness. Beyond that, it's nothing but details—things like wispy hair, dimples, wrinkles, eyelashes, creases, freckles, cheekbones or any of many other facial specifics. They are the decor for your building, the millwork, furniture, and drapery that makes the place unique and filled with life. Without a strong foundation, however, it can all come tumbling down.

The fab five. These five simple shapes represent the basic foundation of any face. The shapes themselves change to correspond with the features of a given model, but the basic underlying template remains constant.

THE THREE BASIC RELATIONSHIPS IN CARICATURE

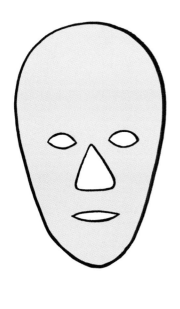

The relationships between the Five Shapes are the basis of facial exaggeration in caricature. There are three different types of relationships:

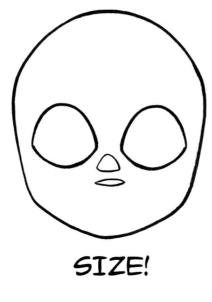

SIZE!

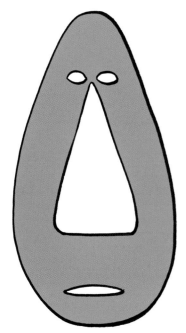

DISTANCE!

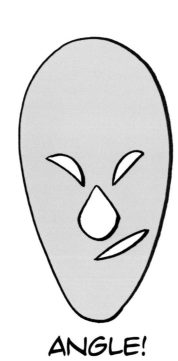

ANGLE!

Relationship therapy. *Exaggerating the relationships between the Five Shapes with respect to size, distance, and angle is what differentiates portraiture from caricature. The trick is determining how a particular face's relationships should be changed— each face is different. The more an artist exaggerates these relationships, the more exaggerated the caricature appears.*

What does all this have to do with caricature? Everything. I mentioned a single word in the last paragraph that really is the secret to caricature as a whole no matter what technique or approach you intend to practice:

RELATIONSHIPS

If caricature has a secret key, it's understanding relationships. The manipulation of the relationships of the Five Shapes forms the bedrock of any caricature. In fact, I'd argue that 90% of the entire caricature resides in how you relate these five simple shapes to one another. These relationships are the foundation upon which the rest of your building is built, where the real power of exaggeration is realized. Make it effective and hopefully dynamic, and almost all the heavy lifting is done.

What do I mean by relationships? I mean the distances between the Five Shapes, their size relative to one another, and the angles they are at in relationship to the central axis of the face.

So, in list form, we have:

- **Distance between features**
- **Size of features relative to each other**
- **Angle of features relative to the central axis of the face**

These three basic relationships are what is exaggerated among the Five Shapes to create a caricature.

In traditional portraiture, the head is divided into "classic proportions" (we'll get into that more later), meaning the features are within a certain, accepted distance of one another, as are their size and angle relative to the face and head shape. You achieve your likeness in a classic portrait, in its most basic form, by correctly drawing the shapes and then the details of each feature according to the model in front of you while staying within the framework of these "classic" proportions. Of course each face varies minutely here and there, but portraits still do

not stray far from the classic formula. In a caricature, like a portrait, the likeness is also achieved by drawing the features as they really look, but you change the relationship of the features based on your perceptions of the face. Look at the very simple drawings on this page and notice they demonstrate how you can change the relationships of the Five Shapes to create very different caricatures.

These basic caricatures contain no detail, and all the shapes used are basically the same with the exception of the head shape (again, more on that later . . . much more), but each face is distinctly different. When the details are added, they will make for highly varied caricatures. The difference lies in the relationships between the Five Shapes and how they have been exaggerated. Caricature is not about choosing one feature and making it bigger, it's about all the features and how they relate to one another.

SOME SIMPLE VARIATIONS OF THE RELATIONSHIPS BETWEEN THE FIVE SHAPES

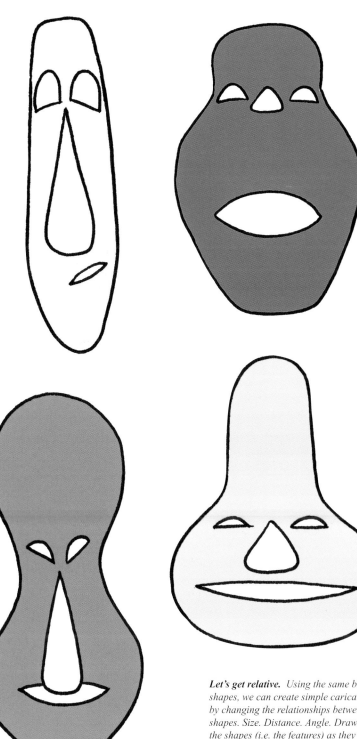

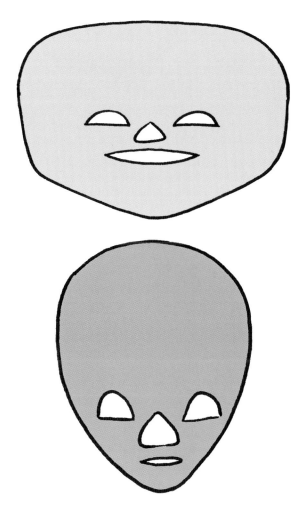

Let's get relative. Using the same basic shapes, we can create simple caricatures by changing the relationships between the shapes. Size. Distance. Angle. Drawing the shapes (i.e. the features) as they really look creates the likeness. Changing their relationships to one another creates the caricature.

SOME EXAMPLES OF THE UNDERLYING FIVE SHAPES AND THEIR RELATIONSHIPS

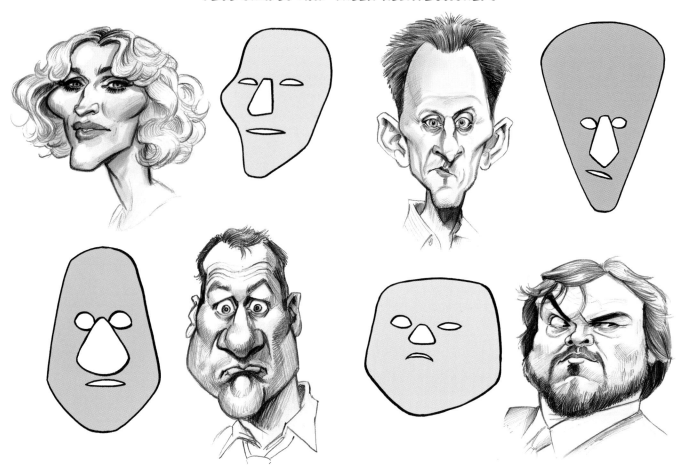

Getting in shape. *These simple studies demonstrate how the Five Shapes and their basic relationships are working under all the details and rendering of the more fully real-ized sketches. Clockwise from top left: music icon Madonna,* LOST*'s Michael Emerson, comedian/actor Jack Black, and TV star Ed O'Neill.*

Above are some quick studies of the Five Shapes as they relate to a few carica-ture sketches.

The shapes are overly simplified here so that they all differ primarily only in re-lationship to one another, namely in terms of distance, size, and angle. The bigger the differences are from classic proportions, the more exaggerated the caricature. It's much easier to see the differences when the details are removed and only the Five Shapes are left. It's also much easier to create those dif-ferences at this simple, fundamental level. Laying down these basic shapes and their relationships is akin to the blueprint stage of our building—it might not be obvious once the rest of the work is finished, but it's the most crucial stage, and getting it wrong could doom the entire project. It's easy to get caught up in details, but the important information rests beneath the rendering. One of the fundamentals of doing caricature is being able to reduce the face to the sim-plest of forms and manipulate them at this base level. After that is accomplished, then you can add the details according to your drawing and rendering style and, of course, according to the specifics of the face in front of you. In this manner, all styles of carica-ture share a common foundation: the Five Shapes.

How does one determine the "correct" ways to change a given person's feature relationships to make a good caricature of them? Well, that's the trick, isn't it? That is where that pesky "seeing" comes in. In his book *How to Draw Caricatures* (Contem-porary Books, 1984), Lenn Redman uses

a concept called the "In-betweener." This average or typical face has the classic portraiture relationships and is used as a point of reference for making observations. Every caricature begins with the observations the artist makes about the subject and how that particular face is perceived. As I mentioned before, this differs among artists, which is what makes caricature such a unique and highly individual artistic expression. *MAD* Magazine legend Mort Drucker has been known to say that there is no "one correct way" to caricature a subject. Any given subject can have several different interpretations with respect to the exaggeration of the relationship of their features—and each may be as successful as the other. Portraiture is basically absolute: the drawing either looks like the person, with the correct features, proportions, and relationships, or it does not. Caricature is subjective to a point. The artist's goal is to draw how he or she perceives the face and to exaggerate that perception. The result may be different than how others perceive that face, but if the three elements we described in our definition—recognizability, exaggeration, and statement—are present, it's still a successful caricature. Hirschfeld was heard to say he once drew Jimmy Durante (an actor famous for his huge nose) without a nose at all, yet it was still recognizable as Durante. In that case, Hisrchfeld made a surprisingly different choice but ended up with a successful caricature despite ignoring his subject's most obvious feature.

That's not to say that any observation is appropriate. You still can't give someone with tiny, beady eyes gigantic, dish-sized ones and call it exaggeration. As discussed earlier, that's not exaggeration, it's distortion. You can, however, choose not to exaggerate the smallness of the eyes but rather find something else to exaggerate. That is the caricaturist's task: to find what it is about the subject's face that makes it unique and alter those relationships to exaggerate that uniqueness.

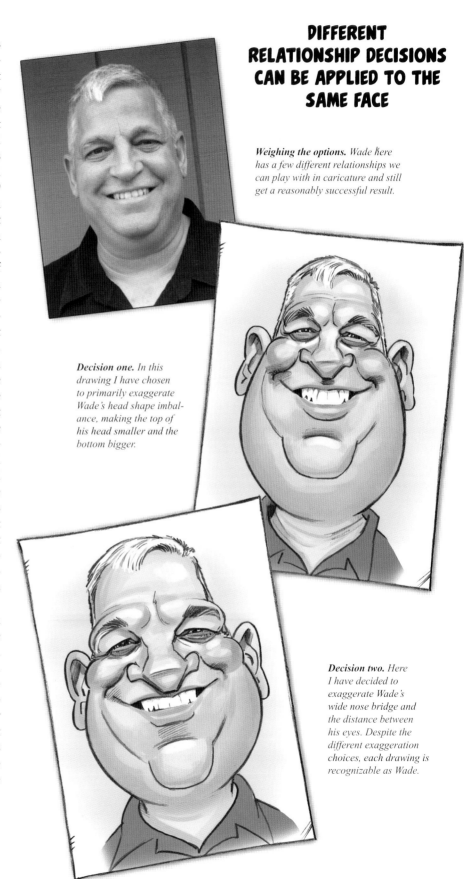

DIFFERENT RELATIONSHIP DECISIONS CAN BE APPLIED TO THE SAME FACE

Weighing the options. *Wade here has a few different relationships we can play with in caricature and still get a reasonably successful result.*

Decision one. *In this drawing I have chosen to primarily exaggerate Wade's head shape imbalance, making the top of his head smaller and the bottom bigger.*

Decision two. *Here I have decided to exaggerate Wade's wide nose bridge and the distance between his eyes. Despite the different exaggeration choices, each drawing is recognizable as Wade.*

FEATURE RELATIONSHIPS APPLIED

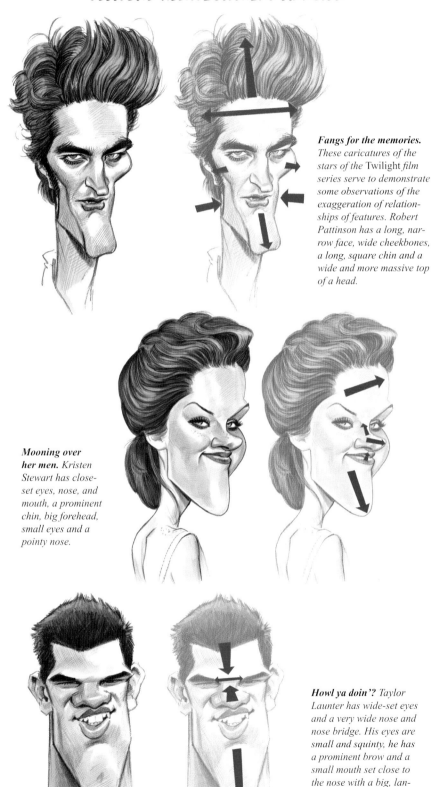

Fangs for the memories. These caricatures of the stars of the Twilight *film series serve to demonstrate some observations of the exaggeration of relationships of features. Robert Pattinson has a long, narrow face, wide cheekbones, a long, square chin and a wide and more massive top of a head.*

Mooning over her men. Kristen Stewart has close-set eyes, nose, and mouth, a prominent chin, big forehead, small eyes and a pointy nose.

Howl ya doin'? Taylor Launter has wide-set eyes and a very wide nose and nose bridge. His eyes are small and squinty, he has a prominent brow and a small mouth set close to the nose with a big, lantern jaw. He also has a very low hairline, which reduces his forehead shape.

SEEING RELATIONSHIPS

So, now we know it's the relationships between features that are the driving force behind caricature. But what exactly is it about those relationships? If caricature is about changing the relationships between features based on the artist's perception of what is considered "normal," then what is considered "normal"?

Deciding what relationships to change and how much to change them is one of the caricaturist's most important jobs, and one of the most difficult to learn. Again, the actual difference between the relationships of features, from human to human, does not add up to much in terms of physical measurements: a "big" nose may be only a fraction of an inch larger than a "normal" nose. Yet we can discern the different feature relationships on almost everybody, some of which seem very pronounced. Our ability to observe minute differences is very fine tuned thanks to our being social animals. Mostly it's an unconscious process, but our brains see that fraction-of-an-inch larger nose as big, or this person's eyes as large, or that person's mouth as small based not so much on physical measurements but rather on our overall perception of the features and how they relate to one another. Bringing those observations into our conscious perception, especially for those faces without obvious unique aspects, is the most difficult part of drawing caricatures. Luckily, there are some techniques and methods you can use to help make those observations.

Classic Portrait Proportion and Observation

We must start somewhere, and the best place is with what is considered the "normal" relationships of features. There are two reasons for this. First, knowing these classic proportions will help you observe where your perception of the subject's face might differ from the norm by providing a point of reference to which you can compare your

subject. Second, once you've made these ob-servations, you can use that same point of reference, the classic portrait proportions, as a baseline—a place to move further and further away from to create your caricature.

Let's start out by looking at the classic human proportions in traditional portrai-ture (I know, this is boring, but it's impor-tant). One method employed for centuries is using the width of an eye, from corner to corner, as the primary frame of reference.

In this method, a front view of the head is five eye widths wide, with a single eye width between the eyes and another be-tween the outside eye corners and the edge of the head. The nose is one eye width wide, and therefore the outer edges of the nostrils line up with the corners of the eyes.

Another simple method for establish-ing the "normal" relationship between eyes and mouth is forming an equilateral trian-gle with three reference points: two on the outside corners of the eyes and one on the center point of the bottom of the lower lip. Every book on learning to draw the human face describes one or both of these methods for standardizing the proportions of the av-erage face.

Do all human faces really conform to these exact relationships? No, of course not. That's the point of caricature. There are dif-ferences from this face to that, some very slight and others more pronounced, and the caricaturist exaggerates these differences to create a caricature. Knowing what layout is expected to be there is half the battle when it comes to seeing where things are different.

Again, making these observations is the trickiest part of doing caricature, but the good news is you don't have to come up with a shopping list of deformities in order to do a caricature. In fact, all you have to do is come up with one good observation.

Just one.

You can use that as your cornerstone and build your caricature around it. It could be as simple as: this person has a skinny face . . . or big eyes . . . or a small mouth . . . or a square jaw . . . or a bent nose . . . or what-ever. The more observations the better, but just one will suffice.

CLASSIC HUMAN PROPORTION

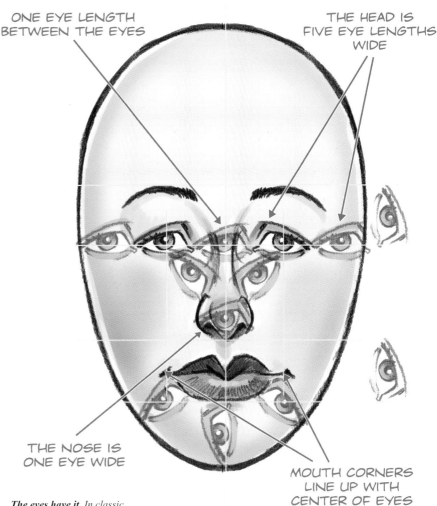

ONE EYE LENGTH BETWEEN THE EYES

THE HEAD IS FIVE EYE LENGTHS WIDE

THE NOSE IS ONE EYE WIDE

MOUTH CORNERS LINE UP WITH CENTER OF EYES

The eyes have it. *In classic portraiture proportion, the width of the eye is often used as a guide for measuring the "normal" relationship of features within the head.*

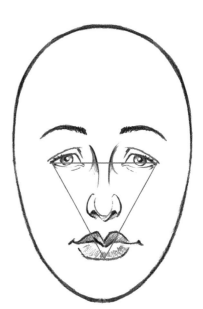

Triangulating in. *Another classic proportion trick is that the outside corners of the eyes and the center of the bottom of the lips form an equilateral triangle.*

EXAGGERATING ONE RELATIONSHIP AFFECTS OTHER RELATIONSHIPS IN THE FACE

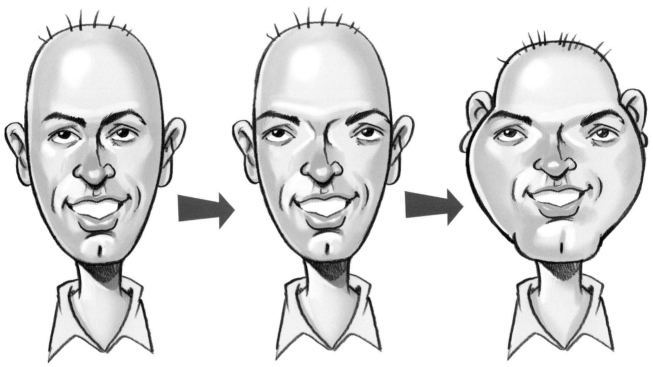

Fig. 1. Our subject with no relationship exaggerations. We decide to exaggerate the distance between the eyes . . .

Fig. 2. If we only move the eyes far apart and make no other corresponding changes, the result is awkward looking and unnatural. . .

Fig. 3. Here we not only moved the eyes apart, but also made the head wider, reduced the cranial mass, and moved the nose and mouth closer to the eyes. The result is a more balanced and natural caricature.

Action and Reaction

Why is only one observation enough? Because, with apologies to John Donne, "no feature is an island." What I mean by this is that all the features relate to one another fundamentally, and you cannot make a change to one feature without affecting the others. This is one of the few constants you can rely on with respect to drawing caricatures: action and reaction.

In physics, every action causes an equal and opposite reaction. In caricature, the action of changing the relationship of a single feature to the other features that surround it causes the others to react in often predictable ways. You cannot change the eyes without affecting the nose, mouth, head shape, and so on, and how that change affects those other features follows (for the most part) a set path.

Say we make an observation about our subject (fig. 1): we decide that the eyes seem far apart. If we move just the eyes farther apart and leave the rest of the face untouched, we end up with a bizarre-looking result (fig. 2).

We can't just ignore the effect our single exaggeration has on the other features. Moving the eyes farther apart forces the other features to react. Typically when the eyes are moved farther apart, the nose should move closer to the eyes, the mouth should move along with the nose, and the head becomes wider and, in turn, shorter (fig. 3).

Additional observations further change the path of the reaction. Say we observe that the eyes are far apart but the mouth is also far from the nose. Because of that additional action, the lower part of the face must be longer, and, therefore, the top of the head becomes smaller:

There aren't many hard and fast rules with regard to caricature, but the few there are mainly have to do with the concept of action and reaction. We will be examining one of these guidelines in the next few pages. Head shape is often the most affected by action and reaction, and I will be focusing on that in the coming chapter. For now we will stick with the interior features and their relationships.

Negative Space

Negative space is a very important concept in any type of drawing, and caricature is no exception. In this book, you will read the words negative space over and over as I explain how to "see" and draw individual features and decide where to exaggerate a face.

Observing negative space simply means looking not at the shape of a particular object but at the shape of the spaces around the object in order to better see the object itself. When you utilize negative space in formulating a caricature, you are really looking at the relationship of a feature to that which surrounds it; this sometimes helps you to better see the shape of the feature in question. For example, I can more easily see and draw this subject's mouth by looking at the negative space between the mouth and the nose and that between the mouth and the bottom of the jawline.

The negative space shows me the relationship between the mouth and the nose and the mouth and the chin as shapes in and of themselves. That makes it easier to draw and easier to exaggerate. Negative space is another way to think about distance, one of the three key elements in feature relationships, which we rely on to exaggerate.

USING NEGATIVE SPACE TO HELP SEE AND EXAGGERATE FEATURE RELATIONSHIPS

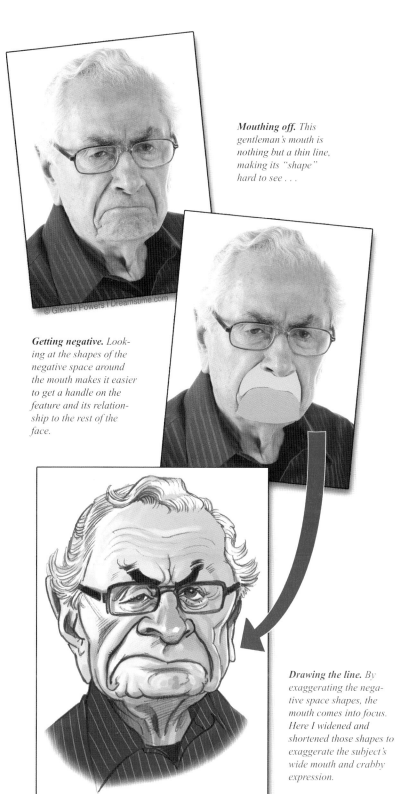

Mouthing off. *This gentleman's mouth is nothing but a thin line, making its "shape" hard to see . . .*

© Glenda Powers | Dreamstime.com

Getting negative. *Looking at the shapes of the negative space around the mouth makes it easier to get a handle on the feature and its relationship to the rest of the face.*

Drawing the line. *By exaggerating the negative space shapes, the mouth comes into focus. Here I widened and shortened those shapes to exaggerate the subject's wide mouth and crabby expression.*

RECOGNIZING THE T-SHAPE CREATED BY THE EYES AND THE NOSE

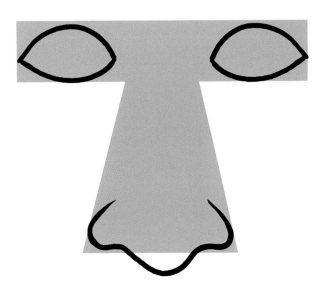

"T" time. The relationship of the eyes and nose creates a basic capital T-Shape that encompasses both elements. By thinking of the eyes and nose as a simple, geometric shape, exaggeration can be applied much more easily.

The T-Shape Theory

I have talked a lot about simplifying the face by boiling it down into the Five Shapes, but it can get even simpler than that in terms of both making observations and playing with the relationships of features to make a caricature. In fact, I believe there are two absolutely crucial, key components to any caricature: the head shape and the T-Shape. I look at these two elements first and try to make observations about them, because they allow me to push, stretch, and exaggerate the face to great effect with relative ease.

When I talk about the T-Shape I am speaking of the geometric shape created by the eyes and nose, as if drawn in contour around them. In simplest terms, they create a capital T. This simple shape describes the relationship between these important facial elements, making it into a single unit. This makes exaggerating the eyes and nose relationship much easier, because you can ignore all the details of the features themselves and concentrate on manipulating just the T-Shape itself.

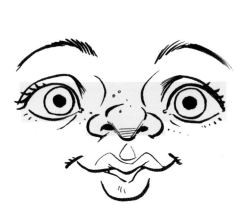

Sometimes the T can be short and wide.

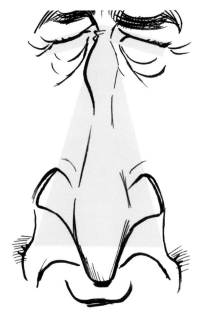

Sometimes it can be long and thin.

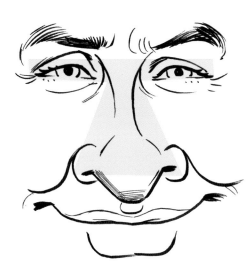

Sometimes it ends up somewhere in between.

VARIOUS T-SHAPES IN ACTION

The angle at which the eyes rest compared to the central axis of the face can change the T into more of a Y, or, alternately, more of an arrow shape.

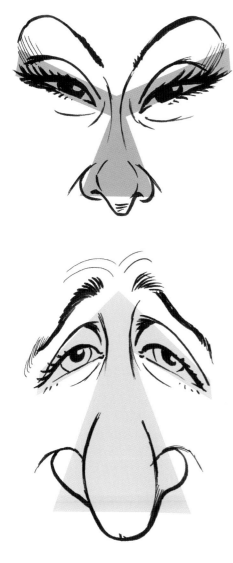

I treat the T-Shape not as a set of simple lines but as a contoured shape with thickness. Therefore the stem (or nose) of the T can be thicker or thinner at either end, and the arms (or eyes) of the T can also change in thickness to accommodate big, round eyes or narrow, squinty ones. Imagine a contoured capital "T" drawn around the eyes and nose in varying relationships.

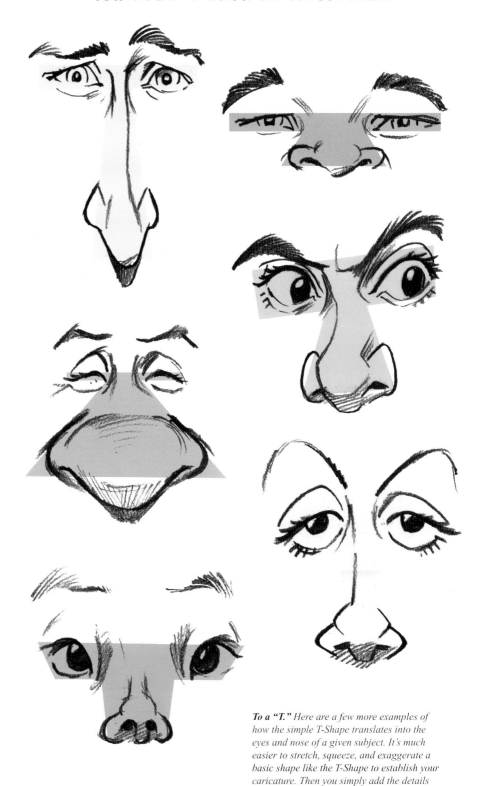

To a "T." Here are a few more examples of how the simple T-Shape translates into the eyes and nose of a given subject. It's much easier to stretch, squeeze, and exaggerate a basic shape like the T-Shape to establish your caricature. Then you simply add the details and accurate drawings of the features within that shape to capture the likeness.

THE RELATIONSHIP BETWEEN THE EYES AND NOSE IN ACTION

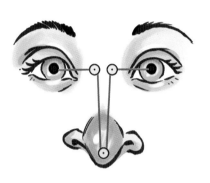

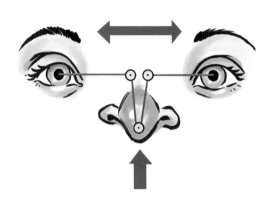

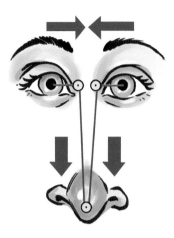

Pulling a fast one. One very general relationship rule is between the eyes and nose. Imagine them connected by a pulley system . . .

Going up. As the eyes are pulled apart, the nose is raised closer into the bridge area.

Going down. If the eyes are drawn together, the nose gets farther away.

THE NOSE, MOUTH, AND CHIN DYNAMIC

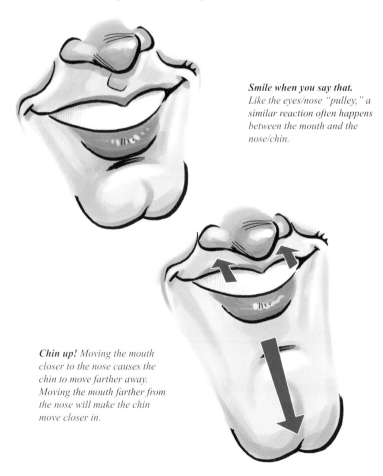

Smile when you say that. Like the eyes/nose "pulley," a similar reaction often happens between the mouth and the nose/chin.

Chin up! Moving the mouth closer to the nose causes the chin to move farther away. Moving the mouth farther from the nose will make the chin move closer in.

The shape of the T reacts to changes you make in the relationship of the eyes and nose. In most cases, the eyes and nose work in a predictable tandem. Imagine that the eyes and nose are connected by a string that travels through a two-wheel pulley located directly between the eyes. The length of the string is constant. If a person's eyes are moved farther apart, the string pulls the nose upward, closer to the eyeline. If the nose is made longer, then the string pulls the eyes closer together. All of this takes place within the T-Shape.

The mouth, nose, and chin have a similar connection. The amounts of distance between these features must add up to a constant. If the mouth is perceived as close to the nose, the chin moves a little farther downward as a reaction, and vice-versa.

This is extreme simplification, but, as I have said before, the simpler you can make the shapes you are working with, the easier it is to exaggerate them and create your caricature. If you imagine a shape as simple as a T, it becomes very easy to exaggerate that T-Shape and then plug the features into it—and, just like that, you have your caricature.

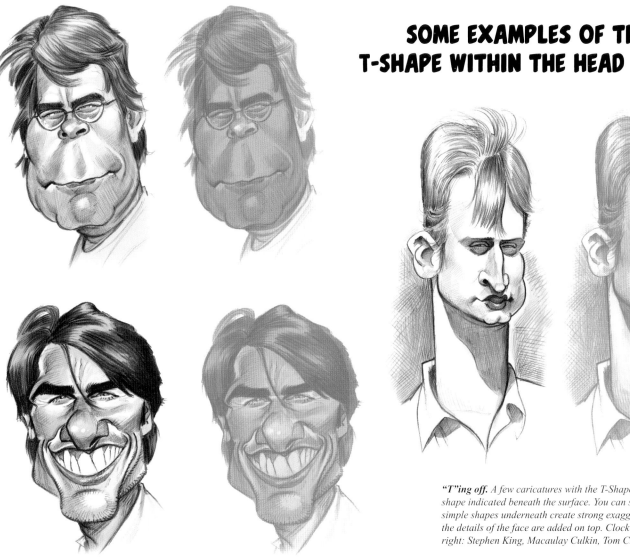

SOME EXAMPLES OF THE T-SHAPE WITHIN THE HEAD SHAPE

"T"ing off. A few caricatures with the T-Shape and head shape indicated beneath the surface. You can see how the simple shapes underneath create strong exaggerations once the details of the face are added on top. Clockwise from top right: Stephen King, Macaulay Culkin, Tom Cruise.

The T-Shape and head shape combine to create the base of your caricature. Over them, the Five Shapes further define the relationships of the features, and over the Five Shapes you can add the features themselves. Things like bone structure, anatomy, expression, skin, hair, and other details further work to create the likeness and bring the underlying structure to life. But never forget that it's all built on these simple foundations.

I would suggest, as an exercise, to set aside the notions of rendering and drawing details on caricatures for a moment and instead fill up a few sketchbook pages with nothing but the head shapes and T-Shapes of some faces from a magazine. Draw one quickly, using just your initial observations and first impressions of the face, then look back at it and try to see where it differs from the "normal" template of classic proportion. Then try it again, this time exaggerating what you produced in your first try. Do this with a dozen faces a day, and watch how your ability to see the caricature in a given face develops. This is a good exercise for any caricaturist, no matter your skill level.

3 HEAD SHAPE: THE ALPHA SHAPE

Heads up! *These three example drawings have very distinct and exaggerated head shapes, making them strong caricatures. Clockwise from right: Actor William Shatner, internet sensation Ted Williams, wrestler "Hulk" Hogan.*

While there are many crucial factors involved in creating a successful caricature, there is one component that is by far the most important and powerful element in any caricature: the head shape.

The head shape is the fulcrum upon which a caricature hinges. The main power of all exaggeration is accomplished through the shape of the head, and realizing this can help you focus your efforts. By treating the head shape as a single shape, it is easier to recognize how that shape differs from "normal"—and it is easier still to draw a corresponding simple shape that exaggerates those properties (as opposed to the more complex, multiple relationships that go on between the features). By stretching and exaggerating the head shape, you create the framework within which your other features and their relationships can be drawn to achieve your caricature.

I have spoken of the Five Shapes and the importance of their relationships already, but let's dig a little deeper. It's fair to say that the head shape is the primary shape—or the "Alpha Shape"—and the other four shapes are the planets to its sun. If a caricaturist can see and exaggerate the head shape, all the other features seem to fall into place. I've talked about the T-Shape as a focal point for the basic caricature, but it's time to amend that notion to comprise the T-Shape and the head shape, which work together as a whole to make up the basic foundation of a caricature. Once we have those shapes and their relationships established, the rest of the caricature quickly follows suit.

EXAGGERATING THE HEAD SHAPE CREATES POWERFUL CARICATURES

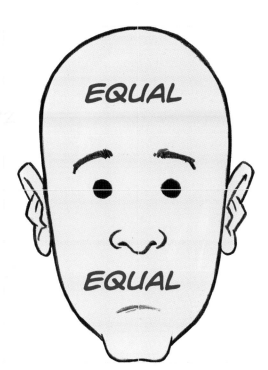

SEEING THE HEAD SHAPE

As I said at the beginning of this book, there's no instant, magic way to teach someone how to see . . . that ability is developed over time, with practice and hard work. Still, there are a few techniques and tricks I have learned, several of which come in handy for both the initial observations and the exaggeration of head shapes.

More Classic Proportion

When considering the head shape, it's important to have an understanding of the classic human proportion and anatomy I previously touched on. A caricaturist can use these idyllic proportions, like Redman's "Inbetweener," as a springboard from which observations can be made. This helps you see what makes a given face unique by comparing it to those "normal" proportions, and it helps you exaggerate those unique aspects by giving you a starting point from which to diverge.

The classic adult head is an oval, slightly flattened along the top. It is divided exactly in half at the eyeline, meaning there is equal distance from the horizontal line of the eyes to both the top and bottom of the head. The distance, or more accurately the mass, of the head above and below the eyes, and how those two areas relate, is a crucial aspect of caricaturing the head shape. I will refer to this mass ratio often.

A head for caricature. Since exaggerating the head shape makes such a high impact on the overall caricature, it should be the artist's goal to stretch that head shape as much as possible. Just remember, exaggerate—don't distort. The exaggeration applied should make sense for the subject being caricatured.

Half full or half empty? A caricaturist uses the traditional rules of classic portrait proportion as a starting point for creating their exaggerations. How does the subject's face differ from the established rules of classic proportion? How far from those established rules of proportion can the artist push their drawing and still maintain likeness and recognizability? Rules like the supposedly equal mass above and below the eyeline in the head are meant to be broken in caricature.

KEEPING IT SIMPLE

Simplifying Shapes

The head shape really comprises many different features, including cheekbones, cheeks, brow, jawline, chin, forehead, and hair. While these are all important elements of the whole, at this stage we need to treat the head as a single shape and keep it as simple as possible. Simple shapes are easier to draw, control, and manipulate. If you start with a complex shape, you might find yourself getting hung up on the details and not be able to see past them to the underlying foundation. There are some tricks you can use to help make initial observations and come up with a simple head shape.

1. Squint Your Eyes

The details in the face can distract you from seeing the simple shapes that are more important. Squinting your eyes when you are looking at the subject is an old portrait artist's trick. Almost close your eyes, so that you are looking through your eyelashes at your subject. This blurs your vision, which eliminates the details and forces you to see only vague shapes and forms. As simple as this method is, it really does make it easier to see the basic shapes and draw them.

Simple Simon. Exaggeration in caricature is best and most easily accomplished when you ignore all the distracting details and simplify the face and its features as much as possible. This is especially true when dealing with the head shape. Try to imagine the head as the most simple shape you can. These examples show the simple geometric shapes that form the basis for the more complex caricatures.

LOOK FOR POINTS OF REFERENCE

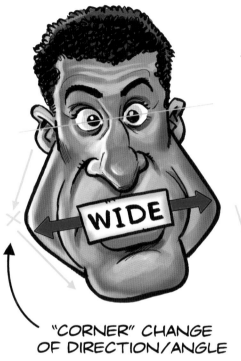

USING DIFFERENT ANCHOR POINTS TO HELP MAKE OBSERVATIONS

WIDE

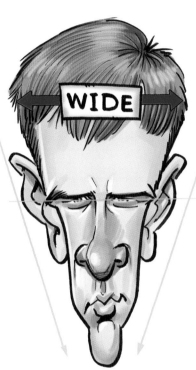

WIDE

"CORNER" CHANGE OF DIRECTION/ANGLE

LOOK FOR STRAIGHT LINES

CENTER AXIS

EYE LINE

WIDE

2. Find Points of Reference

I look for these with every feature I draw. What I mean by a point of reference is any specific point or part of a feature you can use as an anchor point from which to make your observations. Each feature has unique points of reference, but remember you can always use things like horizontal or vertical dividing lines for this purpose.

The horizontal line created by the eyes is a good point of reference, as is the vertical axis that divides the face. Using these lines makes it easier to see where the mass of the head is bigger or smaller, and it is also helpful to note the distance a feature might lie in

relation to them. I also look for the widest point of the head shape, knowing that once I have found these points I need only to make sure the rest of the head shape falls in between them. Try to notice any straight lines along the contour of the head shape, and draw them accordingly. Finally, I look for points along the face contour where there is an angular change of direction. The back of the jaw and sides of the chin often have these points. Any or all of these points of reference can help you see the rest of the head shape by comparing it to the surrounding terrain.

Making a point. Finding different points of reference within a face helps the artist see shapes and relationships because it provides something to use to compare things to. Looking for where the head is widest, where there might be straight lines, places where there is a sharp corner or angle, using the center axis or the line of the eyes—these reference points act as landmarks from which an artist can find direction amid the facial features.

EXAGGERATING HEAD SHAPE IMBALANCE

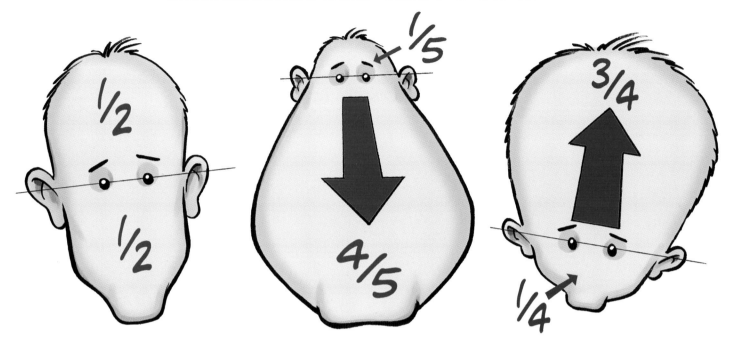

Imbalancing act. One of the simplest observations and exaggerations you can make with respect to the head shape is the balance between the upper and lower head—not just the distance from the center, but the mass of each half.

3. Notice the Imbalance between Halves

When trying to decide what to exaggerate, caricaturists often asks themselves a series of questions about a subject: Is this face wide or narrow? Short or long? Round or angular? Forcing yourself to consider only limited choices sometimes helps you see things that might not have been readily apparent. With respect to head shape, one of the simplest, most powerful questions is: Does this head have more mass above or below the eyes? This draws on the points of reference I mentioned above. Using the horizontal axis of the eyes as a reference point, try to determine if there is more mass above or below that line. In the proportional guidelines of traditional portraiture, the mass is evenly split between the top and bottom halves of the face. Therefore, if you can determine which hemisphere of your subject's face has the greater (or lesser) amount of mass, you have an excellent place to start your exaggeration. The greater the imbalance, the more you can push that exaggeration.

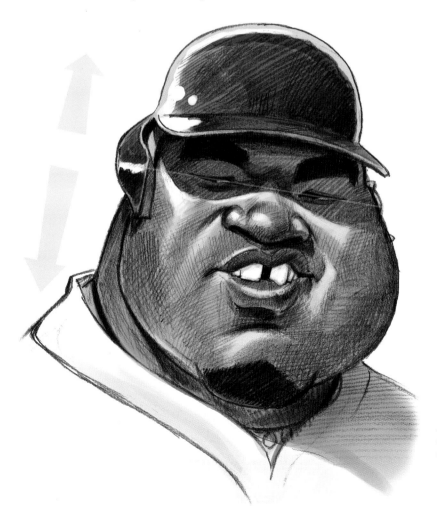

Play Ball! This caricature of Boston Red Sox slugger David Ortiz demonstrates how the imbalance of the halves of the head can create a strong exaggeration.

4. Play with Shape Association

This is a strange but effective way to grasp a simple head shape, and it also helps point you towards how to exaggerate it at the same time. Try to associate the head shape of your subject with the shape of some inanimate object you are familiar with. Maybe this person has a head shaped like a light bulb (small, narrow bottom of the face and a big forehead), or that person's head shape may remind you of a peanut (squeezed at the temples). Try to use whatever strikes you. I don't mean draw a light bulb with a face on it, but rather use your imagination and keep that object in mind as a template for the head shape you draw. This technique is especially helpful in developing a caricaturist's ability to think in simple forms and shapes.

It's a fun exercise to draw those objects with faces on them just to get some practice. Doing this helps increase your ability to spot those shape associations within your subject's head shape.

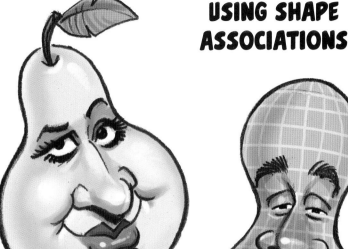

USING SHAPE ASSOCIATIONS

Apples and oranges and pears and toasters. Does the head shape of your subject remind you of some object? Imagining the head shape as some familiar object is a great way to simplify and apply some exaggeration to the head.

THE HUMAN SKULL

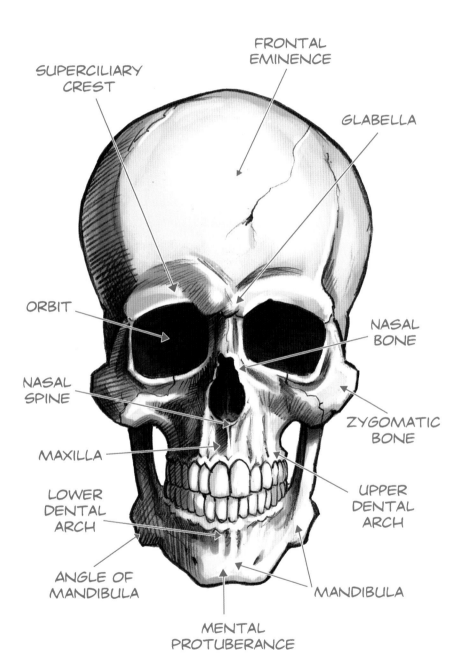

SUPERCILIARY CREST

FRONTAL EMINENCE

GLABELLA

ORBIT

NASAL BONE

NASAL SPINE

ZYGOMATIC BONE

MAXILLA

UPPER DENTAL ARCH

LOWER DENTAL ARCH

ANGLE OF MANDIBULA

MANDIBULA

MENTAL PROTUBERANCE

Boning up on anatomy. While having a Ph.D. in human anatomy is not required to be able to draw the face and figure well, having a basic knowledge and understanding of the skeletal structure, especially those parts that are prominent elements of the surface features, is important.

ANATOMY OF THE HEAD

When working in the studio, meaning when I am not drawing live caricatures and have the time to sketch, I always start with the head shape. I cannot stress enough that the head shape is the vehicle through which the most effective and strongest exaggerations are made. Drawing live is a different matter, and we'll cover that in the chapter "Drawing Live Caricatures."

When I talk about head shape, I'm not talking about just the skull and flesh of the face. Hair plays a big part in head shape: it can easily dominate the visual mass of the head, or it might be virtually nonexistent if cropped close. So, "hair shape" is as much a part of the overall head shape as the skull itself. However, as hair is almost more of an accessory than a structured part of the anatomy, for now we will concentrate on the skull and its component parts, along with the muscles and tissue that create the basic form of the head.

The Skull

The basic head starts with the underlying skull, which, with the exception of the mandible (jaw bone), is a constant and unchanging form. The skull is made up of fused plates that create its shape, and the various protrusions and areas have specific names like the zygomatic bone (cheekbone), mental protuberance (chin), superciliary crest (brow), the orbit (eye socket), the mandibula (jaw), the frontal eminence (forehead) and a few others detailed in the illustration on the left.

That's a lot of tongue-tying names to remember. Not to worry, I don't remember them all either. It's less important to be able to recite the correct names of the anatomy than it is to know where they are and what they look like. You can call them Bob and Fred if it works for you. It's only important to know and understand how they affect the surface of your subject.

The Musculature

The skull does not tell the whole story . . . far from it. Understand that, while everyone has a skull and every skull is made up of the same basic components, in many faces those components are hardly visible. The skull is covered by layers of muscle, cartilage, ligaments, tendons, fat, and skin, and in many subjects it can be hard to see bone structure under all that stuff. It's still there, and knowing where it is and how it works only makes your drawing of the surface features that much stronger—but the head shape itself is also made up of all that muscle, skin, and other tissue. We will discuss the specific muscles and tissue that affect the features in upcoming chapters. For now, let's look at the muscles of the entire basic head as shown on the right.

More brain-numbing names. There is skin and fat above this layer, so the muscles of the face still don't tell the whole story, but knowing about them is important. What we are really drawing is what we see on the surface and what creates the silhouette shape of the head.

Approaching a caricature is all about boiling the complex down to the simplified so it becomes easier to describe and eventually to exaggerate. When sketching the basic head shape, I don't draw a skull; rather, I draw the subject's head while keeping in mind the structure I know is lurking below—namely, the bones of the skull and the muscles that lay on top of them. With that in mind, I split the head into two parts, the face shape and the cranial mass. The face shape is the lower half of the head, from the temples (or brow) down to the bottom of the jaw area. The cranial mass is the upper area of the head, mostly made up of the brain cavity (lower left).

Starting out in the simplest of terms, the cranial mass is basically a ball, and the face shape resembles a curved shield that covers the bottom of this ball and extends down past its lower curve. The result looks like a kind of protective helmet (lower right).

THE MUSCLES OF THE FACE

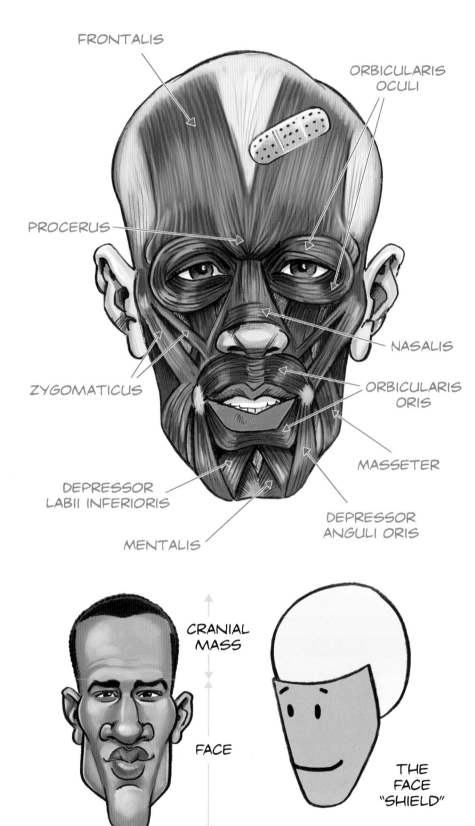

FRONTALIS

ORBICULARIS OCULI

PROCERUS

NASALIS

ZYGOMATICUS

ORBICULARIS ORIS

MASSETER

DEPRESSOR LABII INFERIORIS

DEPRESSOR ANGULI ORIS

MENTALIS

CRANIAL MASS

FACE

THE FACE "SHIELD"

THE SIX BASIC SKELETAL ELEMENTS OF THE HEAD

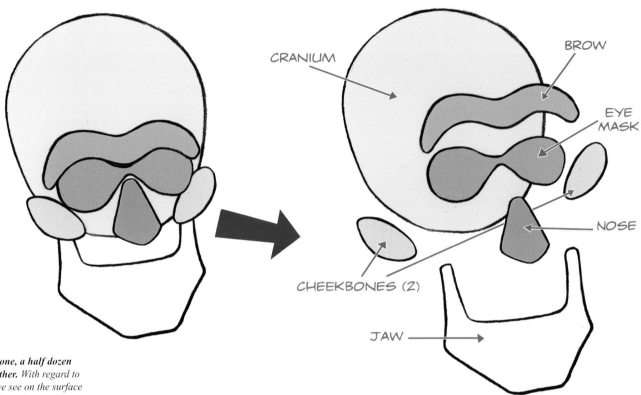

Six of one, a half dozen of another. With regard to what we see on the surface of the face, these six basic skull elements are the most prominent and have the most influence on the face itself. Each are often very evident beneath the skin, and knowing where they are and how they work beneath the surface is important.

Obviously this "facial shield" is too simple—we need to have more information to build our subject's head and face. There are six components that make up the basic head structure (see above):

- **Cranium**
- **Eye Mask (sockets)**
- **Nose**
- **Brow**
- **Cheekbones**
- **Jaw or Lower Face**

These represent the parts of the skull that have the most direct impact on the features of the face. They are the most noticeable through the surface features. I imagine the cranium as a large ball; the eye sockets and nose cavity as simple shapes drawn on that curved face shape; the brow as a roll of mass that sticks to the surface right where the cranium and face shape meet; and the

cheekbones as an egg sliced in half, each half stuck to the right and left sides of the face shape. These elements can move about depending on the face, and they are what I'll be consciously moving when I exaggerate.

The jaw is the most complex of the shapes, incorporating not just the jaw bone but the flesh from the cheekbones down to around the chin to create the lower face. This area might consist of a very obvious jaw bone in leaner faces, and the jaw bone might be entirely obscured by flesh in heavier models, creating a floating chin peeking out of a round shape. The amount of fatty tissue on the face can greatly affect the head shape, especially the lower half. As the face gets heavier and heavier, the flesh overpowers the bone, obscuring it and dictating the lower head shape. By drawing in the six head shapes, we have our basic head structure.

DRAWING AND EXAGGERATING THE HEAD SHAPE

Using these six components, we can create a lot of very exaggerated head shapes (right).

Looking at these, you can really see how the exaggeration in a caricature starts with the head shape. These very simple drawings are already strong caricatures. All that really remains to make them recognizable as the individual subject is inserting the individual features into the appropriate places as dictated by our exaggerated head shape.

I mentioned earlier that the head shape is a place where exaggeration can be most easily applied to the greatest effect. This is because altering the head shape to any appreciable degree creates a drawing radically different than a portrait. Any change to the head shape from the "normal" has a very high impact upon the viewer. The features, by way of their necessary relationships within the head shape, are forced to follow suit and become exaggerated via their relationships. My analogy of the head shape as a fulcrum is an apt one because, just as a fulcrum is the point at which the force applied to a lever is amplified, the slightest exaggeration applied to the head shape can radically change all other aspects of the face. Treating the head like a single (albeit slightly complex) shape makes it relatively easy to decide on those exaggerations and apply them. Unlike the interior features of the face, which all change with expression, the head shape is a constant that only changes with the angle of the head, and then only in the ways any object will change when rotating in space. When exaggerating the head shape, all you really need is one observation upon which to build your caricature. This could be as simple as observing that the model has a skinny face, or a large chin, or a small forehead. Multiple observations are great, but one strong one is all you need to create a cascading effect that can define your caricature.

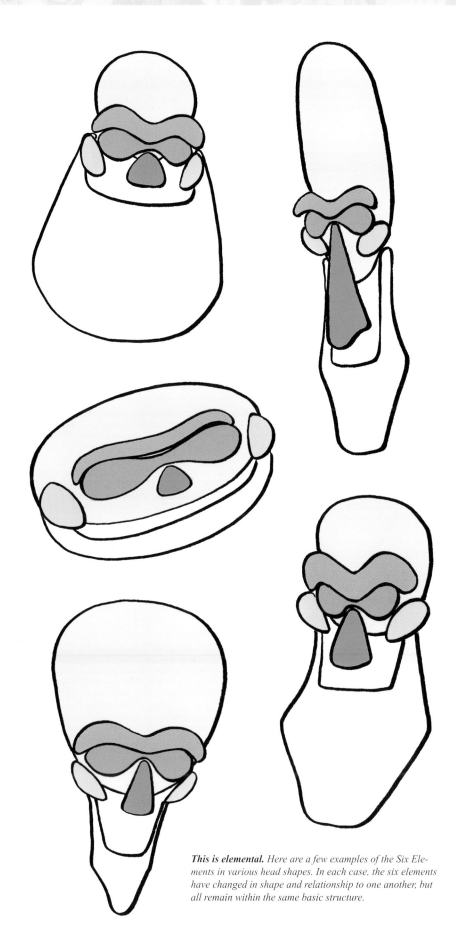

This is elemental. *Here are a few examples of the Six Elements in various head shapes. In each case, the six elements have changed in shape and relationship to one another, but all remain within the same basic structure.*

EXAGGERATING VISUAL WEIGHT

Here are some concepts that are helpful for seeing and exaggerating the head shape. They are variations of the same basic principle, but it's valuable to have several ways to look at exaggeration of the head.

1. Visual Weight

One key to exaggerating the head shape is to decide where the visual weight of the head lies. That can be as simple as using the aforementioned line of the eyes as a reference point and asking yourself if more of the mass lies above the eyes or below them, as we discussed with the half-and-half concept. That is visual weight: the placement of head mass relative to some point of reference like the line of the eyes.

We know that in a "normally" proportioned head the mass is equal on both sides of the eyeline. But how we perceive the face is different than what its physical dimensions might measure. Whenever you can depart from the equal mass rule, it's important to do so. That is caricature.

You can think of visual weight as an actual weight pulling or pushing on the head shape. Imagine the head to be a flexible balloon-like object. A face with a large jaw or lower area is like a balloon partially filled with water . . . its contents pull the shape downward. Likewise, a subject with a big forehead or cranial mass is like a balloon filled with helium . . . the contents try to rise and push against the upper part of the balloon.

You can also imagine that balloon full of air, and think in terms of what happens when you squeeze an area. A small forehead means squeezing the top, which then expands the bottom. A slender jaw or sunken chin means you squeeze the bottom, making the top expand.

Likewise, a narrow, thin face means squeezing the sides, causing the top and bottom to bulge. A short, squat face means applying the pressure at the top and bottom, which would cause the balloon's sides to bulge. This much-abused balloon is a way to visualize action and reaction at work.

Weighty matters. Exaggerating the placement of visual weight within a head shape follows predictable patterns. Weight added to one area pulls the head shape. Pressure applied to the shape makes it bulge and stretch.

2. The Law of Constant Mass

As I mentioned before, there are very few "rules" that are universal as applied to caricature; things like expressions, posture, and unique physical attributes make it almost impossible to be able to say this or that "is always true." Here is one rule that never changes, however, and it's a powerful tool to create convincing exaggerations: the Law of Constant Mass. By using it, you can take that "one observation" about the head and follow through so that the rest of the head shape is affected.

Imagine you have sculpted a perfectly proportioned head out of wet clay. Your head is done, but you have used up all your clay. Then you decide you want to create a caricature rather than a realistic bust of your subject. Looking at the model, you decide they have a large jaw, so you want to make the jaw bigger. With no more clay to work with, you need to get that clay from somewhere else and pack it on to enlarge the jaw. Where should you get it from? You must take it from the top of the head, reducing the size of the top to make the bottom bigger. That is the Law of Constant Mass.

According to this "law," the head has only so much mass. You cannot make one area bigger or smaller without affecting the other areas. A person with a big chin will automatically have a smaller upper head. Likewise, someone with a big forehead will also have a smaller lower face. This serves to create exaggerations with greater impact, since the viewers' perception of a large jaw will be more pronounced when coupled with their perception of a smaller upper head. It's the same effect as when a gray value appears lighter when surrounded by a much darker value and looks darker when surrounded by true white. This is the concept of contrast, which I will talk more about later. The Law of Constant Mass holds true at all directions with respect to the face. If the face is very wide you need to take mass from both the top and bottom to create that width. Of course this will also affect the relationships of the interior features, because they must now fit into the new, exaggerated head shape. It's that powerful and unavoidable chain reaction on all the other shapes that makes the head shape the most important of the Five Shapes.

REDISTRIBUTING CONSTANT MASS

Claying around. Imagine you have a sculpted portrait bust that you want to make into a caricature, but you have used up all your clay . . .

Digging in. You decide the subject has a large jaw and chin, and the only way to add to the bottom part of the head is to take the clay from the top part.

Robbing Peter to pay Paul. The Law of Constant Mass dictates that in order to add mass to one part of the head shape, you must remove it from another. The mass of the head must remain constant, so exaggerating one area will affect other areas. A large jaw calls for a smaller cranial mass.

STRETCHING THE TRUTH

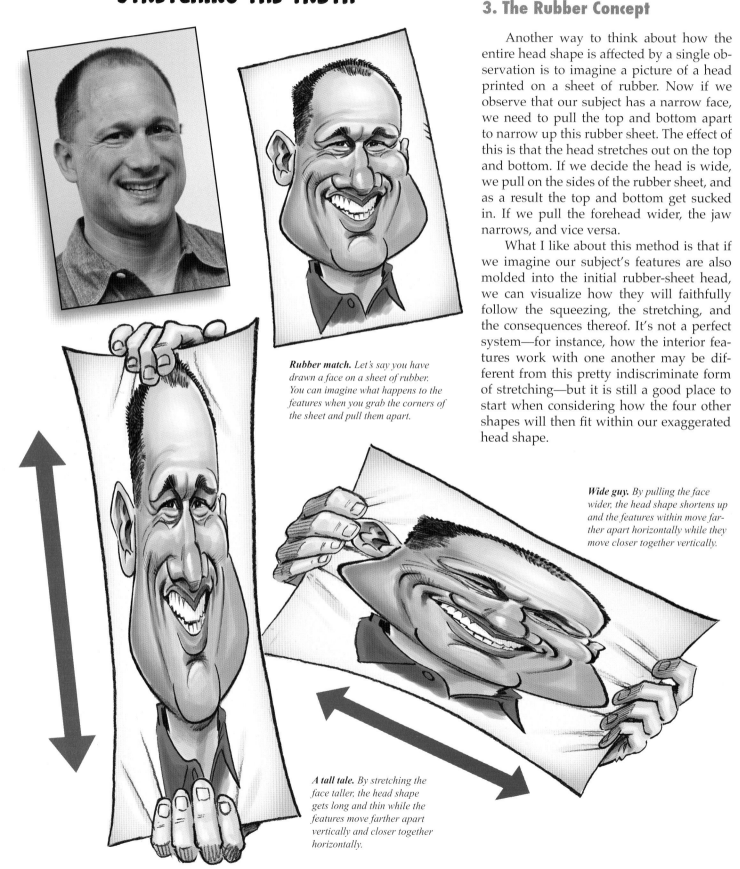

3. The Rubber Concept

Another way to think about how the entire head shape is affected by a single observation is to imagine a picture of a head printed on a sheet of rubber. Now if we observe that our subject has a narrow face, we need to pull the top and bottom apart to narrow up this rubber sheet. The effect of this is that the head stretches out on the top and bottom. If we decide the head is wide, we pull on the sides of the rubber sheet, and as a result the top and bottom get sucked in. If we pull the forehead wider, the jaw narrows, and vice versa.

What I like about this method is that if we imagine our subject's features are also molded into the initial rubber-sheet head, we can visualize how they will faithfully follow the squeezing, the stretching, and the consequences thereof. It's not a perfect system—for instance, how the interior features work with one another may be different from this pretty indiscriminate form of stretching—but it is still a good place to start when considering how the four other shapes will then fit within our exaggerated head shape.

Rubber match. Let's say you have drawn a face on a sheet of rubber. You can imagine what happens to the features when you grab the corners of the sheet and pull them apart.

Wide guy. By pulling the face wider, the head shape shortens up and the features within move farther apart horizontally while they move closer together vertically.

A tall tale. By stretching the face taller, the head shape gets long and thin while the features move farther apart vertically and closer together horizontally.

4. Use the Force, Luke!

You will have to forgive me for getting a little metaphysical here, but the concepts of constant mass, a rubberized face, and visual weight are really only simpler interpretations of the main idea . . . that of a constant force or energy in the face. Let's call it, with apologies to George Lucas, "the Force."

This means that we can treat the features of the face as if they contain a kind of energy that connects them. Imagine lines of light stretching between the Five Shapes, creating a web of energy between the features themselves and the head shape. That energy is a constant. You cannot change the amount of energy (meaning that of any of our three basic relationships: size, distance, or angle) between any of these elements without transferring it to or from other areas of the face. As in our example with the Law of Constant Mass, in order to exaggerate a subject's jaw size we must take that mass (or, in this case, energy) from somewhere, likely the cranium. Likewise, when we exaggerate within the face we end up with similar energy exchanges. For example, if we decide to move the eyes closer together, we find that often causes the nose to get longer. But what if we have a face confronting us that not only has the eyes close together but also has a small nose close to the eyes? Where do we go with that? Visualizing the Force tells us that if the lines of energy between the eyes and nose are all shortened, then that energy must be moved and will make the lines longer elsewhere. The likely result is that the distance between the eyes-nose area (the T-Shape) and the contours of the head shape will expand to compensate.

All of these different tools are simply extensions of the action and reaction theory. It's important to trust the outcome of the cause and effect associated with an exaggeration of the head shape, via the Law of Constant Mass, the rubber concept, or by using "the Force." Even if your lantern-jawed subject does not appear to have a small upper head, it is important to follow through with moving that mass if you want to emphasize

CONSTANT LINES OF FORCE

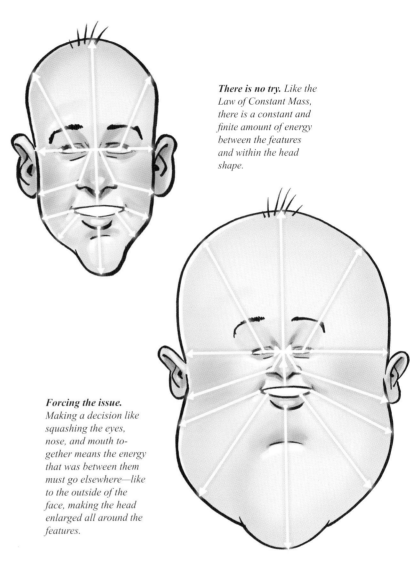

There is no try. Like the Law of Constant Mass, there is a constant and finite amount of energy between the features and within the head shape.

Forcing the issue. Making a decision like squashing the eyes, nose, and mouth together means the energy that was between them must go elsewhere—like to the outside of the face, making the head enlarged all around the features.

the jaw and also maintain a balance in your drawing. Failing to do so could make your exaggeration appear awkward and a lot less clear.

In case I haven't repeated myself enough: the shape of the head is a crucial element to a good caricature . . . it's arguably THE crucial element. Accurately observing the head shape, making good decisions on where to place the visual weight, and then exaggerating that shape is central to an effective caricature. These steps form the glue that holds the rest of the features together.

4 DRAWING AND CARICATURING THE FEATURES

The axiom "you have to learn to walk before you can run" is apropos when it comes to drawing caricatures. Really successful caricatures are firmly rooted in reality, meaning that the best caricaturists have a strong working knowledge of real anatomy and realistic drawing. Stretching the face can be done more convincingly if you know what you are stretching. Therefore, much of learning to draw caricatures is really learning to draw the face in general: understanding basic structure and anatomy, learning how features work in and of themselves and with each other, and, eventually, knowing what to expect with the human face.

As I said before, it's difficult to really teach someone to draw caricatures . . . that comes with improvement to an artist's "sight" and observation skills, which leads to an ability to find that which makes an individual face unique and exaggerate it. However, I can demonstrate how to draw the individual features and share methods for how to help see them, exaggerate them, and draw them to the best effect. Ultimately, the choice of what to exaggerate is still always up to the artist.

Jon, Jake-ob, jingleheimer schmidt.
There is certainly no lack of features to caricature on actor Jake Gyllenhal or
The Daily Show star Jon Stewart.

Here is where style becomes an issue. What I have written about so far can apply to almost any style of caricature, from the richly painted to the most minimalist of line drawings. In these next sections, some aspects of what I talk about will relate more specifically to a style of caricature like my own—that is, one based on cartoon line, either inked or rendered in some other medium. Those with different sensibilities and styles can take from it what they will and apply what makes sense to them. Though I cannot change the fact that my viewpoint is informed by my own style, I will try to center my discussions on material that applies to a broader range of styles.

My method for teaching how to caricature the individual features begins with a lesson on real anatomy. I'm not a big believer in memorizing every anatomical name, but I do believe you must have a good working knowledge of how a feature is put together in order to have a good command of drawing that feature. Following the anatomy lesson, I talk about different techniques to help see the shape of the feature and understand how to draw it, including realistic proportion. Finally I talk about interpreting the feature in terms of exaggeration and how to incorporate it into the whole caricature.

MORE ABOUT POINTS OF REFERENCE

Seeing and drawing anything is all about finding shapes and drawing them correctly, or, in the case of caricature, drawing the exaggeration of them correctly. Either way, first you have to see the object you are drawing and understand its form. We have all seen depictions of an artist raising his or her arm outstretched towards the model, with the thumb sticking out from the fist, while the artist squints at the view of both thumb and model, preparing to begin a new masterpiece. That is supposed to represent an old habit among artists, that of using

their thumb—or hand, or pencil, or some other object—to measure their subject's features relative to one another and to better see angles or other relationships. The thumb acts as a point of reference: a constant that is used to make accurate observations of the subject. Establishing points of reference in the face is key to helping an artist see shapes and make observations. I touched on points of reference in a general way in the last chapter. As I discuss individual features in this and following chapters, I will suggest several things I constantly use as points of reference for specific features. These become starting points on which other observations can be based. Any kind of drawing can benefit from applying points of reference.

Some real characters. Clockwise from top right: actor David Caruso, rapper Jay Z, and physicist Albert Einstein.

THE EYES

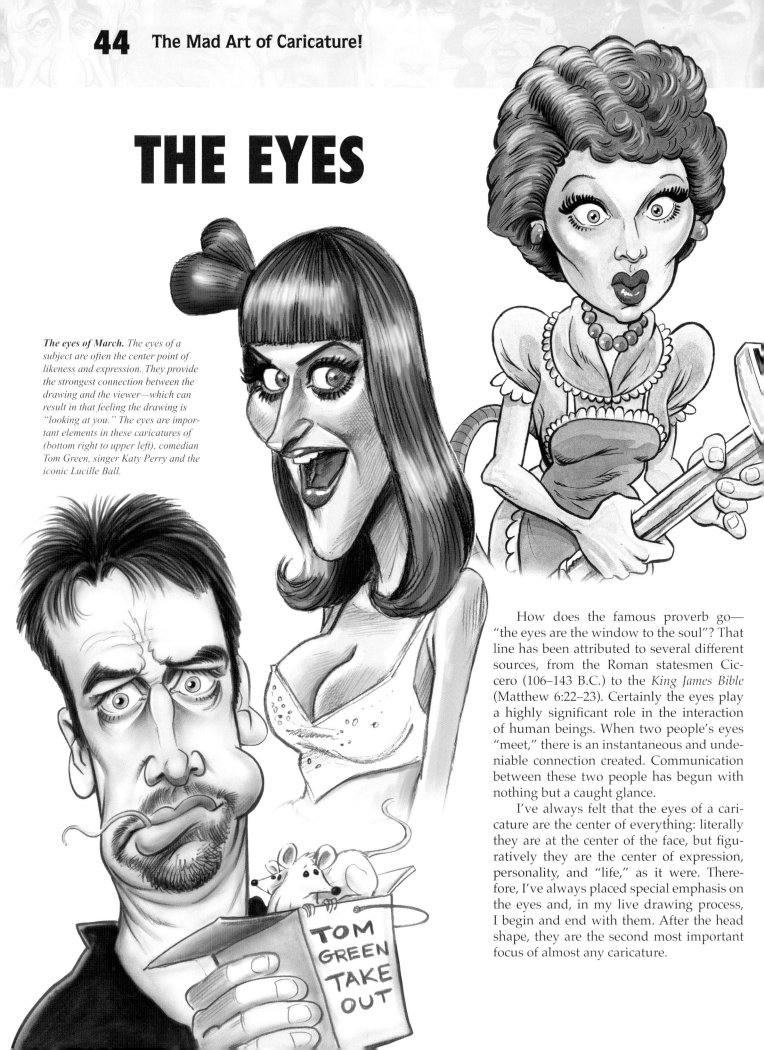

The eyes of March. *The eyes of a subject are often the center point of likeness and expression. They provide the strongest connection between the drawing and the viewer—which can result in that feeling the drawing is "looking at you." The eyes are important elements in these caricatures of (bottom right to upper left), comedian Tom Green, singer Katy Perry and the iconic Lucille Ball.*

TOM GREEN TAKE OUT

How does the famous proverb go—"the eyes are the window to the soul"? That line has been attributed to several different sources, from the Roman statesmen Ciccero (106–143 B.C.) to the *King James Bible* (Matthew 6:22–23). Certainly the eyes play a highly significant role in the interaction of human beings. When two people's eyes "meet," there is an instantaneous and undeniable connection created. Communication between these two people has begun with nothing but a caught glance.

I've always felt that the eyes of a caricature are the center of everything: literally they are at the center of the face, but figuratively they are the center of expression, personality, and "life," as it were. Therefore, I've always placed special emphasis on the eyes and, in my live drawing process, I begin and end with them. After the head shape, they are the second most important focus of almost any caricature.

ANATOMY OF THE EYE

The human eye is made up of a round orb (eyeball) that rests in, and slightly protrudes from, a socket of bone and tissue, the whole of which is surrounded by orbital muscles and covered by skin in the form of eyelids. The visible parts of the eyeball include the pupil (that black circle in the center of the eye), the iris (the colored area around the pupil, which is made up of the stroma, threadlike fibers that radiate from the pupil out to the edge of the iris), and the sclera (the whites of the eyes). The tissue surrounding the eyes include the inner and outer canthus (the "corners" of the eyes), the caruncula (the small, reddish, oval-shaped piece of tissue in the inner corner which is sometimes incorrectly referred to as the "tear duct"), and the semilunar fold (where the eyeball meets the caruncula). The eyelids consist of the upper and lower lid plates (the actual eyelids that fold down and up to cover the eyeball) and the eyelashes, or cilia (the short, thick, curved hairs attached to the free edges of the lid plates in a double or triple row).

The part of the eye that we see is only a fraction of the actual eye itself. The eyeball is not a perfect sphere—there is a bulge on its forward surface immediately over the pupil and iris called the cornea, which contains a pocket called the anterior chamber and acts as a lens above the pupil. This bulge is so subtle that unless you are drawing a very extreme close-up, treating the eye as a perfect sphere works fine. It is important, however, to understand that the eye protrudes quite a bit from the surrounding tissue. The eyeball is recessed in the skull's eye socket, surrounded by the orbicularis oculi muscle. From the ridge of bone of the eye socket, the area around the eye is somewhat concave up to the point where the eyeball itself pushes forward out of the recess, so that the eye protrudes from a slight "pocket" within the orbit.

BASIC EYE ANATOMY

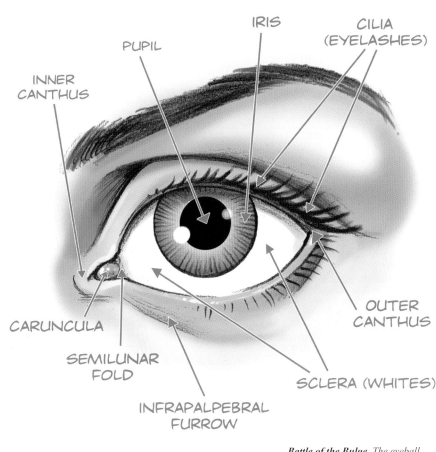

INNER CANTHUS

PUPIL

IRIS

CILIA (EYELASHES)

CARUNCULA

SEMILUNAR FOLD

INFRAPALPEBRAL FURROW

OUTER CANTHUS

SCLERA (WHITES)

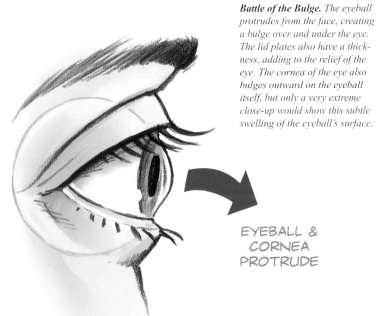

Battle of the Bulge. *The eyeball protrudes from the face, creating a bulge over and under the eye. The lid plates also have a thickness, adding to the relief of the eye. The cornea of the eye also bulges outward on the eyeball itself, but only a very extreme close-up would show this subtle swelling of the eyeball's surface.*

EYEBALL & CORNEA PROTRUDE

SIMPLIFYING THE EYE SHAPE

SEEING THE EYE SHAPE

Eyes on the prize. *Like the head shape, simplifying the eye shape is key to both capturing likeness and exaggerating. Squint your eyes and look through your eyelashes to eliminate all the distracting details . . .*

. . . and look at just the simple shape created by the area between the lashes.

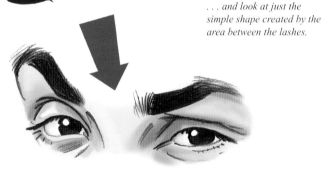

Under the see. *Adding the details back in around your simple shapes captures the eyes. By exaggerating the shapes and their relationships within the Five Shapes, you get your caricature.*

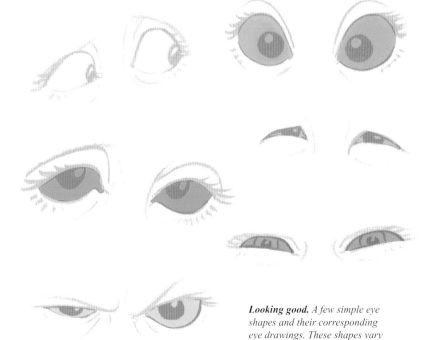

Looking good. *A few simple eye shapes and their corresponding eye drawings. These shapes vary with expression and are seldom perfectly symmetrical.*

The eyes may have special status as the center of the face and the windows to the soul—but remember that the eye is still just another feature and, just like any other feature of the face, it has a shape. When I refer to the "shape" of the eye I am talking about the portion of the eyeball visible between the upper and lower lids. The image on the left shows the simple eye shapes in the photo and the resulting drawing.

The exterior part of the eyes, like the lids themselves and the area that surrounds the eye, is also very important in capturing the eye itself—but it's that initial shape we should pay attention to first. In order to see the eye shape, you must ignore the pupil, iris, and all the lines and visual noise that surround the eye and look at just the pure shape. Imagine the eye as a blank white shape, like Linda Blair's eyes in *The Exorcist*. That shape is what you want to perceive. Remember also that the eye is not flat but protrudes quite a bit from the face, and the lids have a definite thickness to them. Imagining the features of the face as flat instead of three-dimensional is a common problem for beginning caricaturists.

To the left are some examples of a few different eye shapes. While everybody's eyeballs are basically the same, the shapes we see on their faces vary wildly. Thin, tapered, round, flattened, bulbous—expression and the angle of the head makes the eye shapes change. The shapes are not always symmetrical, in fact they are rarely so.

Typically the eye is not shaped like a football or an almond. The upper and lower lids are not mirror images of each other. The lower lid usually creates much less of an arc than the upper lid, as it lays more straightly across from corner to corner. The upper lid overlaps the lower lid at the outer corner and is farther removed from the horizontal axis of the eye (the imaginary line connecting the corners). This horizontal axis, or "corner-to-corner" line, is a useful reference point for making observations about the eye, its shape, and its relationship with the rest of the face. I'll have more on that soon.

The eye shape resembles an asymmetrical yin-yang shape more than it resembles a symmetrical almond. The upper lid line rises somewhat sharply from the caruncula, peaks about one-third of the way across the eye, and then arcs more softly towards the outer corner. The lower lid does the opposite: its lowest point occurs not quite halfway from the outer corner inward, then it arcs softly up to the caruncula. In the simplest of geometric terms, we can represent the eyes as quadrilaterals with the four points being the inner and outer corners, the highest point of the upper lid, and the lowest point of the lower lid. Naturally, we don't draw the eyes with straight lines connecting the dots, but by seeing the shape in simple terms like this we can use these points of reference to better capture the shape of the eyes, as well as to manipulate the feature for exaggeration.

The Corner-to-Corner Line

Let's get back to the corner-to-corner line I mentioned. We can use this to help determine not only the shape of the eye but also its relationship to the axis of the face. Imagine a line going from the outside corner of each eye inward to the inside corner, and then continuing onward to the central axis of the face: this line is essentially the arms of the T-Shape I talked about earlier. By looking at how that line intersects the eye itself, we can gauge how much of the eye shape lies above the line, how much lies below it, and how the contour lines of the eye shape travel along that line. We can also see at what angle the eyes lie in relation to the central axis of the face. Are the outside corners of the eyes higher than the insides? Lower? Even? Are they the same, or is one different than the other? You can use this line to decide how you want to exaggerate the angle you see. The corner-to-corner line is a great tool for perceiving the eye itself, as well as a point of reference for both drawing and observation.

Cornering the market. Imagining a line drawn from the outside to inside corners of the eye is a great point of reference for helping to see its shape and relationships. How much of the shape is above or below the line? At what angle to the center axis of the face are these lines?

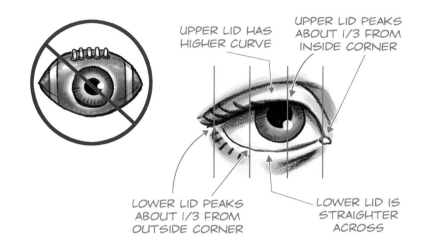

UPPER LID HAS HIGHER CURVE

UPPER LID PEAKS ABOUT 1/3 FROM INSIDE CORNER

LOWER LID PEAKS ABOUT 1/3 FROM OUTSIDE CORNER

LOWER LID IS STRAIGHTER ACROSS

THE CORNER-TO-CORNER LINE

DOES THE EYE SHAPE LAY . . .

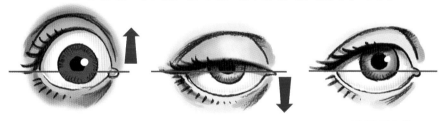

ABOVE THE LINE? BELOW THE LINE? EQUAL?

WHAT'S THE ANGLE?

HORIZONTAL?

UPWARD?

DOWNWARD?

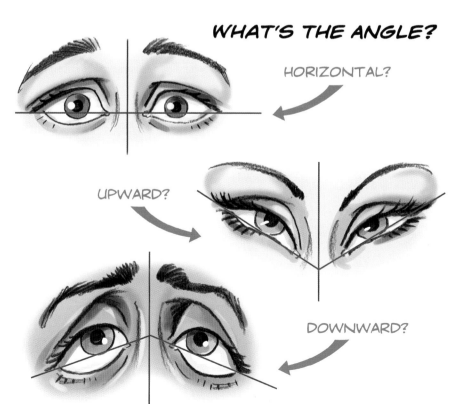

LOOKING FOR POINTS OF REFERENCE

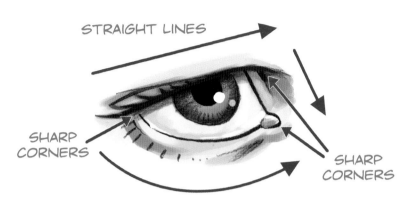

STRAIGHT LINES

SHARP CORNERS

CURVED LINES

SHARP CORNERS

Eye see you. Look for things like straight lines, hard angles, and defining curves around the contour of the eye shape to use as a reference point for drawing the rest of the eye shape.

Contour Lines of Reference

Another method I use for understanding the eye shape is to look for any straight lines in the contour of the eye. Lines that are straight or nearly straight can be used as another point of reference for seeing the rest of the eye and also work well as beginning points for the actual drawing of the eye itself. In many cases, the longer part of the upper eyelid, from the peak to the outside corner, comes close to being a flat line. Look for straight lines and observe their relationships to the rest of the eye's contour to better see the eye shape.

The Mask Technique

One last trick I like to use is something I call the mask technique. This method can help you determine not just the eye shape and placement but also the relationship of the eyes to the rest of the face. Imagine the eye shapes to be openings in a domino mask, one like the Lone Ranger or Batman's sidekick Robin might wear. The top of the mask is defined by the eyebrows, and the lower part by the tops of the cheeks or lower eye socket. There actually is a hollow around the eyes caused by the depression within the orbit, or eye socket opening, which this mask visualization mimics. What you are really trying to picture is the negative space surrounding the eyes. You can imagine a wide variety of shapes and exaggerations using this method of visualization.

Hi-Ho Silver! Imagining a domino mask shape around the eyes helps both to see the eye shape and to place and exaggerate that shape within the head. This is using negative space, in this case the area between the edges of the orbit (eye socket) and the eye shape itself. Once you visualize the simple eye mask, you can exaggerate its shape and relationships with the rest of the features more easily.

DRAWING AND EXAGGERATING THE EYE

The exaggeration of any feature must be done with the whole in mind; it cannot be treated as some separate entity. If you were looking at your model's eye through a pin-hole, you might be tempted to exaggerate the size of the eyes because, when viewed without any surrounding context, the eye will have a round and wide-open look. However, when you take the rest of the face into account, it might very well turn out that the eyes need to be drawn small and beady within a massive face. Remember, exaggeration in caricature is all about the relationships of the features to one another, not the features themselves as examined in-dividually. However, the observations you make about the eyes are a part of the essen-tial whole, especially their angle relative to the center axis and the shapes of the eyes themselves.

The angle of the eyes is the easiest thing about them to exaggerate. If the outer cor-ners are higher than the inner corners, then you simply make them higher still, and if they are lower, you lower them further. Once you make the observation, figuring out the resulting exaggeration is easy.

Exaggerating the shape of the eye is a little trickier. When doing so, it can be easy to compromise the likeness, but when exag-geration here is done right it can greatly en-hance the likeness of the caricature. That's because the shapes of features, especially key features like the eyes, also describe the expression of the subject, and exaggerating expression is a central part of good cari-cature. If someone's eyes become squinty when they smile, then drawing them even more squinty will exaggerate that person's expression as well as the physical appear-ance of their eyes, and expression is per-sonality. Capturing personality is always an essential goal. If your subject's eye shape is squinty, make the eyes more squinty. If they are big and round, make them bigger and rounder.

VARIOUS THINGS TO EXAGGERATE

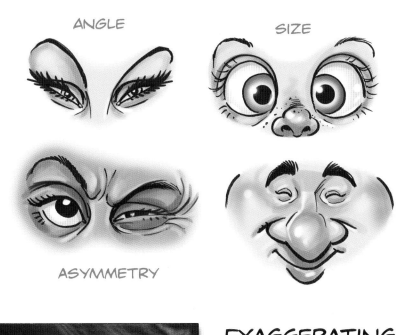

ANGLE

SIZE

ASYMMETRY

EXAGGERATING BY DEGREES

OUR SUBJECT HAS SMALL, CLOSE-SET, SQUINTY EYES . . .

HERE WE HAVE PUSHED THE EYE SHAPES A LITTLE, MAKING THEM CLOSER AND MORE SQUINTY

PUSHED A LITTLE BIT MORE, THE SQUINT EVEN NARROWER AND THE EYES A BIT CLOSER TOGETHER.

EXAGGERATING EYE SHAPE AND THE INFLUENCE OF STYLE

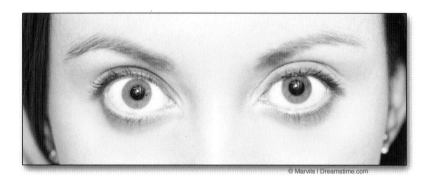

© Marvils | Dreamstime.com

THESE EYES IN MY STYLE

AS MORT DRUCKER MIGHT DRAW THEM

OR AS AL HIRSCHFELD MIGHT HAVE

Exaggerating the eye shape is about "turning up the volume" on their expression and how you perceive the eyes as a whole. If the subject's eyes seem wide open, make them more wide open by drawing them rounder and with more space around the iris and pupil. They should still look like the eyes you are drawing, but, using your observations as a guide, you can turn up the volume a little . . . or a lot—make it as loud as you can without losing the likeness.

Take the set of eyes to the left, which are very round and intense. We can exaggerate their shape by emphasizing the whites surrounding the pupil and iris, as well as the roundness of the lower eye. In this case, I also exaggerate the angle by raising the outside corners, and the asymmetry of the left eye being open wider than the right. I do not crank up the volume too much here; what I am really trying to capture and exaggerate is the intensity of the eyes themselves. Those little observations all combine to create that piercing gaze.

Certain styles of caricature will go farther and "interpret" the shape, actually changing it into a representation of the shape itself. Al Hirschfeld was a genius at capturing a likeness with the sparest of shapes and minimal, elegant linework. On the other end of the style spectrum, we have artists like Mort Drucker, whose work can hardly be compared to minimal, representational shapes. Mort takes the features and applies his unique cartoon-line drawing style to them, softening the shapes and using certain conventions to describe them—all while keeping the recognizability strong. An artist's individual style aside, it all comes down to the same process: seeing the shapes and uniqueness of a person's features and drawing them in a way that the viewer can understand.

Seeing is believing. *Exaggerating the shape of a feature like eyes is where an artist's "style" comes in. Some styles are more cartoonish and linear and might call for a round eye to be drawn as a complete circle, while other styles might require a more realistic approach. Changing the shape to exaggerate the perception of a feature is a fantastic way to caricature—IF the caricaturist makes a good observation and shape-changing decision. Otherwise, you have distortion and a missed likeness.*

Here are several different sets of eyes in many shapes, angles, and sizes, including some notes on drawing and exaggerating:

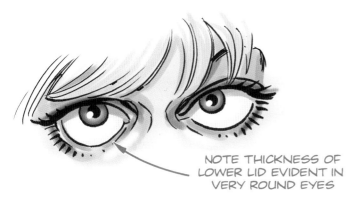

NOTE THICKNESS OF LOWER LID EVIDENT IN VERY ROUND EYES

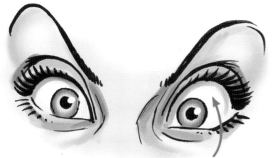

SCLERA VISIBLE ABOVE IRIS MAKES FOR STARTLED EXPRESSION

BROWS INTERACT STRONGLY WITH EYES IN CERTAIN EXPRESSIONS

THREE-QUARTER VIEW EYES CLEARLY SHOW THE PROTRUSION OF THE EYEBALL AND LIDS

EPICANTHIC FOLD IN ASIAN EYES CAN OBSCURE ALL OR PART OF UPPER LID

SCRUNCHED EYES OFTEN SQUEEZE UPPER LIDS SO THEY BARELY SHOW

SQUINTY EYES WITH RAISED EYEBROWS SHOW FULL UPPER LIDS, WITH PUPILS NEARLY HIDDEN BY THE EYELASHES

ASYMMETRY IN EYES IS A POWERFUL THING TO SEE AND CAPTURE. IT DESCRIBES A VERY INDIVIDUAL LOOK OR EXPRESSION

THE NOSE

Do you have Prince Albert in a can? *Not Albert, but Charles. The Prince of Wales has a nose that is begging for exaggeration.*

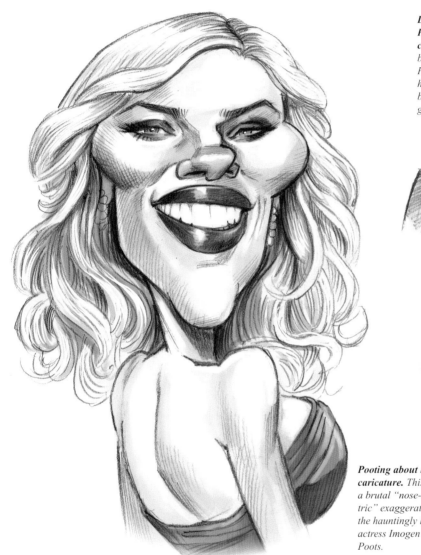

Frankly, Scarlett . . . *Not every nose worthy of exaggeration is big. Actress Scarlett Johansson's nose is small—but also very wide, with upturned and prominent nostrils.*

Pooting about her caricature. *This is a brutal "nose-centric" exaggeration of the hauntingly lovely actress Imogen Poots.*

I think the feature most commonly abused in a caricature is the nose. Many people actually think the definition of caricature is just "a drawing with a big nose." What is it about the nose that makes it such a ripe target for exaggeration, so often picked on (pardon the pun) that even the layman notices? Simply put, the nose is the most obnoxious of features. It sits in the very center of the face. It is a vertical feature, in contrast with the horizontal nature of the eyes and mouth. It sticks out radically from the plane of the face, providing much more of an outcropping than do any of the other features. It's so prominent that it's all too often used as a de facto way to exaggerate the face. But the nose is like any other feature—its perceived relationship with the other features must determine the extent and direction of the exaggeration. Many people have small, button noses that need to be made smaller when exaggerated. In some cases the end of the nose may rest close to the point between the eyes, and in others it might lay far down

the face. Some people have petite sniffers that could be left out entirely, while others have big, honking schnozes that just beg to be stretched. In short, despite its prominence the nose is no different than the other features. It must be exaggerated and drawn in a way consistent with its relationships to other aspects of the face.

ANATOMY OF THE NOSE

The nose is a combination of bone and cartilage, and it consists of various parts that, while unique in appearance from person to person, are nonetheless found in all people. Starting from the top, the point between the eyebrows is called the glabella. The area directly between the eyes (where eyeglasses rest) is called the root, or bridge. The tissue extending from the root downwards the end of the nose is called the lateral surfaces. The end, or "ball," of the nose is called the apex. The two "wings" of the nose (the bulges that define the outside of the nostrils) are called the ala. The septum is the strip of flesh that connects the apex to the face and separates the two nostrils, which are the cavities that open into the interior of the nose and the nasal passages. The alar furrow is the crease made by the separation of the ala and the cheek muscles. The nose protrudes out of the brow, connected at the top by the brow ridge and at the bottom, to the lips and mouth, by the philtrum and the nasolabial furrow. The upper part of the nose, including the brow, glabella, and root is made of bone: the root, or bridge, extends from the brow of the skull and then ends about a quarter to a third of the way down the nose itself. Beyond that point, the nose is all cartilage and soft tissue. Because cartilage continues to grow throughout your life, your nose continues to grow and will alter shape as you age (ears are the same way). That is why many older people have larger noses, and why drawing a larger nose on someone makes them look older in the drawing.

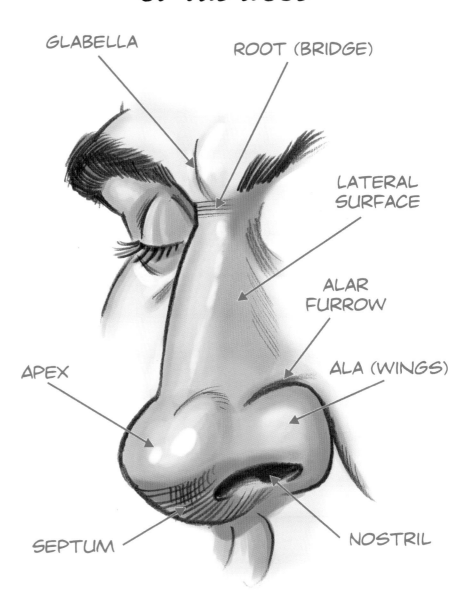

BASIC ANATOMY OF THE NOSE

GLABELLA

ROOT (BRIDGE)

LATERAL SURFACE

ALAR FURROW

ALA (WINGS)

APEX

NOSTRIL

SEPTUM

A nose by any other name . . . Knowing the basics of the anatomy for any feature helps an artist better understand and draw it—and helps a caricaturist exaggerate it.

SIMPLIFYING THE SHAPE OF THE NOSE

SEEING THE NOSE SHAPE

Sam Viviano, acclaimed caricaturist and art director for *MAD* Magazine, once explained how your reference can sometimes "lie" to you about your subject. He used the nose as an example, and I now relay this story all the time when I tell artists about the challenges involved with making accurate observations of this feature. Some of you will be familiar with the 1987 movie *Roxanne*, starring Steve Martin and Darryl Hannah. It was a modern retelling of *Cyrano de Bergerac*, with Martin in the Cyrano role. In Martin's first scene he's in a conversation at a bar with his face looking directly into the camera for what seems like several minutes. He looks normal. Then he turns to the side, and you see he has an incredibly long, Pinnochio-like nose. From straight on, it was impossible to see. That describes, in a nutshell, the difficulty of both observing and drawing the nose from a straight on,

Nose what you're doing. As with all features, simplifying the shape of the nose is the key to both drawing it accurately and applying exaggeration. Seeing the nose as a basic, geometric shape that encompasses the root, both the lateral surfaces and the lower ala, the apex, and the nostril area allows you to put aside the distracting details and manipulate the feature on a simplified level.

Nosing around. The shape of the nose can't be seen completely from a single angle. Here, the front angle shows a narrow root and wide bottom. The profile shows us a pointed and sharply protruding nose not discernible from the front.

DRAWING AND EXAGGERATING THE NOSE

Being mostly cartilage, the nose is a soft and rounded form, with no hard edges and very few areas where abrupt changes of plane allow you to draw sharp, definitive contours. Especially when one is using line and drawing from a straight-on view, it becomes a challenge to create volume and fully describe the nose. There are only two areas that have any strong structure: the bridge, or root, and the end of the nose.

The root, which is defined by the underlying nasal bone, often contains dark enough shadows and strong enough structure to allow for some definitive lines or values to solidify the upper nose form. I look for and try to draw not just the area directly between the eyes along the top of the bridge but also the inner rim of the orbit (eye socket) to each side of the bridge. This curved line or form will curl away from the nose, running along the ridge of the orbit until it gets overpowered by the orbicularis oculi, a muscle that circles each eye and forms part of the upper cheek area. This combination of bone, muscle, and fatty tissue often catches the light, and drawing it helps connect the nose to the eyes and the rest of the face. Don't neglect the brow ridge and glabella, which can have furrows or a deep overhang and will further connect the nose to the brow and the face itself.

DRAWING THE NOSE BRIDGE AND SURROUNDING AREA

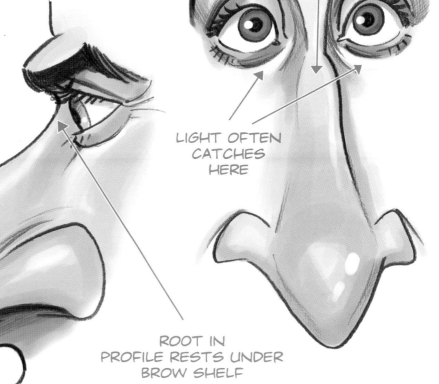

GLABELLA/ROOT AREA

ROOT HAS NASAL BONE STRUCTURE BENEATH

BUMP FROM BONE TO CARTILAGE TRANSITION

ORBIT/ORBICULARIS OCULI LINE CONNECTS ROOT TO EYE AREA AND FACE

LIGHT OFTEN CATCHES HERE

ROOT IN PROFILE RESTS UNDER BROW SHELF

DRAWING THE LOWER NOSE

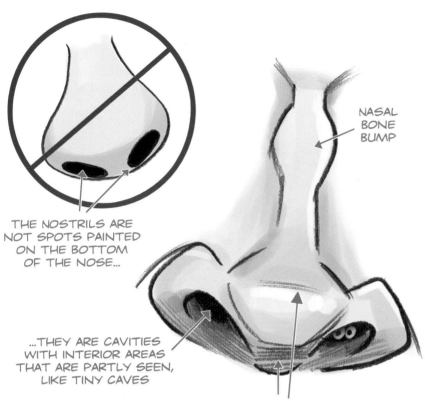

THE NOSTRILS ARE NOT SPOTS PAINTED ON THE BOTTOM OF THE NOSE...

NASAL BONE BUMP

...THEY ARE CAVITIES WITH INTERIOR AREAS THAT ARE PARTLY SEEN, LIKE TINY CAVES

THE APEX IS HARD TO DEFINE IN A FRONT VIEW. INDICATING THE UNDERSIDE SHADOW AND HINTING AT UPPER ANGLE OF THE APEX WITH LIGHT LINES IS BEST

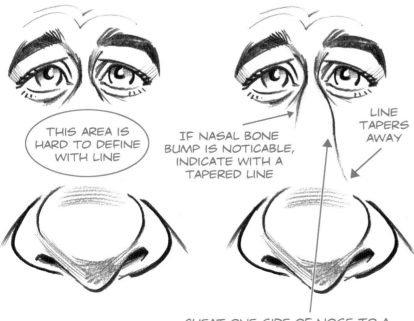

THIS AREA IS HARD TO DEFINE WITH LINE

IF NASAL BONE BUMP IS NOTICABLE, INDICATE WITH A TAPERED LINE

LINE TAPERS AWAY

CHEAT ONE SIDE OF NOSE TO A SLIGHT THREE-QUARTER VIEW TO BETTER DEFINE LATERAL SURFACE

Moving down, the bottom of the nose has some strong attributes that allow for definitive lines or forms to describe. Depending on the angle of the nose, we may see part, all, or none of the nostril cavity, but whatever we do see of it can be drawn with distinct lines. Nostrils are not black spots on the bottom of the nose, however. They are like caves, and the darkness of the cavity is somewhat within the opening, so some area of the inside of the nose needs to be suggested . . . even if it is just a slightly offset area of dark. The wings (ala) of the nostrils are softer and rounder, with their sharpest aspects along the change of plane at the bottom. The end of the nose, or apex, is the hardest to describe from a front view. Drawing the sharper edges of the underside and only suggesting the upper part of the end of the nose is usually the best option. This is where even a slight three-quarter view will help make describing the shape and volume of the nose easier.

It's the area between the root and end of the nose that can be a kind of no-man's-land, because the lateral surfaces have no edges at all, being nothing but soft cartilage and skin. Again, drawing the head at anything other than at a straight-on angle will allow for a more definitive edge along one side, which will make for a more definitive nose. Often, there is a slight, or sometimes very pronounced, bump about one-third of the way down the nose, which is created by the transition from the hardness of the nasal bones to the softer tissue of the lateral cartilage. This bump can be described from straight-on as a widening and then narrowing of the upper plane of the nose, or from a more sideways angle as a distinct bump in the line connecting the bridge to the apex.

Exaggerating the nose, like exaggerating any other feature, is all about the relationship of the nose to its neighbors in the Five Shapes. The nose relates to the eyes quite closely, but its distance from the mouth also matters. In making decisions on how to exaggerate the nose, we must look at it both within the overall head shape and in relation to its surrounding features. The nose often follows predictable patterns based on

the observation of the head shape. A long, thin head probably means a long, thin nose (fig. 1).

A short, squat head shape probably means a short, squat nose (fig. 2).

I say probably, but not certainly. There is a tendency for the above to be true, but you also run into faces like this one (fig. 3), where those tendencies are clearly being broken.

Still, the most difficult observations to make are the ones for which you have no point of reference. Knowing how a feature tends to look within a certain face type will give you something to look for. You might see what you expect, or you might see something you don't expect—which definitely would be an observation worthy of exaggeration. The point is that looking for an expected tendency gives you a point of reference from which to make that observation.

THE INFLUENCE OF HEAD SHAPE ON HOW THE NOSE IS EXAGGERATED

LONG, NARROW HEAD SHAPE = LONG, THIN NOSE

THE RULEBREAKER!

FIG. 1

SHORT, SQUAT HEAD SHAPE = SHORT, WIDE NOSE

FIG. 2

FIG. 3

Heading for trouble. Many times how you have chosen to exaggerate the head shape will influence how you exaggerate the nose—after all you have to fit the nose into that head shape so it makes sense. There are always those faces that break the rules, like the one in fig. 3. Despite the long, narrow face, this subject also has a short, tiny nose. That just means there is greater exaggeration in other relationships to balance the force out—in this case a large distance between the nose and the mouth.

EXAGGERATING NOSE RELATIONSHIPS

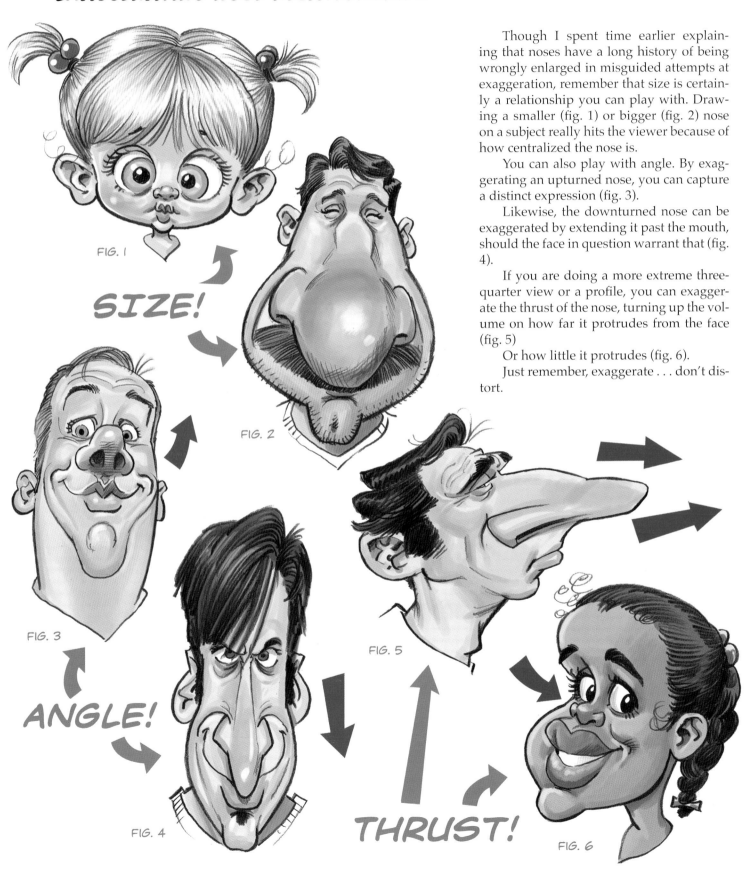

FIG. 1

SIZE!

FIG. 2

FIG. 3

ANGLE!

FIG. 4

FIG. 5

THRUST!

FIG. 6

Though I spent time earlier explaining that noses have a long history of being wrongly enlarged in misguided attempts at exaggeration, remember that size is certainly a relationship you can play with. Drawing a smaller (fig. 1) or bigger (fig. 2) nose on a subject really hits the viewer because of how centralized the nose is.

You can also play with angle. By exaggerating an upturned nose, you can capture a distinct expression (fig. 3).

Likewise, the downturned nose can be exaggerated by extending it past the mouth, should the face in question warrant that (fig. 4).

If you are doing a more extreme three-quarter view or a profile, you can exaggerate the thrust of the nose, turning up the volume on how far it protrudes from the face (fig. 5)

Or how little it protrudes (fig. 6).

Just remember, exaggerate . . . don't distort.

Here are a few caricatures where the nose plays a central role in the exaggeration:

Nosing around. *Actress Ali Larter (upper left) has a small nose with a slightly pug look; Sarah Jessica Parker's face (center) is very long with a down-turned and big nose; Tony Bennett (upper right) has a distinctly hooked nose with a prominent bump in the bridge area.*

Rockin' noses. *These two classic rock icons illustrate two different treatments of caricaturing the nose. With Rush's Geddy Lee (right) I exaggerated his large and crooked nose by making it much bigger. With Eddie Van Halen (left), I drew his nose smaller to better accentuate his long chin and head shape.*

THE MOUTH

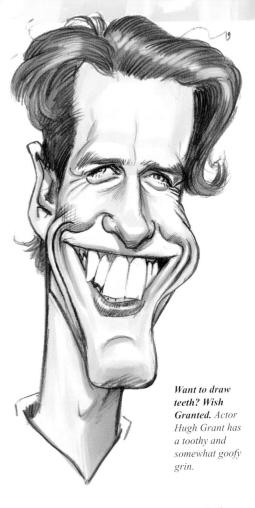

Want to draw teeth? Wish Granted. *Actor Hugh Grant has a toothy and somewhat goofy grin.*

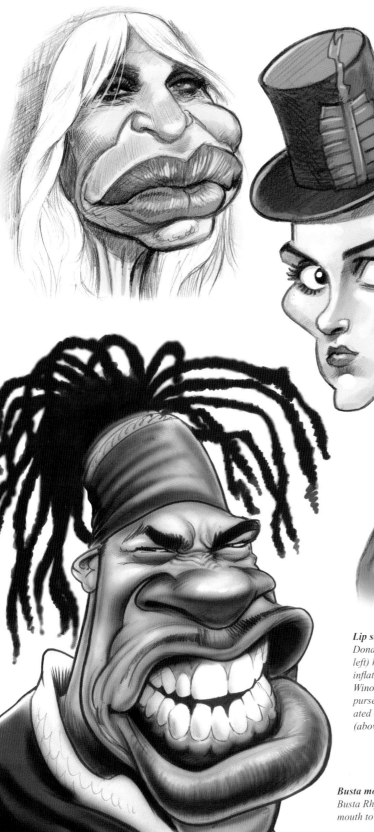

Lip service. *Designer Donatella Versace (upper left) has huge, over-inflated lips while actress Winona Ryder's tiny, pursed mouth is exaggerated in opposite fashion (above, center).*

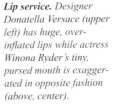

Busta mouth. *Rapper and actor Busta Rhymes has a great deal of mouth to exaggerate.*

The mouth is the most varied of all the features. It changes in so many ways, and for so many reasons. Like all features, the mouth has certain tendencies with regards to the subject's sex, race, and age. But, more than the other features, the mouth changes radically with expression. It is by far the most expressive part of the face, even more than the eyes. As a result, drawing the mouth becomes an exercise not only in observation of its structure but also in sensing its projection of the subject's emotions. The real key to capturing "personality" in a caricature rests in the eyes and mouth. When, as a live caricaturist, you hear those magic words from the model's friends—"He always has that look on his face! THAT'S HIM!"—you know you've just read the subject's expression right and captured it in the drawing. If your drawing elicits this kind of reaction, you have succeeded in producing a caricature with statement. That is what makes a drawing come

to life and spring from the surface of the paper. Mouths are a central part of this, so we will spend a good deal of time examining them, both in and of themselves and, more importantly, in how they relate to the rest of the face.

The mouth is a complex feature. It's made up of bones, muscles, and tissue and contains distinct elements like teeth and lips, which vary widely with age and which interact in many different ways depending on a model's expression. When I talk about the mouth, I am also including the musculature around the mouth that connects it to the nose, cheeks, and chin. Once we have added the mouth, we are finished with the interior of the face.

ANATOMY OF THE MOUTH

The Bone Structure

The mandibula or mandible (jaw bone) is the only movable bone in the skull structure. It has several specific features, including the ramus (the rear part of the jaw, which connects to the skull), the angle (the point at which the jaw turns toward the chin), the mental protuberance (the chin), the mental tubercle (the hollow area behind and under the chin), and the lower dental arch (the area below the bottom teeth). The upper bones of the mouth are part of the larger skull. They include the upper dental arch (the area just above the teeth), the maxilla (the area above the dental arch, just under the nose and nostrils), and the coronoid and condyloid processes (the area where the jaw bones and skull connect). Humans have two sets of teeth (three if you count dentures), which appear at different points in their lives. The first set is made up of 20 deciduous, or temporary, teeth (what we call "baby teeth"), and the second set is our 32 permanent teeth. The teeth all have names and distinct positions and features, but for our purposes we only need to focus on the six teeth that are most prominent and visible in the adult mouth. These are the upper four incisors and first two upper cuspids,

THE SKELETAL MOUTH

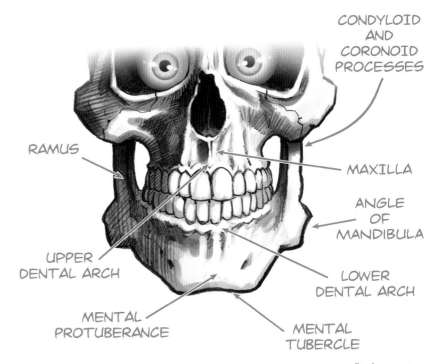

CONDYLOID AND CORONOID PROCESSES

RAMUS

MAXILLA

ANGLE OF MANDIBULA

UPPER DENTAL ARCH

LOWER DENTAL ARCH

MENTAL PROTUBERANCE

MENTAL TUBERCLE

Boning up on anatomy. It's always useful to understand the bone structure under the features.

THE SIX MAIN TEETH

MEDIAL INCISORS

CANINE

CANINE

LATERAL INCISORS

Bite me. With a few exceptions, the six top and most forward teeth are the only ones truly visible when someone is smiling.

commonly called the canines or eye teeth. These six teeth are generally the ones you see when a subject smiles. Other teeth are not as important to a caricature (unless you are drawing Busta Rhymes), as what little of them might be visible is overpowered by the prominence of the aforementioned six. Still, if you want to learn the names of all the teeth, knock yourself out. Your dentist will love you.

THE MUSCLES
OF THE MOUTH

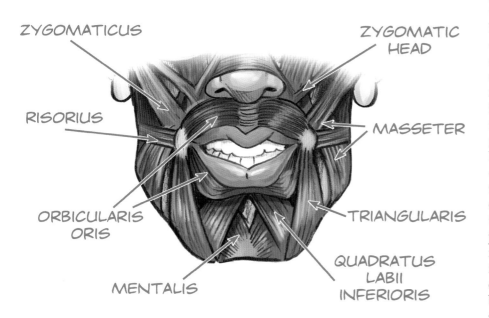

ZYGOMATICUS

ZYGOMATIC
HEAD

RISORIUS

MASSETER

ORBICULARIS
ORIS

TRIANGULARIS

MENTALIS

QUADRATUS
LABII
INFERIORIS

THE SURFACE FEATURES
OF THE MOUTH

NASOLABIAL
FURROW

TUBERCLE

PHILTRUM

LIP RIM

LOBES OF
LIP

GROOVE

MENTOLABIAL
FURROW

Song of the mouth. The muscles beneath the surface are what create the many expressions, folds, and creases that end up being drawn in a caricature. Knowing what they are, where they are, and how they work helps an artist better understand what they are seeing.

The Musculature

The muscles that surround the mouth are highly flexible and interconnected, with the lower layers of the muscles peeking out behind gaps in the upper layers. The orbicularis oris, a large oval-shaped muscle that completely surrounds the mouth itself, is attached to the skin at both corners of the mouth. This connection point on each side is also where the orbicularis connects with three other top-layer face muscles: the zygomaticus, which connects to the cheekbone area; the masseter and risorius, which connects to the rear of the jaw area; and the triangularis, which connects to the bottom of the jaw. The masseter is a large muscle that covers the outside of both sides of the jaw. The quadratus labii inferioris are two muscles that extend under the triangularis from the sides of the chin and angle inward, disappearing under the lower part of the orbicularis oris. The mentalis connects to the skin right at the bottom center of the chin and extends out in the "V" shape to disappear under the quadratus muscles.

The Surface

Finally, let's consider the surface features of the mouth and surrounding areas. The upper lip consists of the tubercle, or meaty area in the center, and two wings that extend to the corners of the mouth. The lower lip has a depression in the center called the groove, which the tubercle fits neatly into (the tubercle actually overhangs it somewhat in most faces), and two lateral lobes on either side that correspond with the curves of the wings above. The area above the mouth is separated from the cheeks on either side by the nasolabial furrows, which are the lines coming from the upper nostrils and extending toward and around the corners of the mouth. The depression directly below the nose and above the tubercle, sometimes defined by sharp ridges on either side, is the philtrum. The recessed area between the lower lip and the top of the chin is the mentolabial furrow.

Whew. That's a lot more of those nearly unpronounceable names. Don't worry about it. You don't need to be able to get a perfect score on an anatomy exam to draw a good mouth. It's just a good idea to have some understanding of what is happening beneath all that skin when you are looking at the features. A working knowledge of the anatomical structure will make you less likely to get fooled by odd lighting or a bad angle. I had to look up most of these terms for this book, but I have long since known all these tissues in terms of understanding where they are and how they work. For example, I may not remember the muscle on the side of the jaw is called the masseter, but I do know it's there, and that it's a muscle you often see tough guys flex when they clench their teeth in the movies. Again, knowing how things work is the first step in exaggerating how they work.

SEEING THE MOUTH SHAPE

The mouth can seem overwhelmingly complex because it has so many elements that interact with one another, and all these elements change drastically depending on expression. Still, when all the extras are boiled away, the mouth is only a shape, just like any feature. When I talk about the shape of a mouth, I mean the shape created by the opening through which the teeth are visible. Like any shape, it will have its widest points, its tallest points, its narrowest, and so on. As you have done for the other features, you need to eliminate the details and visualize the simplest representation you can for the shape, then use that simple shape for a guideline as you render the mouth to include all its details.

As always, it's best to start with an understanding of the traditional proportions and structure of a feature, which we can use as a basis for caricaturing it. In traditional portraiture, the bottom of the lower lip is situated exactly halfway between the bottom

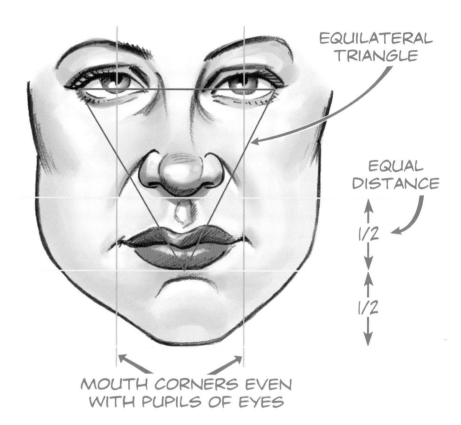

TRADITIONAL PORTRAITURE PROPORTIONS OF THE MOUTH

EQUILATERAL TRIANGLE

EQUAL DISTANCE

1/2

1/2

MOUTH CORNERS EVEN WITH PUPILS OF EYES

of the nose and the bottom of the chin. That places the mouth itself slightly closer to the nose than the chin. The corners of the mouth are usually represented as even with the center of the pupils. There is also a portraiture rule stating that the triangle created by the outside corners of each eye and the bottom center of the lower lip should be equilateral, so the distance between the outside corners of each eye is equal to the distance from either of those corners to the bottom center of the lower lip. As always, caricature artists want to depart from this "norm"—so long as the departure is in keeping with our perception of the face and not done merely to distort.

Measuring up. As with any feature, the first step in learning how to exaggerate it is to understand what are "normal" proportions for that feature. Once we know what it's expected to look like, we can search for ways to smash those expectations.

THE PROTRUDING MOUTH

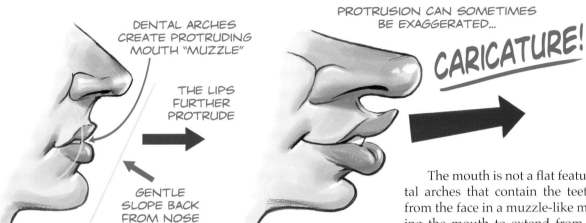

DENTAL ARCHES CREATE PROTRUDING MOUTH "MUZZLE"

THE LIPS FURTHER PROTRUDE

GENTLE SLOPE BACK FROM NOSE TO CHIN

PROTRUSION CAN SOMETIMES BE EXAGGERATED...

CARICATURE!

THE MOUTH GUARD TRICK

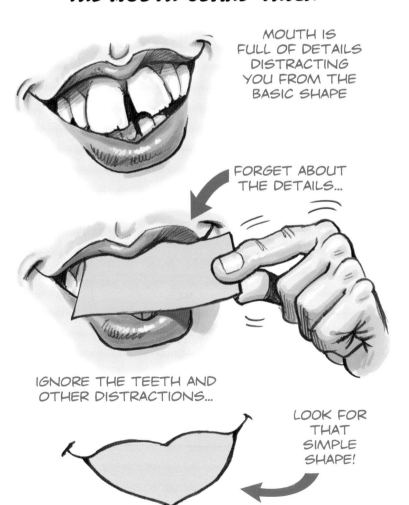

MOUTH IS FULL OF DETAILS DISTRACTING YOU FROM THE BASIC SHAPE

FORGET ABOUT THE DETAILS...

IGNORE THE TEETH AND OTHER DISTRACTIONS...

LOOK FOR THAT SIMPLE SHAPE!

The mouth is not a flat feature. The dental arches that contain the teeth push out from the face in a muzzle-like mound, causing the mouth to extend from the slightly receding plane of the nose to the chin. This is further exacerbated by the fullness of the lips, which also curl forward like a shallow duckbill. From the side, you can see the mouth protrudes not only according to the bones beneath it but also depending on the structure of the lips.

Typically, the upper lip overhangs the lower, which slightly overhangs the chin. The entire mouth structure actually slopes backwards slightly from the bottom of the nose, and the front of the chin ends up roughly on the same vertical plane as the front of the brow in profile. It's important to remember the three-dimensional aspects of the mouth when you draw it, so you can correctly represent how some parts of the mouth obscure other parts. This creates depth, which is necessary for a good caricature, especially if your subject is posed at a three-quarter view.

So, now we need to see the simple shape of the mouth. Forget about the teeth, the lips, the furrows, and all that other stuff. Imagine the subject has placed a slip of heavy paper in his or her mouth, under the lips, so there is a solid-colored space obscuring their teeth, like a boxer wearing a mouth guard.

The area of the paper visible between the lips is the shape we are looking for. Typically, in a smiling mouth, it's narrow at the corner, widest in the center, and has a curve from the corner to tubercle, somewhat flattened center area, and then an opposite curve to the other corner. Of course this is

a ridiculous oversimplification; the shape of the mouth can vary widely—about the only common element is that the top and bottom lip always meet on each side. Sometimes the shape is very narrow, with only a thin white area visible. Sometimes the white space is very tall in the center, and sometimes it's taller toward the corners. The lines that define the shape can be subtle curves or have very distinct, sharp angles as they change direction. To see that shape, we need to make observations, as we do with all the features.

The Corner-to-Corner Line Revisited

One reference point I use for seeing the shape of the mouth is the imaginary line created by the corners of the mouth.

Similar to what we did with the eye, just imagine a line extends from the right corner of the mouth to the left corner. The shape of the mouth (that exposed white area when you think in terms of a paper mouth guard) will interact with that line in some way. Sometimes the entire mouth shape will lie below the corner-to-corner line, giving the subject a wry sort of smile. Other times that shape will lie entirely above the line, as is often the case with small children and infants. For most subjects, the line will intersect the mouth shape in some way.

Using the corner-to-corner line as a point of reference will help you see and interpret that shape. Look at where that line intersects the shape of the mouth and ask yourself some questions: How much of that shape is above the line? Below it? Where is the narrowest part of that shape? The widest? The tallest? The corner-to-corner line is often not perpendicular to the central line of the face but instead lies at an angle. That's because one corner of the mouth is usually higher than the other. Few faces are exactly symmetrical, and there aren't many single observations that can have as great an impact on capturing the "personality" of the subject as nailing a crooked smile.

THE CORNER-TO-CORNER LINE AND THE MOUTH SHAPE

LOOK AT HOW THE LINE INTERSECTS THE SIMPLE MOUTH SHAPE

DOES THE MOUTH SHAPE LIE...

...ENTIRELY BELOW THE LINE?

...ABOVE THE LINE?

...OR IS IT INTERSECTED IN SOME WAY... HOW MUCH LIES ABOVE OR BELOW?

CROOKED MOUTHS ARE EASY TO SPOT...

...THE LINE IS AT SOME KIND OF ANGLE

POINTS OF REFERENCE IN THE MOUTH SHAPE

© Nadezda Soboleva I Dreamstime.com

LOOK FOR POINTS ALONG THE CONTOUR OF THE MOUTH SHAPE WHERE THE LINE CHANGES DIRECTION

USE THESE POINTS TO "CONNECT THE DOTS" FOR A SIMPLE MOUTH SHAPE

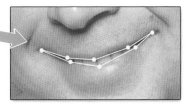

YOU CAN EXAGGERATE THE RELATIONSHIP OF THE NODES TO HELP CARICATURE THE MOUTH

USING NEGATIVE SPACE

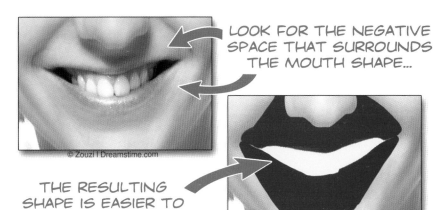

© Zouzl I Dreamstime.com

LOOK FOR THE NEGATIVE SPACE THAT SURROUNDS THE MOUTH SHAPE...

THE RESULTING SHAPE IS EASIER TO SEE AND DRAW

...AND TO EXAGGERATE

The Nodes Concept

Another technique I use for helping see the mouth shape is using what I call nodes. I look for points at which there are distinct changes of angle in the lines of the mouth shape—where a straight line becomes a curved line, or vice versa. In computer design programs, these points are called nodes. Anyone who has ever worked with programs like Adobe Illustrator or Corel-Draw will be familiar with nodes. To create a shape in one of these programs, you must first draw segments of lines connected together. Between the segments is a point, or node, where the line changes direction by means of an angle or a curve. A quick look at a person's mouth shape lets me identify where the real-life nodes of that mouth shape lie. The corners of the mouth are always nodes, and you will find additional nodes at various points toward the middle of the mouth shape too, depending on the fullness and curvature of the lips. Thinking in these terms, you can mentally "connect the dots" with straight or curved lines, depending on the mouth, to re-create the simple shape.

Negative Space

Negative space is another useful tool for seeing and drawing the mouth shape. The area between the mouth and nose, bordered on each side by the nasolabial furrow, creates a distinct shape that defines the relationship between the mouth and nose. Looking at that negative space can really help you see that mouth shape and better understand how it fits into the face as a whole.

Seeing and placing that mouth shape on the face is 90% of the work. Drawing the rest of your subject's mouth becomes fairly easy because the shape of the mouth creates a great frame of reference for making observations about the teeth and other elements. Most of these observations are a function of knowing and seeing what features typically do and then drawing them.

DRAWING AND EXAGGERATING THE MOUTH

Drawing the mouth is a process of accurately capturing the shapes and structures, while caricaturing the mouth is recognizing the unique relationships between it and the other features and exaggerating those relationships. Since the mouth itself can change so drastically with expression, there is no one perfect approach to drawing it that works the best every time. There are some important things to keep in mind when drawing a convincing mouth.

The first thing we need to define is the shape of the mouth, which we should have a good grasp on after following some of the tips in the preceding section. The shape of the mouth is described by the lines that form the inner edges of the upper and lower lips. When drawing in line, these are very distinct edges and deserving of a sharp, strong line. Remember the mouth is not flat but protrudes. We need to suggest that protrusion by paying attention to any overlapping forms and making sure we capture those elements. If the teeth overlap the lower lip, catching that will add to the depth of the mouth. The upper lip often overlaps the lower near the corners, so the line of the lower lip comes from under the upper lip. This is especially true if the head is being drawn at an angle other than straight on—the protrusion of the mouth becomes much more noticeable the more sideways of an angle of the face you draw.

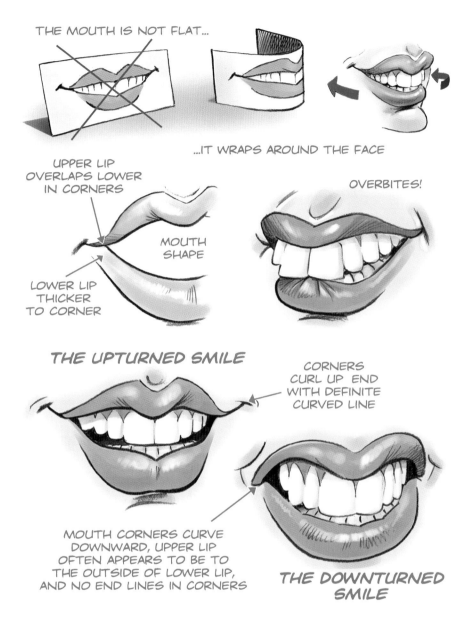

THE MOUTH IS NOT FLAT...

...IT WRAPS AROUND THE FACE

UPPER LIP OVERLAPS LOWER IN CORNERS

MOUTH SHAPE

LOWER LIP THICKER TO CORNER

OVERBITES!

THE UPTURNED SMILE

CORNERS CURL UP END WITH DEFINITE CURVED LINE

MOUTH CORNERS CURVE DOWNWARD, UPPER LIP OFTEN APPEARS TO BE TO THE OUTSIDE OF LOWER LIP, AND NO END LINES IN CORNERS

THE DOWNTURNED SMILE

CONNECTING THE NOSE AND MOUTH

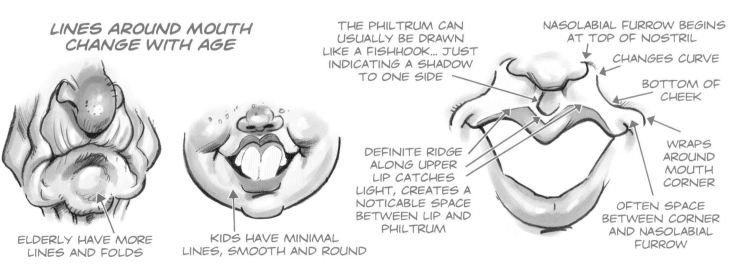

LINES AROUND MOUTH CHANGE WITH AGE

ELDERLY HAVE MORE LINES AND FOLDS

KIDS HAVE MINIMAL LINES, SMOOTH AND ROUND

THE PHILTRUM CAN USUALLY BE DRAWN LIKE A FISHHOOK... JUST INDICATING A SHADOW TO ONE SIDE

DEFINITE RIDGE ALONG UPPER LIP CATCHES LIGHT, CREATES A NOTICABLE SPACE BETWEEN LIP AND PHILTRUM

NASOLABIAL FURROW BEGINS AT TOP OF NOSTRIL

CHANGES CURVE

BOTTOM OF CHEEK

WRAPS AROUND MOUTH CORNER

OFTEN SPACE BETWEEN CORNER AND NASOLABIAL FURROW

DRAWING THE LIPS

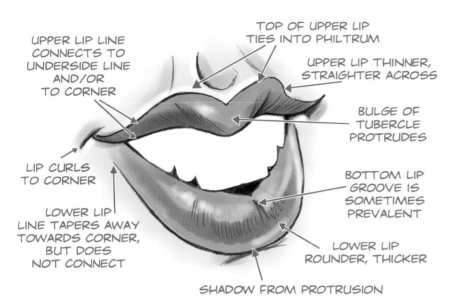

UPPER LIP LINE
CONNECTS TO
UNDERSIDE LINE
AND/OR
TO CORNER

TOP OF UPPER LIP
TIES INTO PHILTRUM

UPPER LIP THINNER,
STRAIGHTER ACROSS

BULGE OF
TUBERCLE
PROTRUDES

LIP CURLS
TO CORNER

BOTTOM LIP
GROOVE IS
SOMETIMES
PREVALENT

LOWER LIP
LINE TAPERS AWAY
TOWARDS CORNER,
BUT DOES
NOT CONNECT

LOWER LIP
ROUNDER, THICKER

SHADOW FROM PROTRUSION

LIPS FLATTEN AND THIN WHEN SMILING

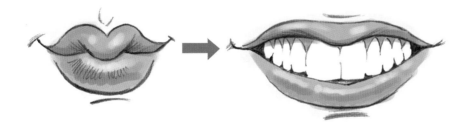

INTERACTION OF TEETH AND LIPS

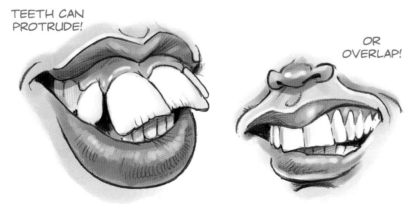

TEETH CAN
PROTRUDE!

OR
OVERLAP!

The upper and lower lips also have a shape, defined by their harder interior edges and the softer ones of their outer edges. The upper lip has a center bulge, the tubercle, which rests directly under the nose and the philtrum. The tubercle is a good place to use as an anchor point for the upper lip, and it is the area that protrudes the most. The sides, or wings, of the upper lip rest behind it as they recede to the corners of the mouth.

Capturing the shape of the upper lip necessitates identifying where that lip is thickest, how it tapers to the mouth corners, and the individuality of the upper edge—which may be dramatically curved like the top of a heart shape, practically a straight line from corner to corner, or contain gentle swells or sharp angles. The lower lip is generally thicker and rounder than the upper. It also contains a central point, but that point is a groove that acts as a seat for the tubercle of the upper lip to rest in. The protrusion of the upper lip causes an area of darkness directly under the groove, between the lip and the top of the chin. As the corners of the mouth pull back in a smile, the lips tend to flatten and straighten out, losing much of the contour curves or angles and diminishing or eliminating the definition of the tubercle and groove. Expression changes the nature of the lips as much as the mouth shape itself.

Drawing teeth is something many new artists struggle with. They either define the lines between the teeth too strongly, or they gloss over them and make every tooth the same size and shape, like fence posts.

Remember it's the upper six teeth that make up the majority of what we can see in a typical smile, and these teeth are different sizes and shapes. I think of the central incisors (front teeth) as shapes resembling "Ten Commandment" tablets, the lateral incisors (the teeth to left and right of the incisors) as upside-down shields, and the canines, or cuspids (eye teeth or "fangs"), as long Tic Tacs with one sharper end. Teeth are not usually squared off on the edges; they are rounded and smooth, covered by a shiny

Don't give me any lip. The upper and lower lips differ considerably. The upper lip is usually straighter across, thinner, darker, and has a sharper ridge. The lower lip is fatter, rounder, and has softer edges. It's not unusual to see parts of the bottom lip obscured by overlapping teeth.

enamel that's always wet. These elements combine to make the separations between the teeth fairly indistinct when viewed from a reasonable distance (that is, barring any pronounced gaps where the darkness of the inner mouth is visible). Therefore, using hard lines or too much darkness between makes the teeth look wooden and blocky. Unless your model has very spaced-out teeth or an obvious gap, you must tread lightly here and merely suggest these separations. I use what I call an *implied line* here (something I talk more about in the chapter on live caricature) to suggest the lines between the teeth without actually drawing them from top to bottom.

The gums are also part of the inner dental structure, and on a few people they are a very prominent part. The lower gums are almost never visible, but the upper gum line can be noticeable if the subject has a powerful, protruding overbite, very small teeth, or both. The gums are not flat but rounded, like kneaded dough that the teeth are stuck into. A ridge of harder tissue follows the curve of the gum line where the roots of the teeth are set into the maxilla bone. This area of the gum line bulges out and then recesses toward the upper gums, leading up into a hollow in the upper maxilla area where the gums merge with the skin of the inner mouth that covers the inside of the upper lip.

The next step is to connect the mouth to the rest of the face. The nasolabial furrow, the philtrum, and the muscles and tissue surrounding the mouth connect it to the nose, chin, and cheek areas. Age becomes a factor here, especially when doing a line drawing. Adding lines around the mouth will instantly age your model. The younger the subject, the more minimal you must be with your linework. In some cases you have to literally ignore lines you can plainly see on a kid's face, simply because drawing that line, no matter how delicately, would make them look like an adult.

Tell the tooth. *Teeth are defined as much by the shape of the gums and the negative space between them, where you can see the darkness of the inner mouth, as they are their actual edges. Teeth are rounded and wet, and the lines that separate them must be delicate and precise or the teeth look blocky and wooden.*

DRAWING THE TEETH

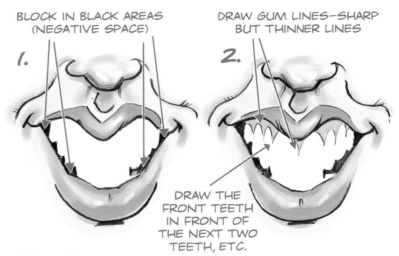

BLOCK IN BLACK AREAS (NEGATIVE SPACE)

1.

DRAW GUM LINES—SHARP BUT THINNER LINES

2.

DRAW THE FRONT TEETH IN FRONT OF THE NEXT TWO TEETH, ETC.

GUM LINES:

BAD!!
THESE LOOK LIKE THE TOPS OF AN OLD WOODEN FENCE

GOOD!!
SHARP LINES, SHOW TEETH COMING OUT OF GUMS AND DEPTH

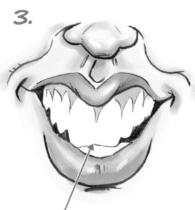

3.

DEFINE VISIBLE BOTTOMS OF TEETH—THE BETWEEN EDGES SHOULD LINE UP WITH CORRESPONDING GUM LINES

BAD!!
LOWER SEPARATIONS DON'T LINE UP WITH UPPER ONES

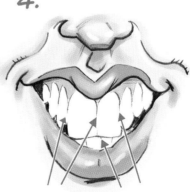

4.

CONNECT GUM LINES AND BOTTOMS OF TEETH— SHARP BUT DELICATE LINES, IMPLIED LINE GIVES ROUNDED WET FEEL; MUST LINE UP!

WORSE!!
NOTHING IS LINING UP!

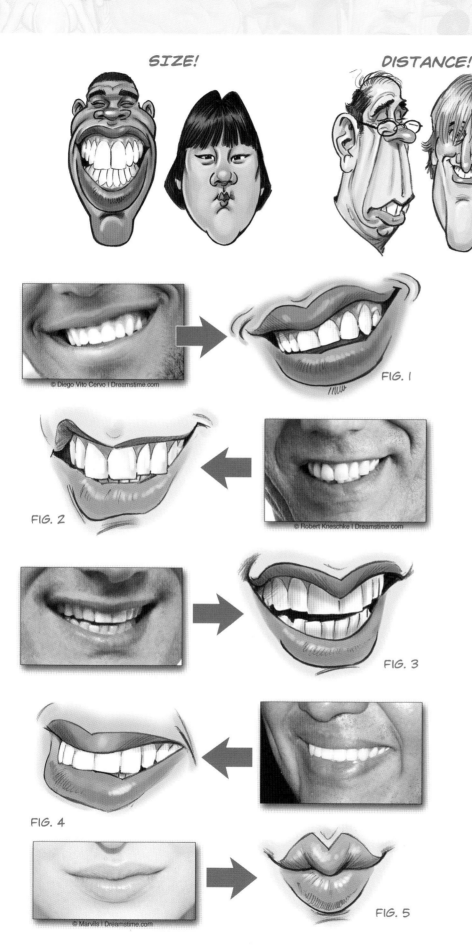

SIZE!

DISTANCE!

ANGLE!

© Diego Vito Cervo I Dreamstime.com

FIG. 1

FIG. 2

© Robert Kneschke I Dreamstime.com

FIG. 3

FIG. 4

© Marvils I Dreamstime.com

FIG. 5

As with the other features, we have three principal relationships we can observe and then use to exaggerate the mouth: size, distance, and angle. By simplifying the shape of the mouth, we can more easily play with these relationships for exaggerated effect.

We can also exaggerate the shape of the mouth itself, thereby exaggerating the expression of the subject. For instance, a crooked smile can be made more crooked (fig. 1).

When there is an imbalance or asymmetry in the mouth shape, this also can be exaggerated (fig. 2).

The negative space between the upper and lower dental arches can also be something that can be exaggerated, as can gaps between the teeth (fig. 3).

It might seem that you should expect the teeth to remain obediently within the mouth shape . . . not so! The front teeth often protrude over the lower lip, and they may partially obscure it (fig. 4). Teeth can be very prominent features, as can gums. Observing and recognizing the relative importance (or unimportance) of these elements is something you have to develop an eye for.

Sometimes you don't have an inner mouth shape to play with—not to worry. A closed mouth also has a shape. It's just defined by the outer edges of the lips rather than the inner edges (fig. 5).

Remember that, more so than the other features, the mouth projects expression—so exaggerating things like the crookedness of a smile, the toothiness of a grin, or the pucker of pursed lips captures not just likeness but a recognizable attitude and personality.

***Mouthing off.** On the opposite page are a few more familiar faces who have distinct mouths that are central to their caricature.*

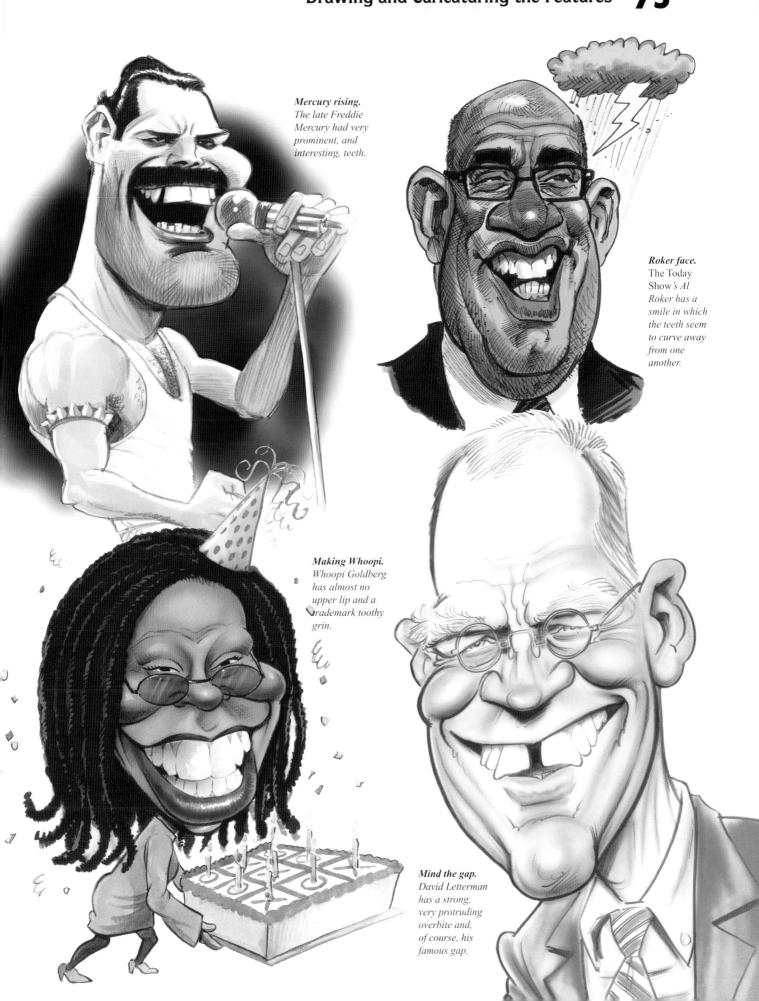

Mercury rising. *The late Freddie Mercury had very prominent, and interesting, teeth.*

Roker face. The Today Show's *Al Roker has a smile in which the teeth seem to curve away from one another.*

Making Whoopi. *Whoopi Goldberg has almost no upper lip and a trademark toothy grin.*

Mind the gap. *David Letterman has a strong, very protruding overbite and, of course, his famous gap.*

5 CARICATURING THE REST OF THE HEAD

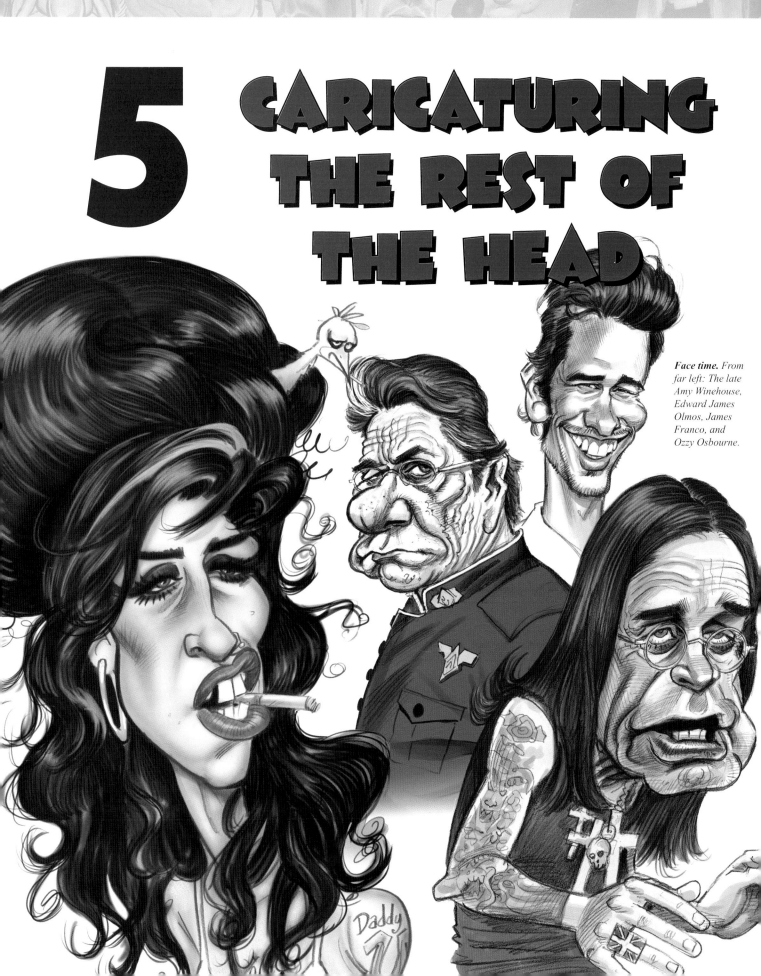

Face time. *From far left: The late Amy Winehouse, Edward James Olmos, James Franco, and Ozzy Osbourne.*

Daddy

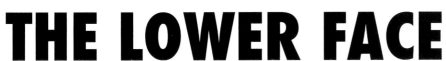

THE LOWER FACE

THE JAW AND CHIN

The lantern jaw, the sunken chin, the jolly jowls—the lower face describes much about its owner. What brawny, muscular outdoorsman would be complete without a big, granite jaw? What dainty, fair lady would have anything but a small and rounded chin? These are stereotypes, but the message is clear: the nature of the lower face suggests a type as well as a look.

The bottom of the face is defined by the chin and jaw. Like any bone structure, the amount of flesh and fat that cover it will determine how much of the underlying bone is evident and how much is hidden. Chins and jaws vary greatly from person to person and are therefore ripe for exaggeration—bearing in mind that their exaggeration will influence not just the likeness but the perceived personality of the subject.

Anatomy of the Jaw and Chin

The jaw, or mandible, is the only separate bone in the skull structure. It connects to the main skull just forward and below the bottom of the ear, forming a hinge called the condyloid process. The mandible has a sharp corner on each side under the condyloid process, where the jawline changes direction and forms a ridge along each side to meet at the chin. The chin is an area of bone called the mental protuberance, which juts out from the front plane of the face. There is a well-defined "top" surface to the chin that is further emphasized by the protrusion of the lower dental structure, which creates a valley of sorts between the muzzle-like projecting teeth and the chin itself. This defined edge is called the mentolabial furrow. The very bottom edge of the chin area has a dual bulbous formation known as the mental tuberosities.

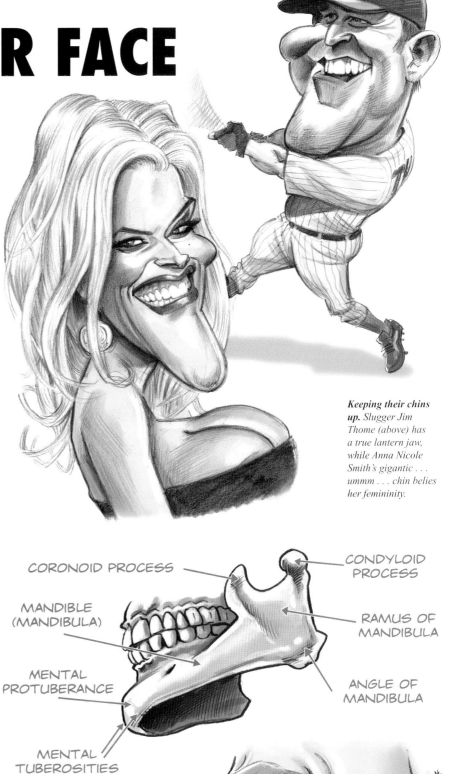

Keeping their chins up. Slugger Jim Thome (above) has a true lantern jaw, while Anna Nicole Smith's gigantic . . . ummm . . . chin belies her femininity.

CORONOID PROCESS

CONDYLOID PROCESS

MANDIBLE (MANDIBULA)

RAMUS OF MANDIBULA

MENTAL PROTUBERANCE

ANGLE OF MANDIBULA

MENTAL TUBEROSITIES

MENTOLABIAL FURROW

THE JAW AND CHIN ARE PART OF THE OVERALL HEAD SHAPE

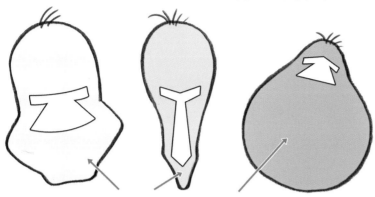

OUR HEADSHAPE/T-SHAPE OBSERVATIONS HAVE ALREADY DEFINED THE JAW/CHIN SHAPE

THE LEAN JAW

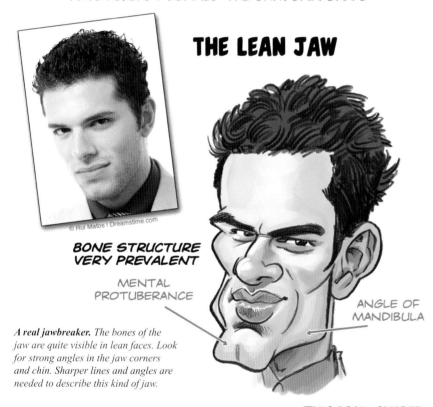

© Rui Matos1Dreamstime.com

BONE STRUCTURE VERY PREVALENT

MENTAL PROTUBERANCE

ANGLE OF MANDIBULA

A real jawbreaker. The bones of the jaw are quite visible in lean faces. Look for strong angles in the jaw corners and chin. Sharper lines and angles are needed to describe this kind of jaw.

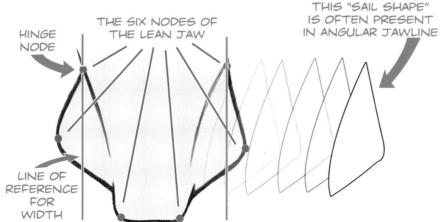

HINGE NODE

THE SIX NODES OF THE LEAN JAW

THIS "SAIL SHAPE" IS OFTEN PRESENT IN ANGULAR JAWLINE

LINE OF REFERENCE FOR WIDTH

Seeing the Jaw and Chin Shape

As you may have seen in a "before" and "after" photo from any diet ad, the lower area of the face changes tremendously with the weight of the subject. Most of the fat in the face gathers about the cheeks and the area under the chin, and the shape can differ widely depending on how heavy the face is.

I talked about this in the chapter on head shape. If you were able to observe and capture your model's head shape as the first step in creating your caricature, then much of the work in determining the jaw and chin shape should already be done. The contour of the head shape will include the basic shape of the jaw. However, when we actually get to the point of examining the details, we will need to see more specifics in the shapes there.

As I look for the shape of the jaw and chin, I try to categorize the face as either lean or heavy. In a lean face, I can see the bones of the jaw, and in a heavy face I do not. Of course, each face falls somewhere on a spectrum of lean to heavy, but thinking of my model as simply one or the other helps me decide what points of reference to look for.

The Lean Jaw

Here we clearly see the mandible bone, and the angles of the mandibula (corners of the jaw) stand out as obvious visible points. The leaner the face, the sharper those corners become. As the face gets more and more fleshy, that sharp angle begins to round out, but the change of direction still remains noticeable.

The shape of the lean jaw is made up of six points, or nodes. There is one at either side of the jaw's hinge, two represent the corners of the jaw, and the other two define the outside corners of the chin. Imagine a straight vertical line along the side of the face that intersects the hinge node, then, using this straight line as your point of reference, you can judge whether the corner point rests outside or inside that line and by how much. Likewise, using vertical

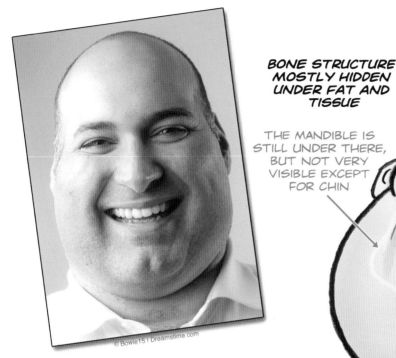

THE HEAVY FACE

BONE STRUCTURE MOSTLY HIDDEN UNDER FAT AND TISSUE

HEAVY FACES ARE ROUND! NO ANGULAR LINES!

THE MANDIBLE IS STILL UNDER THERE, BUT NOT VERY VISIBLE EXCEPT FOR CHIN

MASS!

Round and round. *Heavy faces obscure most or all of the underlying bone structure. Flesh, fat, and surrounding tissue need round shapes and curved lines—no angles.*

THE LOWER FACE BECOMES A "LOOP" HANGING FROM THE JAW HINGE THAT DESCRIBES (AND EXAGGERATES) THE FACE'S MASS AND WEIGHT

lines that stretch from the center of the eyes downward, you can judge how wide the nodes of the chin need to be.

Looking at the negative space around the mouth also helps us see the jaw shape. In a lean jaw, there is a triangular "sail" shape made by the three nodes on either side of the jaw bone. If you treat these triangles as separate shapes within the main shape, negative space can help you get a better grasp of the mass of the jaw.

The Heavy Face

A prevalence of fatty tissue in the face obscures part or all of the mandible bone, which can create a whole different shape that little resembles a jaw bone. We all know the term *double chin,* referring to a face with fleshy mass under the jaw. In heavier faces, this fatty tissue and skin hangs there and defines the lower edge of the face, covering the shape of the mandible itself. Double chins become jowls as the amount of mass increases. In very heavy faces, the jaw is completely obscured and the chin becomes a seemingly separate island floating in a round mass of skin.

Round is the operative word with heavy faces. Diminished or altogether gone are the

sharp corners of the jaw, and the bottom edge no longer traces along the nodes of the chin but instead circles around it. The more mass, the rounder the lower face becomes and the more negative space surrounds the chin. Here the shape becomes more of a loop, starting at the nodes of the jaw hinge and curving around the chin. The negative space becomes crucial here, and you must study the distances between the chin and the contour line of the lower face to figure out how much mass needs to be described.

Getting loopy. *Visualize the lower half of a heavy face as a loop of string, hanging from the condyloid process (the jaw hinge). The heavier the face, the more mass is present surrounding the chin, and the more string you need for the loop. The chin can become like an island in a sea of jowls.*

OTHER TREATMENTS FOR THE HEAVY FACE

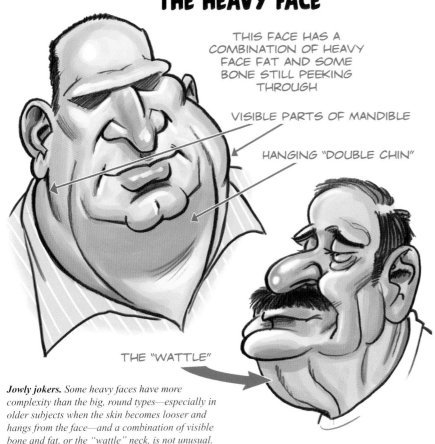

THIS FACE HAS A COMBINATION OF HEAVY FACE FAT AND SOME BONE STILL PEEKING THROUGH

VISIBLE PARTS OF MANDIBLE

HANGING "DOUBLE CHIN"

THE "WATTLE"

Jowly jokers. Some heavy faces have more complexity than the big, round types—especially in older subjects when the skin becomes looser and hangs from the face—and a combination of visible bone and fat, or the "wattle" neck, is not unusual.

DIFFERENT CHIN TYPES

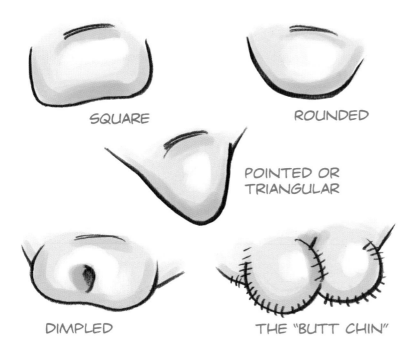

SQUARE

ROUNDED

POINTED OR TRIANGULAR

DIMPLED

THE "BUTT CHIN"

Not all heavy faces are just big, round shapes from ear to ear. Especially in older subjects, the skin and tissue about the jaw can appear layered and hang more loosely. Parts of the mandible bone are sometimes visible even if the subject has a double chin or jowls. There are two basic shapes in these cases, one in front of the other. First, we can see a more rounded version of the lean jaw, and, behind that, we see a smaller version of the ear-to-ear loop, which seems to start from about where the back molar teeth would be located and either wraps around the chin or melts into the neck. In the latter case, there is no defined line for the jaw and chin area, and the neck actually becomes part of the lower face shape. In some older subjects, there is a hollow space within this shape that stretches from under the chin into the lower neck. This hollow stretch helps define the loose-hanging neck skin often called a "wattle" or "turkey wattle."

Now let's look at the chin, which is a shape within the shape of the jaw. There are three basic chin shapes: the square chin, the round chin, and the pointy chin.

The shape of the chin is created by the mental protuberance, which defines the sides of the chin shape, and the mentolabial furrow, which defines the top. The square and pointy chin shapes have corners, or nodes, while the round chin is a variation of an oval or circle. The chin shape can be a part of the contour of the overall face shape, as in a lean jaw, or rest entirely within the face shape, as in a heavier face. Looking not just at the shape of the chin itself but also at the negative space around it will help you draw it accurately. I especially pay attention to the distance of the mentolabial furrow (or top of the chin) from the mouth itself compared to the distance of the top of the chin to the bottom.

The chin can also have interesting features like dimples or clefts. These can range from a simple divot in the chin that looks like someone pounded a small nail in there to the dreaded "butt chin" that separates the entire shape into two cheeky hemispheres.

Drawing and Exaggerating the Jaw and Chin

The jaw line begins either at the opening of the ear or from under the cheekbones if they are prominent, continues down at the angle at which the mass of the subject's face dictates, and either curves in toward the chin or turns more sharply at the angle of the mandibula. These are ordinarily some of the boldest lines or sharpest contours in the face.

As I said, this area is ripe for exaggeration. Because it represents half of the all-important head shape, your choices of how to exaggerate the jaw and chin are a function of the observations you already made while considering things like visual weight, the Law of Constant Mass, and the imbalance between halves. The mass of the jaw and how it compares to the mass of the cranial area really determines how much you should exaggerate it. One rule of thumb is that heavier faces almost always have more mass below the eyes than above them, so you can typically expect that the Law of Constant Mass will require you to give that subject a smaller upper head and enlarge the bottom of the face. Big, lumberjack-type men with heavy jaws warrant the same treatment.

One thing to keep in mind with respect to jaws is that a large, angular jaw is a very masculine feature, and women very seldom have that physiognomy. A few pages down the road I have a short section discussing the differences in the sexes as they apply to caricature.

HEAD SHAPE EXAGGERATION INCLUDES THE LOWER FACE

CONCEPTS LIKE THE LAW OF CONSTANT MASS, ACTION AND REACTION, AND THE EXAGGERATION OF THE HEAD SHAPE DICTATES HOW TO CARICATURE THE JAW AND CHIN

THE LAW OF CONSTANT MASS IN ACTION!

JAW AND CHIN MASS IS INTER-DEPENDENT

ACTION AND REACTION AGAIN! THE MORE MASS YOU GIVE THE JOWLS, THE MORE YOU SHRINK THE CHIN...

...OR THE LONGER THE CHIN, THE LESS MASS IN THE JAW!

KIDS HAVE VERY LITTLE JAW AND CHIN MASS. THEY HAVE AN UNDEVELOPED MANDIBLE BONE.

THE CHIN CAN SIGNIFICANTLY JUT OUT FROM THE FACE...

THINK AND EXAGGERATE THREE-DIMENSIONALLY!

Chin up. Exaggerating the jaw/chin/lower face is a part of the decisions made for the overall head shape, as the shape of these features is part of the contour of the head. The concepts discussed in Chapter 3 all apply to caricaturing the lower face. Considerations like age and the angle of the head are things to keep in mind.

THE STRUCTURE OF THE CHEEKBONES

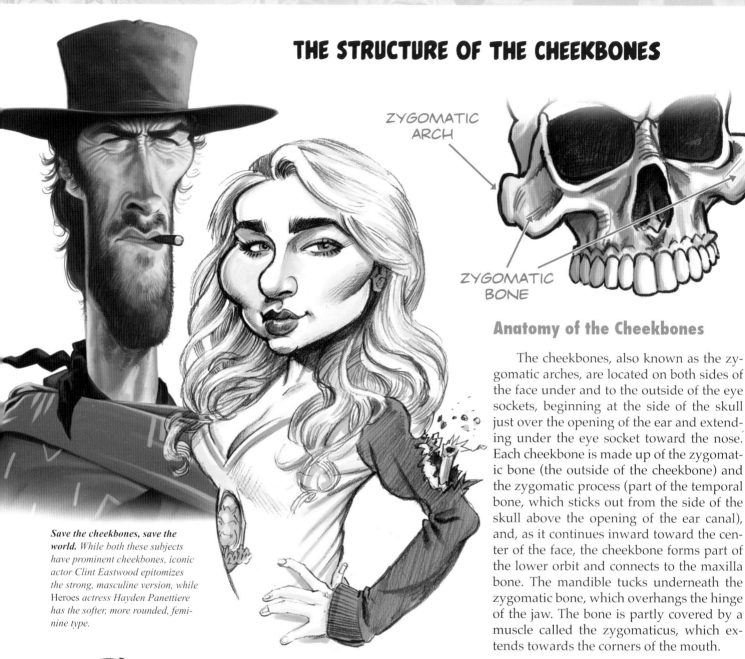

ZYGOMATIC
ARCH

ZYGOMATIC
BONE

Save the cheekbones, save the world. *While both these subjects have prominent cheekbones, iconic actor Clint Eastwood epitomizes the strong, masculine version, while* Heroes *actress Hayden Panettiere has the softer, more rounded, feminine type.*

Anatomy of the Cheekbones

The cheekbones, also known as the zygomatic arches, are located on both sides of the face under and to the outside of the eye sockets, beginning at the side of the skull just over the opening of the ear and extending under the eye socket toward the nose. Each cheekbone is made up of the zygomatic bone (the outside of the cheekbone) and the zygomatic process (part of the temporal bone, which sticks out from the side of the skull above the opening of the ear canal), and, as it continues inward toward the center of the face, the cheekbone forms part of the lower orbit and connects to the maxilla bone. The mandible tucks underneath the zygomatic bone, which overhangs the hinge of the jaw. The bone is partly covered by a muscle called the zygomaticus, which extends towards the corners of the mouth.

THE CHEEKBONES

The cheekbones are important anchor points on the exterior contour of the face. They act as a transition point between the top and bottom parts of the head. I think of the cheekbones as if they were "handles" on either side of the face, from which the bottom part of the head's weight is supported. They also seem a little like car bumpers, protruding out like they might serve to protect the rest of the face from impact.

Seeing the Cheekbone Shapes

The prominence of the cheekbones in a given subject is a function of the leanness of the face—someone with a thin face will have much more distinct cheekbones than someone with a more fleshy face. In a very round, fat face, the cheekbones might be nearly invisible. In those instances, the cheeks themselves hide the shapes of the bone beneath. Cheekbones are always present, however, even in the heaviest of faces.

FACE
HANDLES!

In simplest terms, I treat the cheekbone area of the face as belonging to one of two categories:

Cheekbones Proper

When the actual zygomatic bone is visible in the face, I know I will be drawing the cheekbones themselves. The thinner the face, the more prominent the cheekbones appear. Pronounced cheekbones form a kind of teardrop or elongated egg shape, the top of which wraps above and behind the corner of the eye. They tend to reach their widest point outside of the face just under the level of the eyes. Subtler cheekbones will have very rounded contours, while sharper, more defined ones will have stronger angles and lower sections that descend farther into the face.

Cheeks

The bones themselves are covered by muscle, tissue, and skin, which all affect how the surface of the face will look. When the cheekbones themselves are not very visible, the cheeks become the focus of this area. Whereas cheekbones are sharp and angular, cheeks are round and soft. The cheek shape actually begins under the inside corner of the eye, wraps around the bottom of the eye socket, bulges up past the corner of the eye, and then breaks the plane of the face contour as it curves out and back downward to meet the line that connects the corners of the mouth to the nose (nasolabial furrow). Cheeks take much of the definition out of the face, making for a more continuous contour from the temple to the chin and back up to the opposite temple (or sometimes a contour that loops under the chin entirely). In very full faces, I may use a single line to define this entire lower face shape.

Expression changes this area of the face considerably. A face that shows a "cheekbones proper" shape when in a neutral expression can suddenly have those cheekbones disappear when the cheeks take over during a big grin.

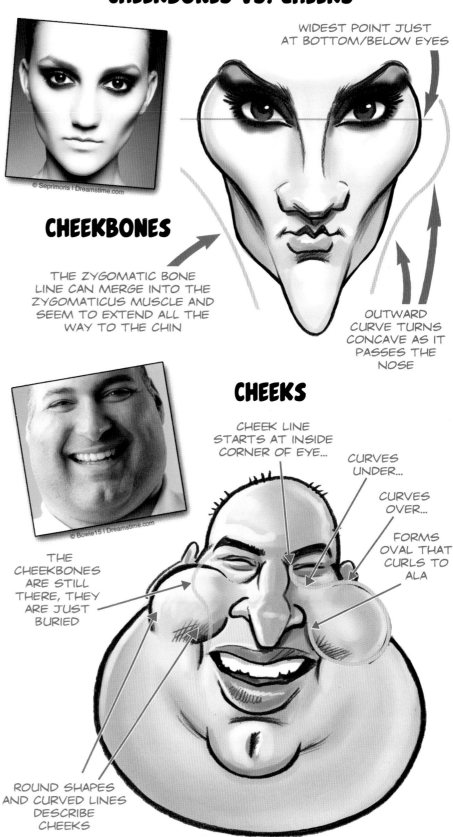

CHEEKBONES VS. CHEEKS

WIDEST POINT JUST AT BOTTOM/BELOW EYES

© Seprimoris | Dreamstime.com

CHEEKBONES

THE ZYGOMATIC BONE LINE CAN MERGE INTO THE ZYGOMATICUS MUSCLE AND SEEM TO EXTEND ALL THE WAY TO THE CHIN

OUTWARD CURVE TURNS CONCAVE AS IT PASSES THE NOSE

CHEEKS

CHEEK LINE STARTS AT INSIDE CORNER OF EYE...

CURVES UNDER...

CURVES OVER...

FORMS OVAL THAT CURLS TO ALA

© Bowie15 | Dreamstime.com

THE CHEEKBONES ARE STILL THERE, THEY ARE JUST BURIED

ROUND SHAPES AND CURVED LINES DESCRIBE CHEEKS

Drawing and Exaggerating the Cheekbones

Cheekbones are a great feature to exaggerate if doing so is warranted. In western culture, having "high cheekbones," or strong and well-defined cheekbones that appear to be set higher on the face, is considered attractive and helps define classic beauty in women. In men, strong cheekbones create a rugged and muscular appeal.

Cheekbones proper start at the ear, just above the level of the eyes, and then swoop down, peaking just below the eyes then extending towards the corners of the mouth

Cheeky monkeys. Different cheekbone types impart a masculine or feminine feel. Be careful when breaking that convention if a particular subject demands it.

as the zygomaticus muscle begins to cover the bone. In extremely lean faces, you can merge the cheekbone with the lines created by the zygomaticus above the mouth and the triangularis muscle below it, so that the line of the cheekbone literally connects to the chin. There is a hollow area between the outside of the jawline and the line connecting the cheekbone and chin (when present), which is deeper in faces with sharper cheekbones and jawlines.

The stronger and more distinct the cheekbones, the more angular the lines of the cheekbones become. This is especially true for men. A manly jaw and cheekbones will create a sort of mushroom shape within the male face. This shape becomes more defined the leaner and more severe the face.

In general, women have more prevalent but rounder and softer cheekbones. Women often use cosmetics (the significance of which we will discuss in the next chapter) to make their cheekbones appear more pronounced, so we should oblige by giving these features the attention they require. Where prominent cheekbones in men can be likened to a mushroom shape, in women we see more of a heart shape.

Exaggerating the cheekbones, like exaggerating any other feature, entails playing with their relative relationship to the head shape. However, it is seldom necessary to exaggerate cheekbones by making them smaller, since shrinking them would simply mean leaving them unseen. If the cheekbones stick out as noticeable to you, then that usually means they need to be bigger in your caricature.

You can also play with the sharpness and the overall mass of the cheekbones. Some cheekbones seem high and are little more than the edges of a thick plate beneath the skin, while some are much more massive and seem to take up the entire side of the face.

Finally, observe how strong cheekbones will break the exterior plane of the face. How much farther you push them outside this plane will determine how extreme your exaggeration will be.

CHEEKBONES AND THE SEXES

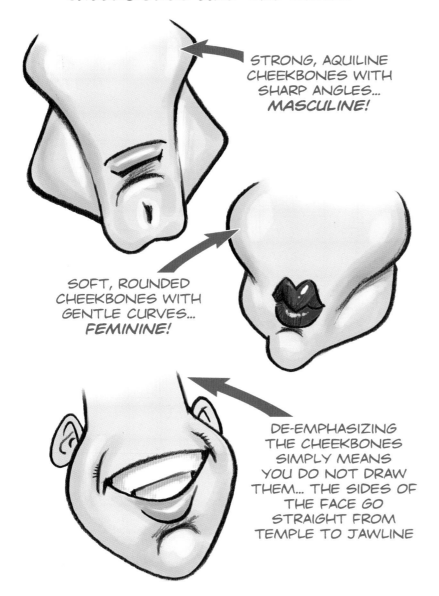

STRONG, AQUILINE CHEEKBONES WITH SHARP ANGLES... MASCULINE!

SOFT, ROUNDED CHEEKBONES WITH GENTLE CURVES... FEMININE!

DE-EMPHASIZING THE CHEEKBONES SIMPLY MEANS YOU DO NOT DRAW THEM... THE SIDES OF THE FACE GO STRAIGHT FROM TEMPLE TO JAWLINE

THE EARS

Ears are the second-most maligned feature in all of caricature, right after noses. It's very easy (and lazy) to pick on ears by making them huge for a cheap laugh. As with any feature, it might be more accurate to exaggerate ears by making them smaller than they really are if the subject in front of you calls for that.

Anatomy of the Ear

Ears themselves are not part of the skull structure, though the skull has a hole in it where the ear canal recesses into the bones, providing a path for vibrations we hear as sounds received through the eardrum. The ear itself is made of cartilage, and, like the nose, continues to grow throughout our lives. Thus older people, especially older men, have larger, longer ears. Ears are as unique as fingerprints, and they have been used by police and other investigators to identify people who have otherwise altered their appearance.

The ear is made up of ridges of cartilage including the helix (the primary ridge along the outside of the ear) and the anti-helix (a raised ridge inside the ear shape that resembles a letter Y). There is usually a protrusion of cartilage called the tragus that sticks out like a tab from the front edge of the ear over the ear canal opening. All ears have lobes, or lobules; some people's lobes are attached and some people's dangle. Dangling earlobes are soft, pillowy bags that hang at the bottom of the ears. Attached earlobes don't hang but rather connect directly to the sides of the head.

Are you listening, Father Flanagan? The ears and nose are the only two adult facial features that continue to grow as you age. However, Spencer Tracy's ears were plenty substantial even as a young man.

THE ANATOMY OF THE EAR

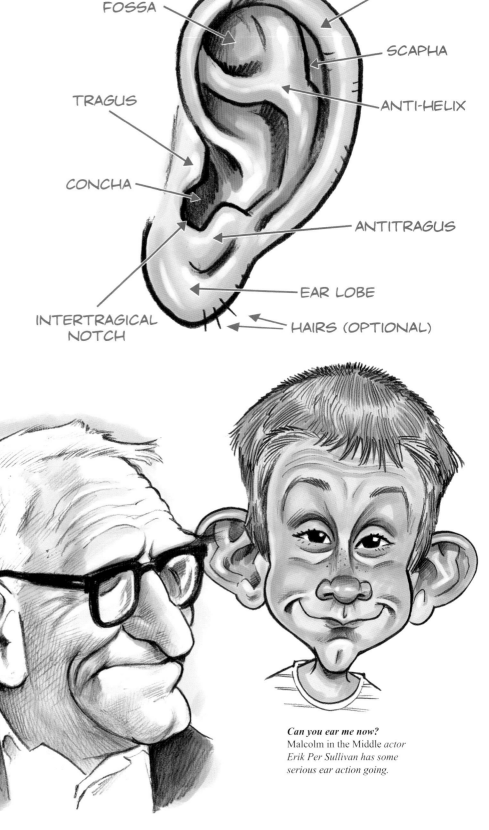

TRIANGULAR FOSSA

HELIX

SCAPHA

ANTI-HELIX

TRAGUS

CONCHA

ANTITRAGUS

EAR LOBE

INTERTRAGICAL NOTCH

HAIRS (OPTIONAL)

Can you ear me now? Malcolm in the Middle *actor Erik Per Sullivan has some serious ear action going.*

THE EAR SHAPE

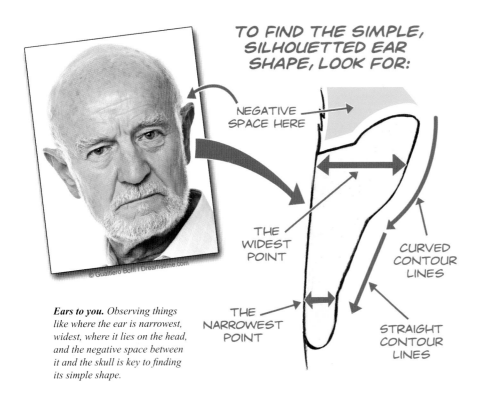

TO FIND THE SIMPLE, SILHOUETTED EAR SHAPE, LOOK FOR:

NEGATIVE SPACE HERE

THE WIDEST POINT

THE NARROWEST POINT

CURVED CONTOUR LINES

STRAIGHT CONTOUR LINES

Ears to you. Observing things like where the ear is narrowest, widest, where it lies on the head, and the negative space between it and the skull is key to finding its simple shape.

© Gualtiero Boffi | Dreamstime.com

EAR PLACEMENT ON THE HEAD

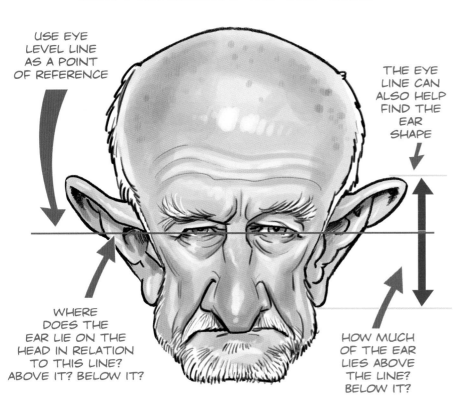

USE EYE LEVEL LINE AS A POINT OF REFERENCE

THE EYE LINE CAN ALSO HELP FIND THE EAR SHAPE

WHERE DOES THE EAR LIE ON THE HEAD IN RELATION TO THIS LINE? ABOVE IT? BELOW IT?

HOW MUCH OF THE EAR LIES ABOVE THE LINE? BELOW IT?

Seeing the Ear Shape

The shape of the ear is pretty easy to see, since it is conveniently silhouetted and protrudes from both sides of the face. I look for points where the ear shape is widest or narrowest, and where it is closest to the face. In some cases the helixes inside the ear stick out past the outer ridge, giving the ear a lumpy silhouette. The negative space between the upper part of the ear and the side of the head can also be a key that helps describe the ear shape and its relationship to the head.

Along with the ear's shape, its placement on the head is important. In that familiar traditional portraiture model, the ear's top is even with the top of the eyes and its bottom lies even with the bottom of the nose. In real life, some people have higher ears and some have lower ears. Noticing where the ear is placed on your subject can have a great impact on the caricature, as it provides a good element to exaggerate.

Drawing and Exaggerating the Ear

When it comes to drawing the ear, certain parts are more important than others, especially if you are simplifying it for live caricature or cartoon illustration (more about that below). First, let's look at the four anatomical elements that comprise the ear: the helix, the tragus, the lobe, and the anti-helix. The helix runs along the outside contour of the ear shape from just above the ear canal opening all the way to the ear lobe. Often this ridge is most clearly defined along the top of the ear and becomes less obvious as it runs down the outside of the ear. Its thickness varies—look for whether your model has a very thin and sharp helix or one that is thick and bulky. The anti-helix looks a bit like a piece of elbow macaroni that has been placed in the ear with the curved edge near the outer ridge. The helix and anti-helix sometimes touch and sometimes even overlap. The top of the anti-helix separates into two branches that disappear beneath the helix.

The tragus can be shaped like a rectangle, triangle, or half oval, and it can be large and obvious or barely a bump. The lobe, attached or not, is separated from the tab of the tragus by a teardrop-shaped negative space. The lobe also has a sort of tabbed top ridge, and the shape of the lobe itself can range greatly, from only a swell of tissue at the bottom of the ear to enormous lobes—and this is not even taking into account the ways people modify their ears with piercing or gauging. Getting the individuality of the ear can be simple if you just look at these four elements and draw them accordingly.

After the shape and placement of the ear have been established, I feel just a few suggestions of the interior details are all that's needed. What you include in your drawing should be distance specific—that is, ignore those things on your model that aren't noticeable at the distance from which you are viewing him or her. People usually do not notice much about the inner workings of other people's ears, so a hyperdetailed ear on a caricature would be distracting. However, ears can be like eyebrows, in that if you DO notice them in a casual glance, that means there is something about them that is unusual.

Size is the obvious thing to exaggerate (whether pushing the ears to be bigger or smaller), but there are other relationships to consider as well. Some ears really stick out from the head, while others lay very close to it. Examine the negative space between the ear and the side of the head to see if that's something you want to exaggerate. Ear placement, as I mentioned, is something you can play with. Someone whose ears are high up or seem very low will be perceived as having distinctive ears, and so making them higher or lower would be very effective.

Of course, sometimes the ears are partially or completely obscured by hair. Then they are really easy to draw!

So, what's left? I mentioned earlier when discussing head shape that the hair, while a big part of the head shape, would wait until later. This is that later. Actually I'm now going to discuss three elements that create the top of the head: the eyebrows, the forehead, and the hair.

SIMPLIFYING THE EAR

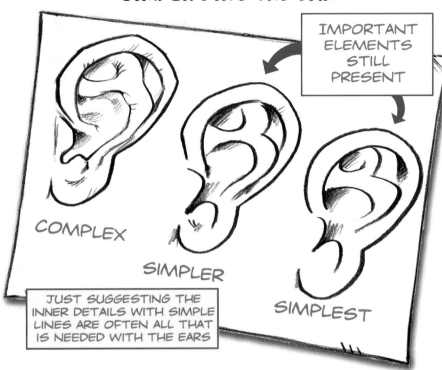

IMPORTANT ELEMENTS STILL PRESENT

COMPLEX

SIMPLER

SIMPLEST

JUST SUGGESTING THE INNER DETAILS WITH SIMPLE LINES ARE OFTEN ALL THAT IS NEEDED WITH THE EARS

EXAGGERATING THE EAR

SIZE!

BIGGER

SMALLER

PLACEMENT!

NORMAL

HIGH

LOW

THE UPPER HEAD

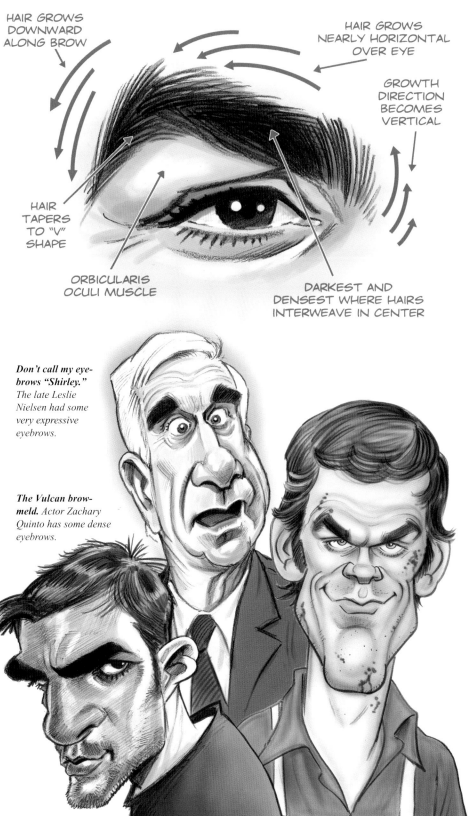

HAIR GROWS DOWNWARD ALONG BROW

HAIR GROWS NEARLY HORIZONTAL OVER EYE

GROWTH DIRECTION BECOMES VERTICAL

HAIR TAPERS TO "V" SHAPE

ORBICULARIS OCULI MUSCLE

DARKEST AND DENSEST WHERE HAIRS INTERWEAVE IN CENTER

Don't call my eyebrows "Shirley."
The late Leslie Nielsen had some very expressive eyebrows.

The Vulcan browmeld. Actor Zachary Quinto has some dense eyebrows.

Killer Eyebrows.
Dexter's Michael C. Hall has them.

THE EYEBROWS

The eyes and mouth might be the most varied and expressive parts of the face, but eyebrows would be third in line. They change considerably with expression and, especially, with what the subject is communicating. When the mouth talks the eyebrows follow suit, raising and dropping with the conversation like facial punctuation marks.

Anatomy of the Eyebrow

There might not seem to be much to the eyebrow, after all it's only a bunch of hair. But the eyebrow is actually a bit more complicated than that. It's a bunch of hair that grows on, and defines, the bones of the brow—and those are some pretty prominent parts of the skull. Since there are seldom a lot of fat deposits around the brow, it is one of the most clearly defined bony areas in the face. So the eyebrows serve the dual purpose of representing one of the most distinctive and visible bone structures on the face while also communicating strong expression.

The hair of the eyebrow is designed to keep sweat and moisture from rolling down into the eye socket. The shape of the eyebrows and the direction of the hair diverts any moisture from the forehead, sending it along the brow and down the sides of the face or the nose.

Eyebrows are also a feature that people can change quite easily. Many women pluck or wax their eyebrow hairs to shape their eyebrows into a thinner and more defined form. Eyebrows that look like two fat caterpillars perched above the eyes is rarely considered feminine or attractive, and don't

get me started on the unibrow. Because grooming (or lack of it) can alter a subject's eyebrows, the amount of variation possible is nearly endless.

Seeing the Eyebrow Shape

Despite the hairy nature of eyebrows, they consist of a shape, just like any other feature. To picture that shape, imagine drawing an outline around the main bulk of the eyebrow. I don't mean a contour line that encompasses every hair, but rather one that surrounds the area where the hair is darkest and most concentrated. Some people have very distinct and trim eyebrows, while others may have very light or diffused eyebrows with thinner hair spread over a larger area. If you need to, squint your eyes to eliminate all the extraneous hairs and see just the densest part of the eyebrow.

Establishing points of reference will help you see the shape you want to draw and possibly exaggerate. Finding the thickest point in the eyebrow is one easy observation to begin with. Many eyebrows are thickest at the corner of the brow bone, where the bony ridge changes direction and heads down towards the cheekbone. From there, the eyebrow tapers down to the inner and outer ends. That said, eyebrows do come in many different shapes and sizes, and it's not unusual to see the thickest part in the center by the glabella or at the opposite ends above the outside corner of the eye.

Negative space comes into play when drawing the eyebrow, especially, because the shape of that negative space between the eyebrow and eye has much to do with the eyebrow's expressive qualities. Look at the shape created by the line that defines the bottom of the eyebrow and the upper lid of the eye.

Emotions, attitude, and animation are all described by this negative space. When I am drawing the eyebrow, I look at this shape as much or more than I look at the shape of the eyebrow itself.

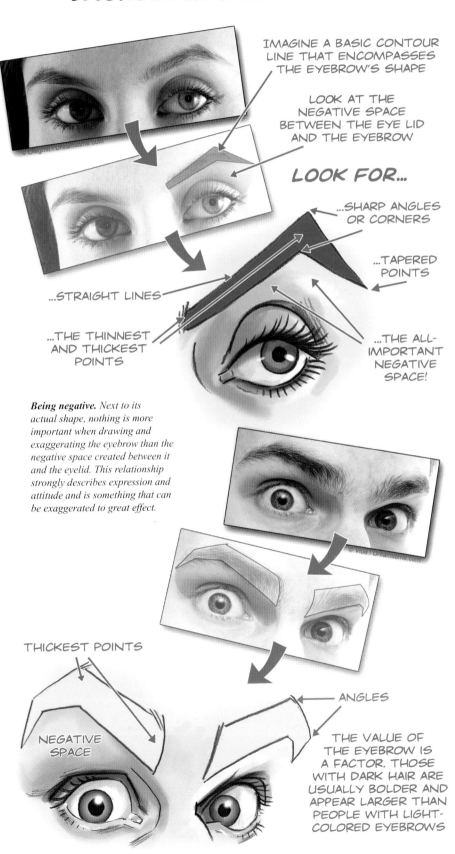

EYEBROWS AS A SIMPLE SHAPE

IMAGINE A BASIC CONTOUR LINE THAT ENCOMPASSES THE EYEBROW'S SHAPE

LOOK AT THE NEGATIVE SPACE BETWEEN THE EYE LID AND THE EYEBROW

LOOK FOR...

...SHARP ANGLES OR CORNERS

...TAPERED POINTS

...STRAIGHT LINES

...THE THINNEST AND THICKEST POINTS

...THE ALL-IMPORTANT NEGATIVE SPACE!

Being negative. Next to its actual shape, nothing is more important when drawing and exaggerating the eyebrow than the negative space created between it and the eyelid. This relationship strongly describes expression and attitude and is something that can be exaggerated to great effect.

THICKEST POINTS

ANGLES

NEGATIVE SPACE

THE VALUE OF THE EYEBROW IS A FACTOR. THOSE WITH DARK HAIR ARE USUALLY BOLDER AND APPEAR LARGER THAN PEOPLE WITH LIGHT-COLORED EYEBROWS

DRAWING THE EYEBROWS

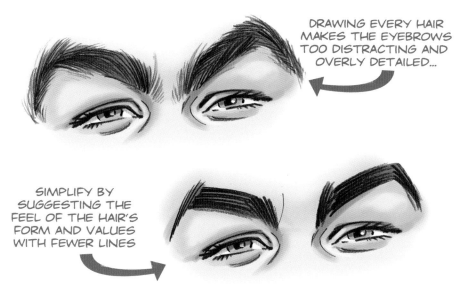

DRAWING EVERY HAIR MAKES THE EYEBROWS TOO DISTRACTING AND OVERLY DETAILED...

SIMPLIFY BY SUGGESTING THE FEEL OF THE HAIR'S FORM AND VALUES WITH FEWER LINES

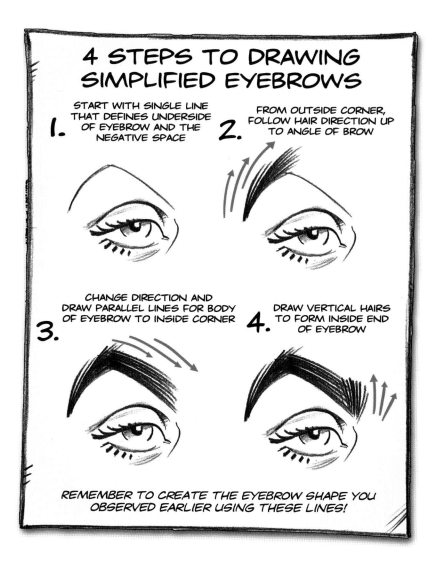

4 STEPS TO DRAWING SIMPLIFIED EYEBROWS

1. START WITH SINGLE LINE THAT DEFINES UNDERSIDE OF EYEBROW AND THE NEGATIVE SPACE

2. FROM OUTSIDE CORNER, FOLLOW HAIR DIRECTION UP TO ANGLE OF BROW

3. CHANGE DIRECTION AND DRAW PARALLEL LINES FOR BODY OF EYEBROW TO INSIDE CORNER

4. DRAW VERTICAL HAIRS TO FORM INSIDE END OF EYEBROW

REMEMBER TO CREATE THE EYEBROW SHAPE YOU OBSERVED EARLIER USING THESE LINES!

Drawing and Exaggerating the Eyebrow

Hair presents a challenge for many artists, because it seems so very complex. I'm not just talking about eyebrows, of course, but also the eyelashes, hair on the head, and facial hair. After all, we are looking at thousands—or hundreds of thousands—of tiny strands! How do you draw all that? The short answer is: you don't.

When working with artists on live drawing techniques, I often talk about distance-specific drawing. What I mean by this is that you should limit your drawing to the information a viewer can see from the distance implied by the composition of that picture. When you draw a person's face on a piece of paper, you are describing that face, from a certain distance. The artist controls that distance. If you draw a giant face that fills the paper, you have created a close-up. Drawing a tiny face and body surrounded by a lot of white space would result in a long shot. Normally the distance depicted is somewhere in between, perhaps several feet or so—about the distance you would stand from someone when engaging in a casual conversation. Distance-specific drawing means that you don't draw every little hair on the head because at that distance your eyes won't see every hair unless you specifically focus on them. They will pick up vague values and textures, but those individual hairs melt together for even the most eagle-eyed of viewers. The eyelashes are the same way, as are the eyebrows. Drawing every little hair will not look natural. It's much better to suggest the hair is there using either a value with a few linear elements to indicate the hair texture or, when working in line, just a few lines creating a main shape.

When I draw a subject's eyebrows, I am drawing the shape of the negative space between the eye and eyebrow as much as I am drawing the eyebrow shape itself. In fact, I usually sketch in my subject's eyebrow as a single line defining the negative space between the eye and the bottom of the eyebrow. In effect, that single line is the bottom of the eyebrow, over which I can then build the rest of the eyebrow shape.

EXAGGERATING THE EYEBROWS

Eyebrows, like ears, wrinkles, or freckles, are one of those "background" features that we can often take for granted in the face. We only notice them if they stand out as unusual looking. You notice someone's eyes or nose or mouth pretty much all the time, as they are central to the face. Eyebrows only garner our attention if they stick out, so to speak. The basic rule is: if the eyebrows catch your attention, they deserve some attention of their own.

Remember a caricaturist's three friends: size, distance, and angle. All play into exaggerating the eyebrow.

Size is a fairly obvious target; if someone is sporting a pair of those fat, hairy, caterpillar eyebrows I mentioned earlier, then bigger eyebrows are definitely called for in your caricature. Remember, when you draw the eyebrow you are also drawing the brow of the skull, and someone with a cave-man brow is probably also going to get bigger eyebrows because you can't exaggerate the size of the brow without the eyebrows coming along for the ride.

Distance and angle play a combined role in how eyebrows can be exaggerated, and we can see this through the all-important negative space between the eyes and eyebrows. Eyebrows that reside very close to the eyes (resulting in very little negative space) can be drawn so close that they literally obscure parts of the eye. Lots of negative space can be equally exaggerated.

The angle of the eyebrow, as determined by its relationship to the central axis of the face, is a particularly strong marker for expression. If there is a sharp angle in the eyebrow at any point from the glabella to the outside corner of the brow, the artist can exaggerate that angle to great effect.

Finally, even the most expertly tweezed eyebrows are not perfectly symmetrical. With changes in expression, they can take on a wildly asymmetrical appearance. Just like representing a crooked smile, seeing and capturing uneven eyebrows can replicate a great expression and result in the kind of "That's his look!" reaction every caricaturist aims for.

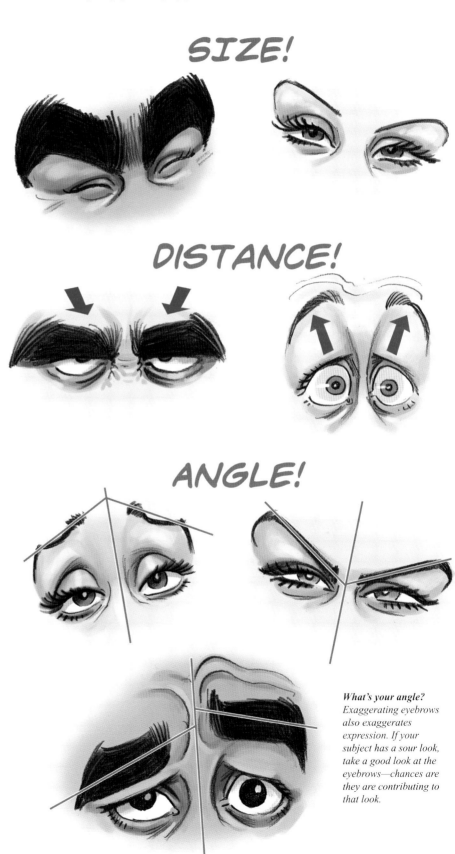

SIZE!

DISTANCE!

ANGLE!

What's your angle? Exaggerating eyebrows also exaggerates expression. If your subject has a sour look, take a good look at the eyebrows—chances are they are contributing to that look.

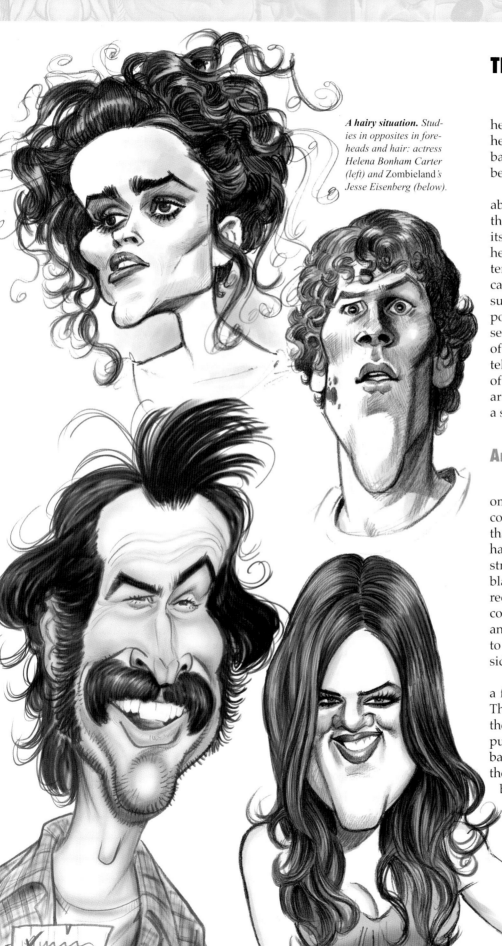

A hairy situation. Studies in opposites in foreheads and hair: actress Helena Bonham Carter (left) and Zombieland's Jesse Eisenberg (below).

THE FOREHEAD AND HAIR

The hair is really a part of the overall head shape—it can literally dominate the head shape in some cases. In others, it might barely be a factor. Like any feature it should be approached as a simple shape.

Our perception of hair shape is mostly about hair length, which is responsible for the bulk that can sometimes make the face itself seem like a small part of the whole head shape. Just changing a hairstyle can alter your perception of a person's face. Any caricaturist who has started to draw a live subject with her hair pulled back into a tight ponytail, only to look up a minute later and see the model has let an enormous amount of frizzy hair fall loose to her shoulders, can tell you that. There is no end to the number of different styles, textures, and nuances an artist can be confronted with when drawing a subject's tresses.

Anatomy of Hair

There really isn't much to hair "anatomy." Hair differs in more ways than just color. Blonde hair is finer and more brittle than dark hair, and blondes, on average, have more hairs on their head (140,000 strands) than do brunettes (110,000 strands), black-haired people (108,000 strands), or redheads (90,000 strands). Darker hair is coarser and tends to be thicker as a result, and hair will differ in thickness from person to person depending on many factors besides the average for each color.

Each hair sprouts from the scalp from a follicle, which anchors it into the dermis. The follicle is sometimes called the root, or the bulb—which you can see when a hair is pulled from the head. Hair grows from the base of the neck all along the skull up to the forehead, where it stops abruptly at the boundary we call the hairline. The hairline can vary in shape and is found higher or lower on the forehead, depending on a person's age and genetics.

Hair today, gone tomorrow. Jason Lee from My Name is Earl *(far left) has hair all around, including prominent sideburns and mustache, and while I have absolutely no idea why Khloe Kardashian (right) is famous, she does have great hair.*

THERE ARE ENDLESS VARIETIES OF HAIR

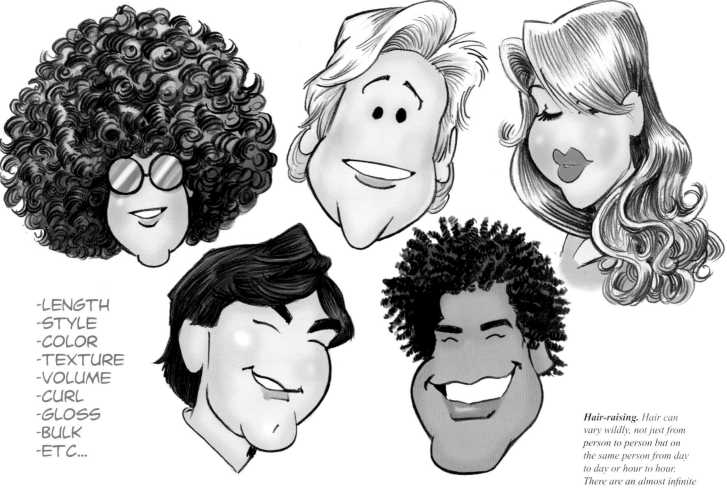

-LENGTH
-STYLE
-COLOR
-TEXTURE
-VOLUME
-CURL
-GLOSS
-BULK
-ETC...

Hair-raising. Hair can vary wildly, not just from person to person but on the same person from day to day or hour to hour. There are an almost infinite number of variations of hairstyles, colors, textures, and types of hair. This is actually a boon to the caricaturist, because hair is by nature a highly individualized feature. It's not easy (or cheap) to choose how your nose, teeth, or eyes look, but anyone can change their hair to suit their personality and tastes.

Shades of hair color can go from platinum blonde (that almost white color found naturally in only young kids, a few Swedes—and, unnaturally, after a visit to any salon) to an inky black. In between there are various natural shades of blonde, brown, red, and black, as well as an entire spectrum of bottled hair colors. Age affects both the color and the texture of hair. As years pass, hair slowly (or quickly) begins to turn gray, usually beginning at the temples and sometimes along the hairline, until eventually most of the head has turned gray or sometimes white. Gray hairs are very coarse and brittle, much more so than hair on the same head that is not gray. The grizzled look of shorter gray hairs is a result of this rougher texture.

Hair also behaves differently from one person to another—and sometimes from one day to another! Some people have very straight hair, while others have a natural curl that can vary from a soft wave to Shirley Temple ringlets to tight, kinky curls. This can be, and often is, altered by various styling. Straight-haired people can get perms that turn them into curly-haired people, and curly-haired people can get their hair straightened. It can drive you crazy.

Finally, hair also changes in its density as a result of aging, much less so in women than in men, but older ladies also see their hair thin out. At least for them it usually stays put. Men experience various levels of baldness as they age, from the receding hairline to the chrome-dome bald.

USING NODES TO FIND THE SHAPE OF THE FOREHEAD

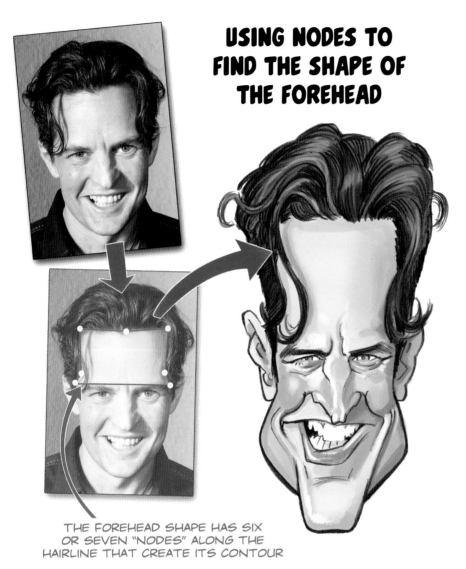

THE FOREHEAD SHAPE HAS SIX OR SEVEN "NODES" ALONG THE HAIRLINE THAT CREATE ITS CONTOUR

DIFFERENT HAIRLINES

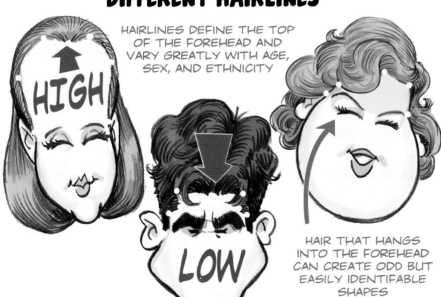

HAIRLINES DEFINE THE TOP OF THE FOREHEAD AND VARY GREATLY WITH AGE, SEX, AND ETHNICITY

HIGH

LOW

HAIR THAT HANGS INTO THE FOREHEAD CAN CREATE ODD BUT EASILY IDENTIFABLE SHAPES

Seeing the Forehead Shape

To discuss drawing hair, I need to begin by talking about the forehead. The forehead is a shape, and it's a much easier shape to comprehend than the complex hair. Not much is really going on in the forehead itself, it's just the smooth dome of the skull covered by some of the thinner skin on the face. There are muscles there, but they rarely show themselves beneath the skin, and any wrinkles or folds that might show up in the forehead are a result of various expressions and age. For us, the main importance of the forehead is its function as negative space, bordered by the hairline above, the sides of the hairline down each side of the head to the temples and the ear, and the tops of the eyebrows.

Forehead shapes are sometimes very apparent, like when a subject has short hair or has their long hair pulled back or styled up so that the entire hairline is visible. Sometimes it's obscured by a curtain of bangs or bits of hair that hang down into the face, but that also creates a shape. Wherever you see skin above the eyes, that's the forehead shape.

The hairline can vary from being just about straight across to having a marked low point in the center called a "widow's peak." There are also corners at the top edges of the forehead, where the hairline turns sharply down towards the bottom of the face. Traveling down from these corners, the hairline begins to curve in towards the corner of the eye but then stops and begins to angle slightly back towards the ear again. The result is a shape like the one pictured.

With six distinct turning points, or nodes, along the sides and three along the top center, the forehead can be a wide variety of shapes, multiplied further by the fact that some or all of the forehead could be hidden by hair.

Forehead is forearmed. The shape of the forehead is quite obviously defined by the hairline, from ear to ear along the scalp, and the tops of the eyebrows. Imagining "nodes" or points where the hairline changes direction, angle, or comes to a point allows us to easily see the forehead shape—then we just connect the dots.

Seeing the Hair Shape

Despite its complex nature, upon close examination hair is really just another shape on the head. The trick to seeing hair shape is to forget about the fact that it's made up of about 100,000 strands and instead imagine it's made of clay or some sculptable material. Try to picture the hair as the simplest shape you can, or as a combination of simple shapes. Recognize that the hair shape is made up not just of strands of hair but also the space between the strands. Hair puffs out. Long hair billows and twists. Some people tease or frizz their hair to erect voluminous pompadours, while others can't help looking like they've absorbed all the static electricity within city limits. As you can easily tell when you compare wet hair to dry, styled hair, the air between strands is as responsible for what the hair looks like as are the actual strands. It's all about seeing the simple shapes. That is the key to drawing and exaggerating any feature convincingly, including hair.

Depending on the length and style, multiple strands of hair will gather together in locks that follow similar waves, curls, or directions. Single hairs can fly any which way, but together they tend to go the same direction. Natural oils and static electricity cause hairs to attract one another, and it's these chunks—locks, waves, curls, and such—that are the shapes we are looking for.

I start looking at hair shape by observing the basic contour of the hair as it rests on top of or frames the face. I ignore all the curls, highlights, and so on and look at just the simplest shape I can imagine.

Next, I look within this shape to find the next level of shapes. Hairdos vary, but many have a foreground (bangs, front of hairline, or front top of head), middle ground (sides above ears) and background (hair visible behind ears, jaw, or neck, or the crown of head if visible).

Rare hair. The hair is a complex thing made up of many thousands of tiny strands that collect in hundreds of locks in many layers and formations. In order to find the simple shape, that basic form that defines the overall mass and volume of the hair, we have to ignore all those details and distill the hair down to its essence.

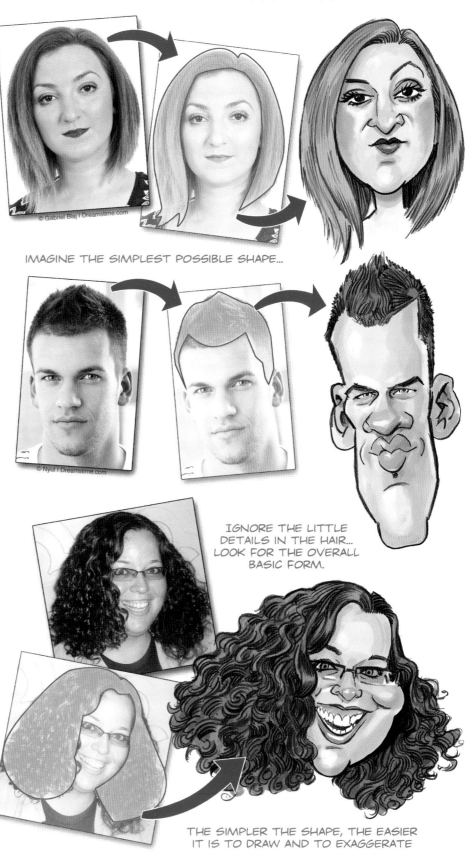

SIMPLIFYING HAIR SHAPE

IMAGINE THE SIMPLEST POSSIBLE SHAPE...

© Gabriel Blaj | Dreamstime.com

© Nyul | Dreamstime.com

IGNORE THE LITTLE DETAILS IN THE HAIR... LOOK FOR THE OVERALL BASIC FORM.

THE SIMPLER THE SHAPE, THE EASIER IT IS TO DRAW AND TO EXAGGERATE

MULTIPLE AND OVERLAPPING HAIR SHAPES CREATE DEPTH

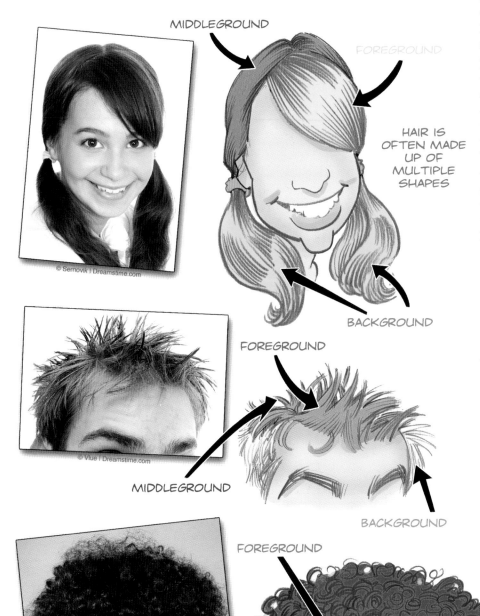

MIDDLEGROUND

FOREGROUND

HAIR IS OFTEN MADE UP OF MULTIPLE SHAPES

© Sernovik | Dreamstime.com

BACKGROUND

FOREGROUND

MIDDLEGROUND

© Vlue | Dreamstime.com

BACKGROUND

FOREGROUND

© Okssi68 | Dreamstime.com

COMPLEX HAIR IS ALSO LAYERED WITH FOREGROUND, MIDDLEGROUND, AND BACKGROUND

MIDDLEGROUND

BACKGROUND

Sometimes these sections of hair create obvious shapes, and other times there is little distinction in the transition. If I can see definite shapes, I'll sketch them out. If not, I look for other shapes within the larger hair shape. I'll look for parts in the hair or any places I can see the roots. This indicates a definite edge, and anywhere there's an edge a shape can't be far behind. Hair length affects the shapes because longer hair tends to gather together more than shorter hair, which can appear more grizzled or spiky. The weight of longer hair pulls it down and creates narrower, longer shapes that can be straight or have waves varying from gentle to tightly curled. Some hairstyles are easier to simplify and draw: long, straight hair or hair with slight waves has more obvious shapes. Shorter hair has less surface area to attract the surrounding hairs, so they gather into smaller bundles like short curls, half curls, spikes, or bristles.

The hair itself is so varied a feature that I could write a whole book on every single different hairstyle you might see and how best to draw it, but much of that is really a part of an artist's style of drawing and rendering. In fact, hair is one of the elements that varies the most in interpretation through the individual artist's style. A nose is a nose, and so forth, but when you draw hair, you are really trying to draw the FEEL of the hair, not every strand. Thus, hair is more of an interpretation than it is a definite feature, and so it's more subject to the type of drawing technique and style being utilized. With all that said, there are a number of concepts and tips with respect to drawing hair that are more or less universal.

Follicle follies. Hair is not just one single shape but generally consists of a foreground, middleground, and background. Sometimes these shapes are very obvious, like in the case of a hairstyle with bangs and a ponytail. In other styles the separation is more gradual. The important thing to remember is to think in three dimensions.

CAPTURING THE ESSENCE OF HAIR BY SIMPLIFYING FORMS AND LINES

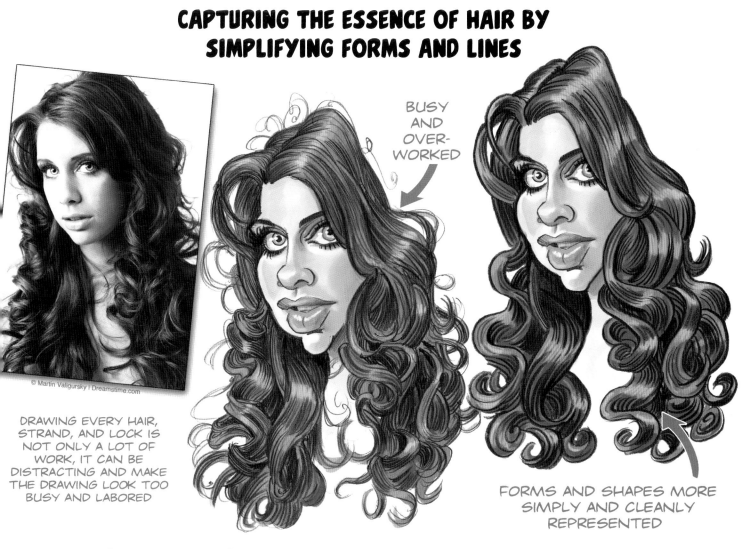

© Martin Valigursky | Dreamstime.com

DRAWING EVERY HAIR, STRAND, AND LOCK IS NOT ONLY A LOT OF WORK, IT CAN BE DISTRACTING AND MAKE THE DRAWING LOOK TOO BUSY AND LABORED

BUSY AND OVER-WORKED

FORMS AND SHAPES MORE SIMPLY AND CLEANLY REPRESENTED

Drawing and Exaggerating the Hair

It seems like I say this about every feature, but with hair simplification is absolutely crucial. Even if you could muster the time and stamina to do so, you would not want to draw every hair, or lock of hair, on the head because it would look bizarrely surreal and unnatural.

Simplify and Represent

Many artists get caught up with details like tiny little hairs, but remember to adhere to distance-specific drawing, which tells us that, at a proper distance, our eyes do not actually register all those hairs. Unless we are closely studying the hair, what we really see are various forms and shapes, with texture and values of dark and highlights. The trick is to simplify how we perceive the hair so we can give our viewer the same kind of information in our drawing. Simplifying makes the hair look natural and convincing.

Imagining having to form the hair out of clay is a good way to visualize this simplification process. You can see how the hair gathers in basic forms, each with varying levels of detail. Each level of detail is composed of smaller and more individual shapes. Some hairstyles are simple and require just a few shapes, while other, more complex heads of hair call for numerous smaller shapes in order to properly describe them.

Hair apparent. As with any feature, simplifying its forms is key. Since hair is so complex, boiling it down to simple forms is not often easy. Some hairstyles demand more work and thought. Imagine the hair as being made up of big, solid shapes so you are forced to think about the basic forms and how they flow rather than all the details.

DEFINING HAIR SHAPES WITH LIGHT

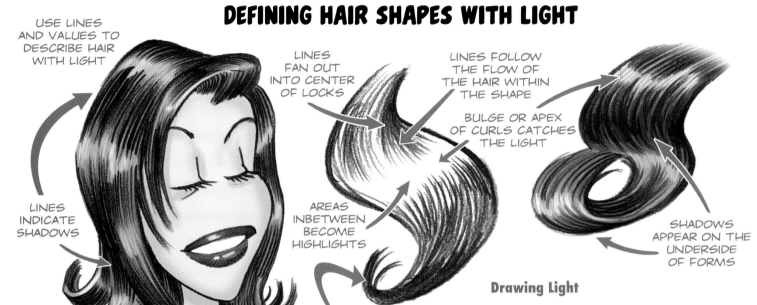

USE LINES AND VALUES TO DESCRIBE HAIR WITH LIGHT

LINES INDICATE SHADOWS

LINES FAN OUT INTO CENTER OF LOCKS

AREAS INBETWEEN BECOME HIGHLIGHTS

HAIR IS DARKEST WHERE IT GATHERS AT THE ROOTS AND THE END OF LOCKS

LINES FOLLOW THE FLOW OF THE HAIR WITHIN THE SHAPE

BULGE OR APEX OF CURLS CATCHES THE LIGHT

SHADOWS APPEAR ON THE UNDERSIDE OF FORMS

Drawing Light

When you draw hair, you are really drawing the shapes created by the values of light and shadow you perceive in the hair's natural highlights and color. Hair is darkest at the roots and ends, while the central mass of locks and shapes catches the light, creating highlights. Regardless of whether you are drawing in line, painting in values, doing a highly detailed study, or just loosely sketching, the shadows and highlights are what give hair the appearance of volume and mass. The darker the hair, the greater the contrast.

Thinking in terms of light and values, even in a line drawing, helps reduce the hair to a more simplified form. When working in line, thicker, bolder, and denser lines will read as darker hair, and thinner, lighter lines will make the hair appear lighter.

USING OVERLAPPING SHAPES

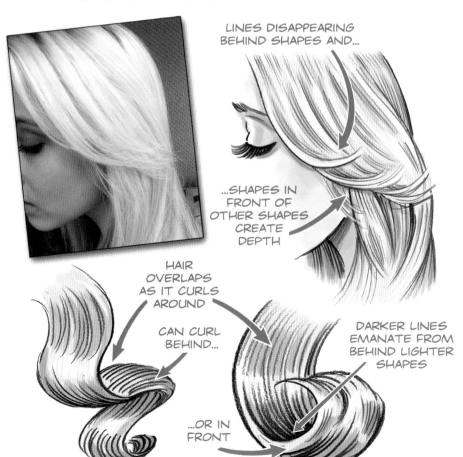

LINES DISAPPEARING BEHIND SHAPES AND...

...SHAPES IN FRONT OF OTHER SHAPES CREATE DEPTH

HAIR OVERLAPS AS IT CURLS AROUND

CAN CURL BEHIND...

DARKER LINES EMANATE FROM BEHIND LIGHTER SHAPES

...OR IN FRONT

Overlapping Shapes

Hair is made up of layers—that is, it consists of shapes in front of other shapes. This helps give hair the appearance of volume. Even the straightest of long hair will have some locks that overlap others, and whole sections will appear to sit behind the foreground hair. This is especially evident if your model's hair has waves and curls, which can only be re-created convincingly by suggesting those overlapping shapes.

The following pages show some of the kinds of curls, waves, and shapes you can expect to see when drawing hair.

The Wave

A flowing mass of hair with a soft wave can resemble water. Note the lines suggest that the hair all goes in the same direction, but the lines are drawn closer together at the roots and more separated at the highlight, then they all flow closer together again as they gather. The longer the hair, the more of this closer-farther dynamic we see.

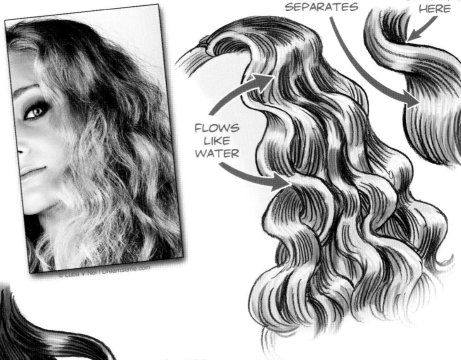

SEPARATES

GATHERS HERE

FLOWS LIKE WATER

The Ribbon

Tighter and thinner locks can become ribbons of wave shapes, twisting in about themselves as they cascade down.

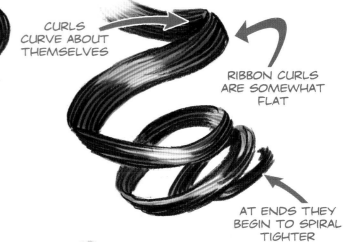

CURLS CURVE ABOUT THEMSELVES

RIBBON CURLS ARE SOMEWHAT FLAT

AT ENDS THEY BEGIN TO SPIRAL TIGHTER

The End Curl

Hair with a curl to it will naturally gather and curl at the end of the lock. Note how the end curl can end up either in front of or behind the lock, creating depth.

HAIR GATHERS AT THE ENDS INTO POINTS

LAYERING END CURLS CREATES DEPTH

CURLS CAN WRAP TO THE OUTSIDE OF THE HEAD...

...OR TO THE INSIDE

CURLS USUALLY SEPARATE INTO MULTIPLE LOCKS AT ENDS

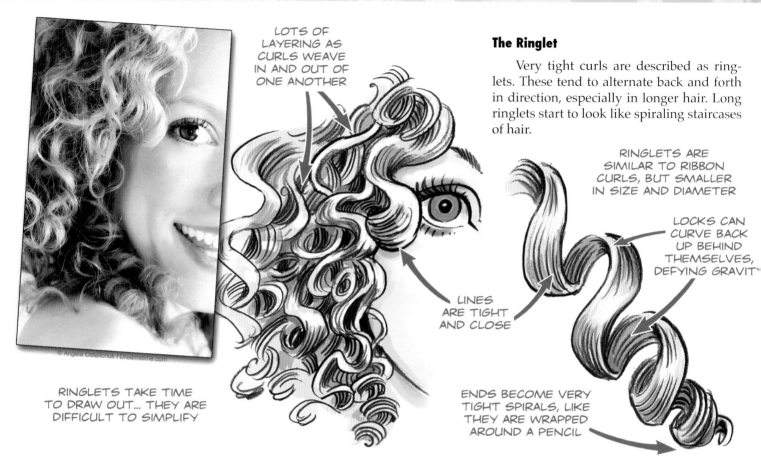

LOTS OF LAYERING AS CURLS WEAVE IN AND OUT OF ONE ANOTHER

RINGLETS TAKE TIME TO DRAW OUT... THEY ARE DIFFICULT TO SIMPLIFY

LINES ARE TIGHT AND CLOSE

The Ringlet

Very tight curls are described as ringlets. These tend to alternate back and forth in direction, especially in longer hair. Long ringlets start to look like spiraling staircases of hair.

RINGLETS ARE SIMILAR TO RIBBON CURLS, BUT SMALLER IN SIZE AND DIAMETER

LOCKS CAN CURVE BACK UP BEHIND THEMSELVES, DEFYING GRAVITY

ENDS BECOME VERY TIGHT SPIRALS, LIKE THEY ARE WRAPPED AROUND A PENCIL

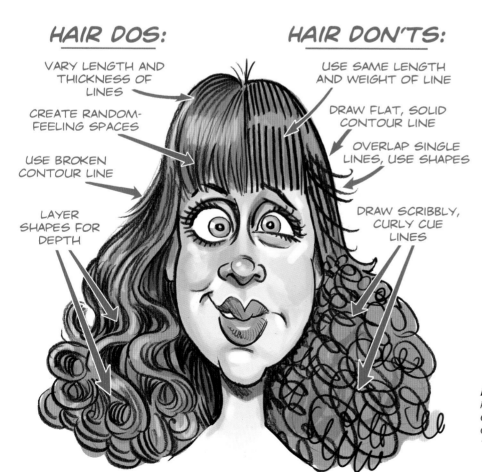

HAIR DOS:

VARY LENGTH AND THICKNESS OF LINES

CREATE RANDOM-FEELING SPACES

USE BROKEN CONTOUR LINE

LAYER SHAPES FOR DEPTH

HAIR DON'TS:

USE SAME LENGTH AND WEIGHT OF LINE

DRAW FLAT, SOLID CONTOUR LINE

OVERLAP SINGLE LINES, USE SHAPES

DRAW SCRIBBLY, CURLY CUE LINES

When drawing hair you should avoid laying down perfectly parallel lines or single, overlapping hairs. Hair never exists as perfectly parallel lines. Even the straightest hair has some variation in its flow. Highlights are also never uniform but will vary over even the plainest-looking head of straight hair.

Make sure your hair lines represent shapes and not individual hairs. Drawing single lines that overlap, or "curly cues," reads as individual hairs, not shapes, which makes the hair look flat and unconvincing.

Some hairdos defy simplification into general shapes and, as such, are just going to be time consuming to draw. Short and spiky hair, dreadlocks, tight ringlets, wavy hair extensions, and many other kinds of complex hairstyles simply take a lot of time to capture. Just keep it as simple as you can, meaning you should try to use the lowest levels of shape detail you need to in order to describe the hair well.

Hair'em scare'em. The opposite page has several subjects whose hair (or lack thereof) is an important element in their caricature. Clockwise from the lower left: John Lennon, Nick Offerman, Ruper Grint, Piers Morgan, Michael Jackson, Emmitt Smith, and Stacy "Fergie" Ferguson.

Exaggeration and Hair

Like any feature, hair can and should be exaggerated when the subject's hair is calling for it. Usually exaggerating hair means playing with the volume, or mass, of the whole—this could range from massive tresses to a completely bald pate. It's also possible to exaggerate the hair's style, meaning that if a subject has very curly hair, we could exaggerate this by not only making it curlier but also making the hair more prominent by giving it a bigger mass compared to the face.

This page contains some examples of hair in caricature.

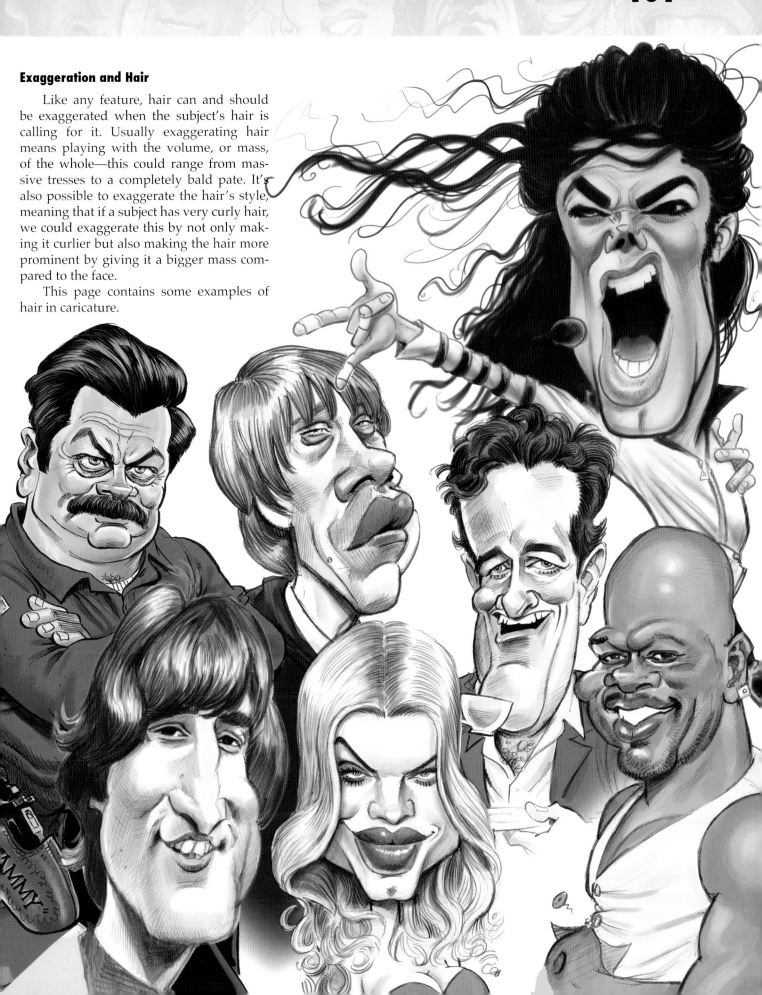

6 BEYOND THE FACE

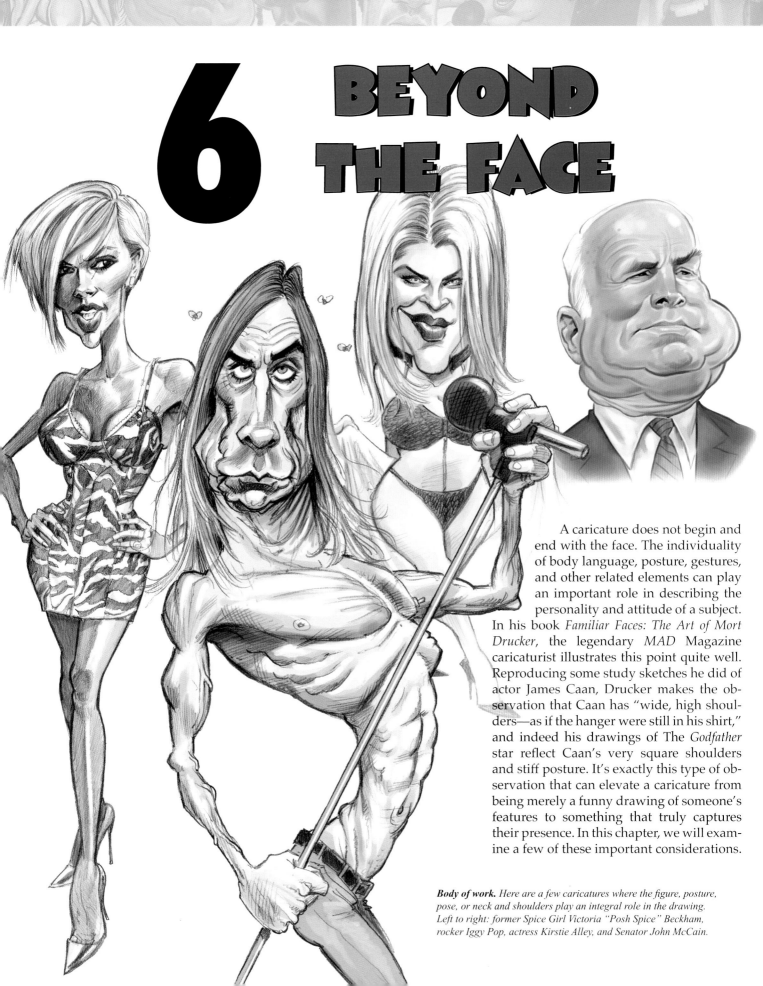

A caricature does not begin and end with the face. The individuality of body language, posture, gestures, and other related elements can play an important role in describing the personality and attitude of a subject. In his book *Familiar Faces: The Art of Mort Drucker*, the legendary *MAD* Magazine caricaturist illustrates this point quite well. Reproducing some study sketches he did of actor James Caan, Drucker makes the observation that Caan has "wide, high shoulders—as if the hanger were still in his shirt," and indeed his drawings of The *Godfather* star reflect Caan's very square shoulders and stiff posture. It's exactly this type of observation that can elevate a caricature from being merely a funny drawing of someone's features to something that truly captures their presence. In this chapter, we will examine a few of these important considerations.

Body of work. *Here are a few caricatures where the figure, posture, pose, or neck and shoulders play an integral role in the drawing. Left to right: former Spice Girl Victoria "Posh Spice" Beckham, rocker Iggy Pop, actress Kirstie Alley, and Senator John McCain.*

THE NECK AND SHOULDERS

Capturing a person's likeness, or recognizability, does not stop at the jawline. A person's posture, the angle at which they hold their head, the thickness of their neck, the squareness of their shoulders—these are important aspects of a person's recognizability and should not be ignored. This is especially true if the subject has some obvious uniqueness to any of these aspects. Full-figure caricatures incorporate the entire body, posture and all, but even in a typical live caricature the neck and shoulders are a part of the whole. Few caricatures are of the "floating head" variety.

I drew this caricature of Javier Bardem as he looked in the film *No Country for Old Men*. The slump of his shoulders, his clothing, and the style of his hair all combine to make his neck look enormously thick and beefy. I exaggerated this effect in the caricature on the left by pulling all the visual weight from the top of his head into his jaw, neck, and sloping shoulders. Compare these two identical drawings of his face, only one of which shows attention to the unique look of his neck and shoulders. It is the same face in both, but the one on the left captures his recognizability much better.

This is a consideration that will help enhance a caricature of just about any subject. While some people have nondescript necks and "average" posture, others have very distinct and unusual upper bodies that demand attention. Recognizing this uniqueness is the first step to caricaturing it, and you will never spot things like this if you don't look for them in the first place. As always, the rule of thumb is: if you notice something about a person's neck and shoulders at a casual glance, it's important.

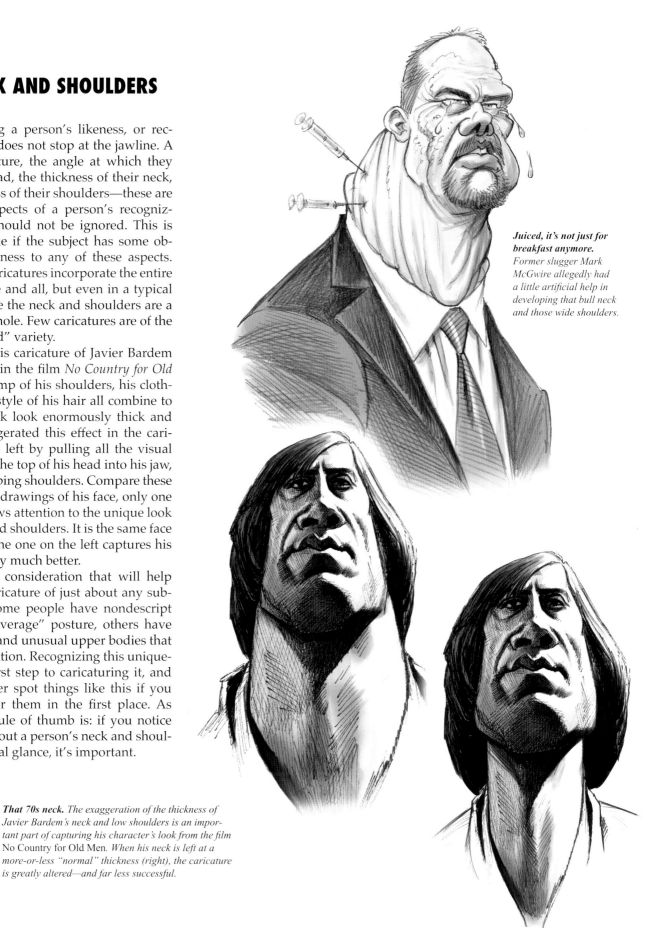

Juiced, it's not just for breakfast anymore. Former slugger Mark McGwire allegedly had a little artificial help in developing that bull neck and those wide shoulders.

That 70s neck. The exaggeration of the thickness of Javier Bardem's neck and low shoulders is an important part of capturing his character's look from the film No Country for Old Men. *When his neck is left at a more-or-less "normal" thickness (right), the caricature is greatly altered—and far less successful.*

THE MUSCLES OF THE NECK

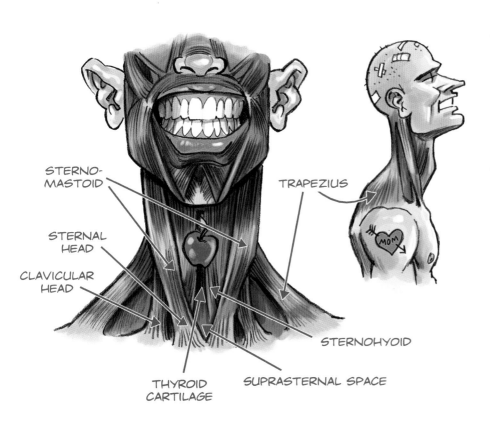

STERNO-MASTOID

TRAPEZIUS

STERNAL HEAD

CLAVICULAR HEAD

STERNOHYOID

THYROID CARTILAGE

SUPRASTERNAL SPACE

Anatomy of the Neck and Shoulders

The neck has two major muscle groups that are of primary concern to the caricaturist: the sterno-mastoid and the trapezius. The sterno-mastoid muscles begin on the sides of the neck under the angle of the jaw and stretch diagonally downward to meet at the sternum. They create a strong V-shape, the interior of which protrudes somewhat and contains the Adam's Apple (if visible). Just above the base of the neck, the sterno-mastoid muscle splits into two branches, forming a wider base between the sternum and clavicle. The trapezius muscles or "traps" start at the rear base of the skull and come from behind the sterno-mastoids, extending like wings to each side of the neck and forming the shoulder lines to the shoulder bone. The area where the bottom of the neck merges with the upper body includes some visible bones, most notably the clavicle, or collar bone, and the upper U-shape of the sternum. From behind or at a side angle, the seventh vertebra is often visible, especially if the subject is craning their neck.

Drawing and Exaggerating the Neck and Shoulders

In explaining how to draw the neck, I find it's easiest to just point out some of the common mistakes artists make:

The neck is not made of parallel lines. The neck shape is wide at the base of the skull, narrower as it goes downward, and then wider again as the trapezius muscles take over the contour line.

The neck does not suddenly sprout from a horizontal shoulder line. The trapezius muscles form an angle, of varying degree, between the sides of the neck (sterno-mastoids) and the roughly horizontal line of the clavicle bone.

SOME DOS AND DON'TS OF DRAWING THE NECK

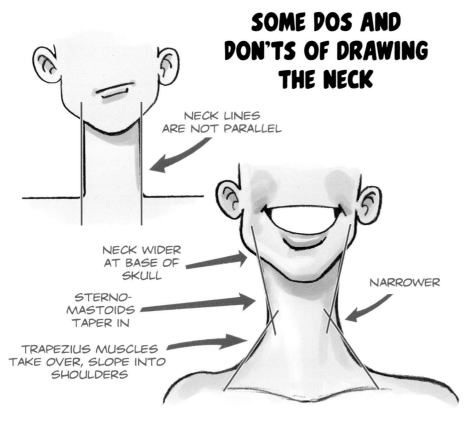

NECK LINES ARE NOT PARALLEL

NECK WIDER AT BASE OF SKULL

STERNO-MASTOIDS TAPER IN

TRAPEZIUS MUSCLES TAKE OVER, SLOPE INTO SHOULDERS

NARROWER

MORE TIPS FOR DRAWING THE NECK

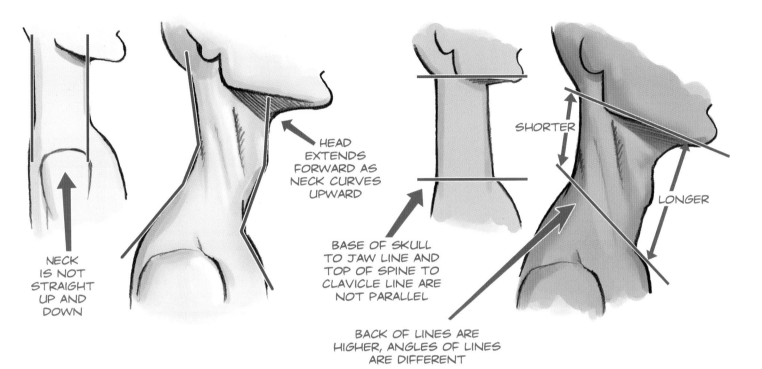

NECK IS NOT STRAIGHT UP AND DOWN

HEAD EXTENDS FORWARD AS NECK CURVES UPWARD

SHORTER

LONGER

BASE OF SKULL TO JAW LINE AND TOP OF SPINE TO CLAVICLE LINE ARE NOT PARALLEL

BACK OF LINES ARE HIGHER, ANGLES OF LINES ARE DIFFERENT

The neck does not stand straight up. The head juts forward slightly (or greatly in some cases) from the upper body.

The angles of the neck from back to front are not parallel. At any angle except a straight-on front view, the rear points of the neckline are higher that the front points. The line from the point at the bottom of the neck where the traps begin to slope down the back to the sternum is at a steeper angle than the line from the base of the neck to the base of the jawline. In other words, the line forming the back of the neck is shorter than that forming the front.

In traditional portraiture, the neck begins at the base of the ears and follows the sterno-mastoid muscles in toward the sternum. Then the trapezius muscles come from behind those lines to slope to the clavicle bone line. This basic six-line formation (with variation depending on the subject) defines most necks. Some people have gently curving necks, with a concave line representing their traps, and some have a convex line for

the traps, appearing at a starker angle to the initial neckline. Men have larger and more defined sterno-mastoid muscles, and thus they have a thicker-looking neck in most cases. The trapezius muscles in women tend to be less developed, making them smaller and less noticeable. As a result, the average woman has a more horizontal shoulder line than a man.

From a side angle, the back curves upward to the seventh vertebrae and then forms a straight or slightly convex line to the base of the skull. The base of the skull rests at the central axis of the body, which places the rest of the head forward of that axis. There is a strong curvature to the vertebrae under the neck muscles, and this can sometimes cause the neck to have a corresponding curve, especially if that neck is extremely thin.

The principal aspects to look for in exaggerating the neck are the thickness, the length, and the forward thrust (or the angle it has when viewed from the side).

Thickness

While traditional portraiture dictates the neck should be as wide as the head itself, in caricature this looks too wide. The wider the neck, the more muscular and masculine the subject appears. Drawing a neck as thick as the head itself will make any caricature subject look like a football player. In caricature, I consider a "normal" neck thickness to be one-half to two-thirds the width of the head. The neck should be centered along the central axis, which places the lines of the neck about even with the outside corners of the eyes. I will deviate from this only for exaggeration purposes—if my model has a thick neck I will make it wider than the outsides of the eyes, and if they have a thinner neck I'll draw it thinner than those reference points.

Again, men tend to have thicker necks than women, due to heavier sterno-mastoid and trapezius muscles. So, the bigger and more muscular the man is, the thicker his neck appears. Since thicker necks read as more masculine, the neck is a useful tool for accentuating the contrasting masculinity or femininity of a subject. If your drawing contains both a man and a woman, making sure the man's neck is drawn thicker (if warranted) than the woman's can reinforce the contrast of their gender. Very large and muscular men, like bodybuilders or the standard lumberjack type, can have "necks" that literally start under the ears and angle away from the face. These really aren't necks at all but overdeveloped trapezius muscles that scream brutish strength and power. In some cases like these it's not a bad choice to connect the ears directly to the shoulders with a single curved line.

Women generally have more slender necks, with fewer harsh angles and more gentle curves. Thinner necks will show more of the curve of the vertebrae, adding to the elegance of the female neck. Focusing on the neck's tapering to a narrower shape from the point where it meets the skull also adds to the femininity of the neck.

Necking order. The three points of exaggerating the neck—thickness, length, and thrust—are not mutually exclusive. When one aspect is exaggerated, another often has to follow suit. When exaggerating thickness, the length is usually affected. If you exaggerate the length, Thrust is often a factor. They are all interrelated.

EXAGGERATING THICKNESS

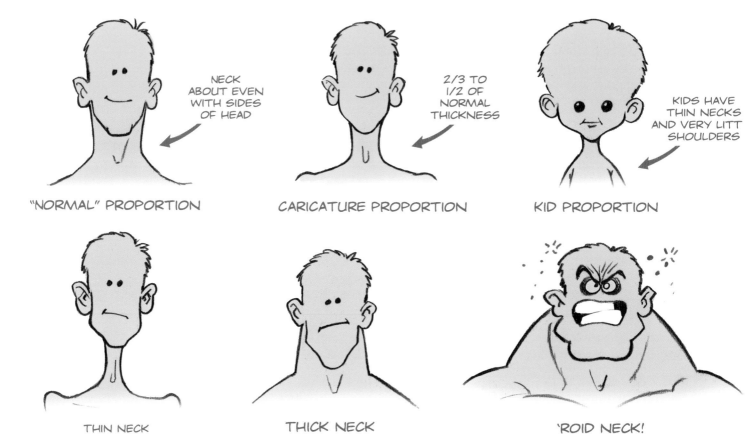

NECK ABOUT EVEN WITH SIDES OF HEAD

2/3 TO 1/2 OF NORMAL THICKNESS

KIDS HAVE THIN NECKS AND VERY LITT SHOULDERS

"NORMAL" PROPORTION　　CARICATURE PROPORTION　　KID PROPORTION

THIN NECK　　THICK NECK　　'ROID NECK!

Length

How long a neck appears is related to its thickness—a short neck will appear thicker than a long neck, even if that neck is the same actual, measurable thickness. In very short necks the trapezius muscles are close to the skull, which results in the squat, muscular, wrestler-type neck and shoulders. In those instances, the traps are drawn with the convex lines I mentioned. Conversely, long necks are usually thinner and have trapezius muscles that are less prevalent; these can be drawn with more gentle curves and concave lines. One way to think about how the neck reacts to exaggeration is to imagine the neck is made of soft rubber. To create a long neck, you would grab the head by the ears and pull it upward, which would subsequently stretch the traps and make the neck thinner. To shorten the neck, you would push down on the crown of the head, which would in turn cause the base of the neck to bulge out, becoming thicker as it was compressed.

Forward Thrust

When a person is standing naturally, their head always protrudes slightly forward from the body. In some people this dynamic is very pronounced. When you draw someone at a three-quarter angle or in profile, you can accentuate this forward thrust if you feel it will add to your caricature's recognizability.

There's an old saying: "Rules were made for breaking." This is certainly true in caricature, as you have to break past boundaries of classical portraiture if you're going to exaggerate to any effect. This can mean not only elongating or shortening a neck but also playing with the angle of that neck. A person with a head that juts far forward on a very noticeably angled neck might even be drawn in profile with their shoulders higher than their head—it all depends on how far you want to take your stretch. If a subject seems to have an awkward posture or holds his or her head oddly, then drawing that person in an unnatural-looking pose will exaggerate that effect.

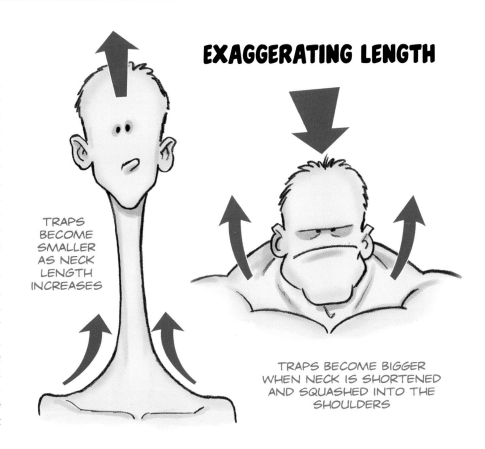

EXAGGERATING LENGTH

TRAPS BECOME SMALLER AS NECK LENGTH INCREASES

TRAPS BECOME BIGGER WHEN NECK IS SHORTENED AND SQUASHED INTO THE SHOULDERS

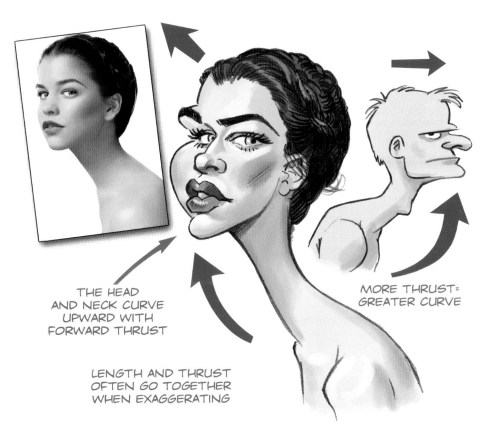

EXAGGERATING THRUST

THE HEAD AND NECK CURVE UPWARD WITH FORWARD THRUST

MORE THRUST= GREATER CURVE

LENGTH AND THRUST OFTEN GO TOGETHER WHEN EXAGGERATING

DRAWING HANDS

Hands are one of those things many caricaturists (and artists in general) struggle to draw well. They are complicated structures composed of moving parts, and they are incredibly expressive. Hands are a very important element of caricatures that include the figure or caricatures used for comic book work. Gestures and the attitudes people can convey through the use of their hands are a big part of acting and, therefore, of visual storytelling.

Next to faces, hands are probably the most expressive and intricate part of the human form. People probably spend more time looking at their own hands than they do looking at anything else over their entire lives. Since we are all so familiar with the way hands look, a poorly drawn hand sticks out like a sore thumb (sorry about the pun). For the caricaturist, hands are something that can be exaggerated just like any other feature.

I'm a cartoonist, so the hands I draw are not realistic hands by most definitions. However, my style of cartooning lends itself more to realistic representation than, say, a certain four-fingered gloved mouse or other cartoony characters do. Therefore, much of the information in this chapter will apply to drawing hands realistically as well as in cartoon form. I'll attempt to explain the basic anatomy of a hand, identify some things to keep in mind at all times when drawing them, and point out common mistakes and issues that plague many artists when it comes to drawing hands.

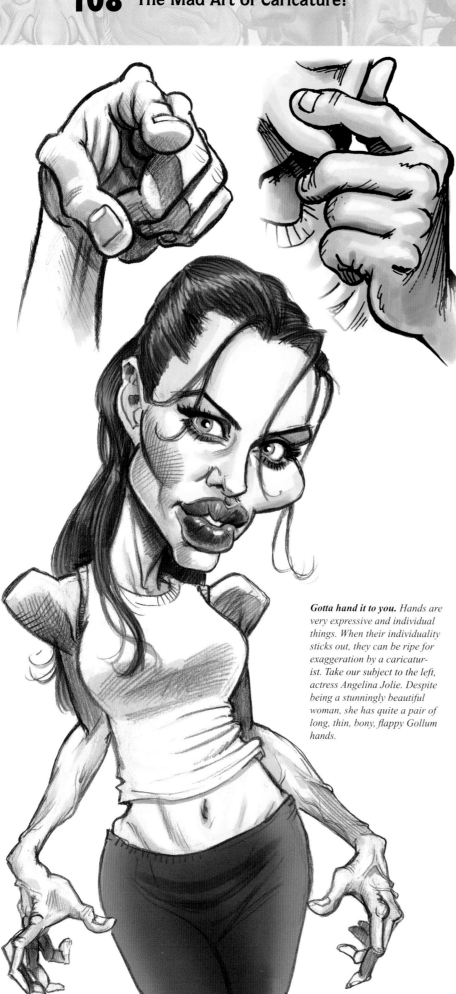

Gotta hand it to you. *Hands are very expressive and individual things. When their individuality sticks out, they can be ripe for exaggeration by a caricaturist. Take our subject to the left, actress Angelina Jolie. Despite being a stunningly beautiful woman, she has quite a pair of long, thin, bony, flappy Gollum hands.*

Anatomy of the Hand

If you've gotten this far into the book, you know by now that any drawing must start with an understanding of the basic form and structure of your subject matter. The most common problems with drawing hands stem from incorrect notions of the form of the hand. Again, I'm not a big stickler for memorizing the names of muscles and bones. People tend to zone out when you start tossing around carpal this and metatarsal that in a drawing demonstration. That said, labels really can be a useful tool for some people, so a lesson on some general surface anatomy with layman's terms seems to be the best approach. On the right is a breakdown of a hand with the important surface elements labeled. Not really much to it, is there? Everybody knows what knuckles and fingernails are, and we can all point to them easily on our own hands. Artists get tripped up by not understanding how these parts relate to one another and how they move in relationship to one another. The hand is capable of so many different gestures and movements, and it requires some study before you can really get a grip on how the knuckles line up, where the pad creases fall, and how the fingers bend and interact—all these are important elements to drawing convincing hands.

Relationships of Hand Structure

I can sum up the biggest problem most beginners have with drawing hands in one word: curves.

For some reason people seem to insist that hands are made up of straight lines (they're not), fingers are parallel to each other (again, no), knuckles line up in a row (they don't), and the edges of the hand are straight, parallel lines (nope). Once artists begin to see the curves in the hands and start thinking of them as flexible objects made of multiple parts, they quickly improve their hand drawings.

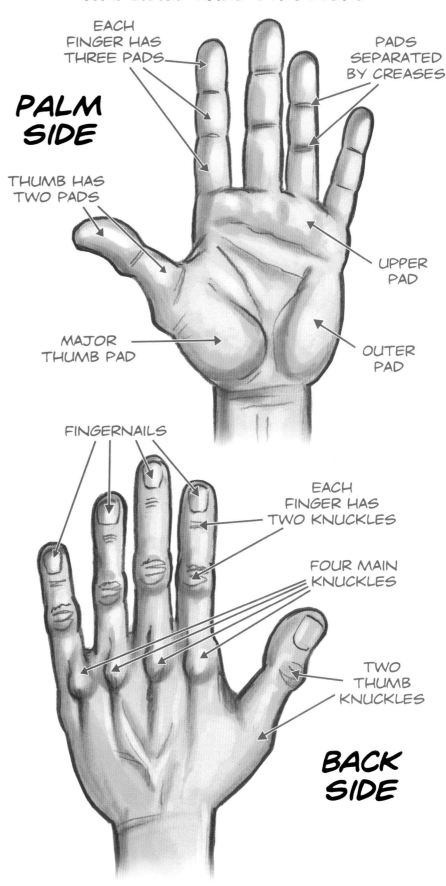

SIMPLIFIED HAND STRUCTURE

EACH FINGER HAS THREE PADS

PADS SEPARATED BY CREASES

PALM SIDE

THUMB HAS TWO PADS

UPPER PAD

MAJOR THUMB PAD

OUTER PAD

FINGERNAILS

EACH FINGER HAS TWO KNUCKLES

FOUR MAIN KNUCKLES

TWO THUMB KNUCKLES

BACK SIDE

STRUCTURE OF THE FINGERS

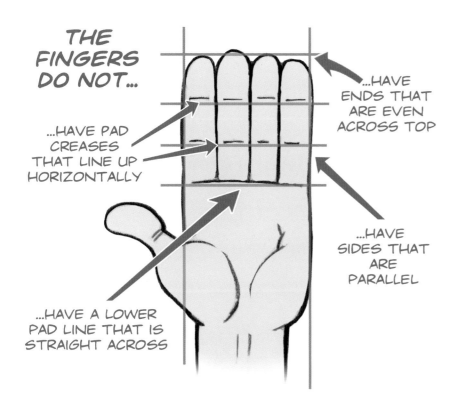

THE FINGERS DO NOT...

...HAVE ENDS THAT ARE EVEN ACROSS TOP

...HAVE PAD CREASES THAT LINE UP HORIZONTALLY

...HAVE SIDES THAT ARE PARALLEL

...HAVE A LOWER PAD LINE THAT IS STRAIGHT ACROSS

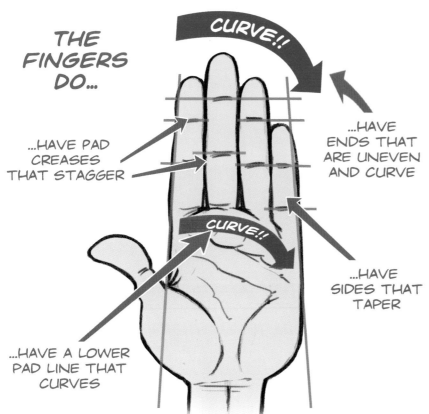

THE FINGERS DO...

CURVE!!

...HAVE ENDS THAT ARE UNEVEN AND CURVE

...HAVE PAD CREASES THAT STAGGER

CURVE!!

...HAVE SIDES THAT TAPER

...HAVE A LOWER PAD LINE THAT CURVES

Fingers

Everybody knows (or should know) that the fingers are not all the same length. Our middle finger is the longest (all the better for making a crude gesture), and the pointer and ring fingers alongside it are almost the same length (the ring finger is a little shorter). The pinky is the odd man out, much shorter than the rest of the team. That disparity forms a curve along the top of any outstretched hand. One thing newer artists often miss is that this curve is not just a function of the length of the fingers, because the knuckles are also curved. So our pinky is not only shorter, it's got the double whammy of also being set farther down into the hand. The ring finger is actually the same length as our pointer, but it appears shorter because its knuckle is lower on the hand than the pointer's.

Likewise, the pads of fingers are not the same size, and the creases that define the separation between the pads are staggered. The pinky's first crease from the tip lines up with the ring finger's second crease, and the tip of the pinky lines up with the ring finger's first crease.

Knuckles

Each finger has three knuckles. The main knuckle is located at the base of each finger, and the two minor knuckles appear farther up toward the tip. The main knuckle is knobby and has tendons that cross it as they run up into the finger, which makes the main knuckle look as though cords lie just under the skin there. The second knuckle is covered with a very circular patch of wrinkled skin, and the smallest, final knuckle is simply indicated by some horizontal creases. You would think the knuckles would line up with the corresponding creases separating the pads on

the underside of each finger, but you'd be wrong. Curl your pointer finger and look at it from the side. The second knuckle and the crease under it line up exactly—but the smaller upper knuckle lies more forward on the finger than the crease below it. And that difference seems small compared to what we see in the main knuckle. Here is where a lot of people get confused with hands. Open your hand and look at it with the palm facing you. Look at the base of each finger and where those creases lie.

Many people assume the knuckle of the finger rests directly behind the crease right under the bottom finger pad. Now turn your hand around. That main knuckle is significantly lower on the hand. In fact, it's below the upper pad of the palm that curves below all the fingers. More of your actual finger structure resides inside the palm than you might think. Understanding that is a big part of figuring out hands.

Thumb

Our celebrated opposable thumb is a shorter, meatier version of our fingers. It has only two knuckles, one of which is hidden when the thumb is extended. Compared to the fingers, the thumb has a much more diverse range of movement. I think of its base as the meaty part of a chicken drumstick, and that drumstick can rotate inward, across, and in circles. The "drumstick" of the thumb coexists with the thinner "drumstick" of the outer part of the hand, which is a little like a lower extension of the pinky's base. These two larger elements bookend the hand and the palm. This drumstick is a curvy piece of flesh and muscle—when drawing the thumb, remember that the curved lines work with the straight ones to define its form.

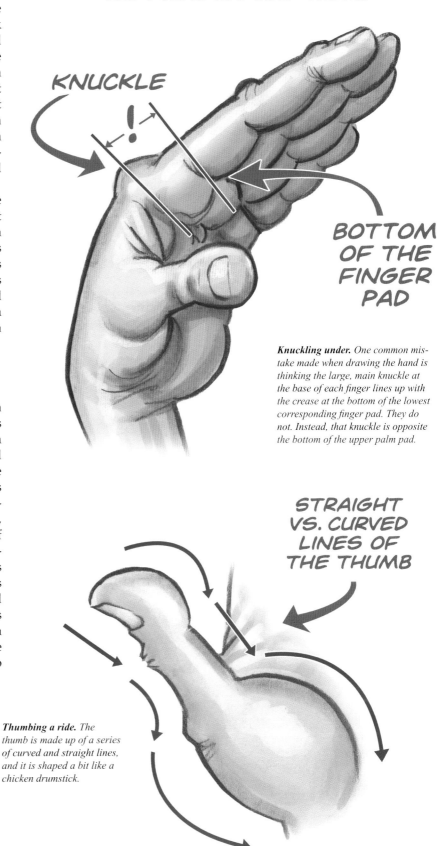

THE KNUCKLES AND THUMB

KNUCKLE

BOTTOM OF THE FINGER PAD

Knuckling under. *One common mistake made when drawing the hand is thinking the large, main knuckle at the base of each finger lines up with the crease at the bottom of the lowest corresponding finger pad. They do not. Instead, that knuckle is opposite the bottom of the upper palm pad.*

STRAIGHT VS. CURVED LINES OF THE THUMB

Thumbing a ride. *The thumb is made up of a series of curved and straight lines, and it is shaped a bit like a chicken drumstick.*

CONSTRUCTION OF THE PALM

THE "BLOCK" PALM ESTABLISHES THE BASIC SHAPE, BUT IT IS TOO RIGID...

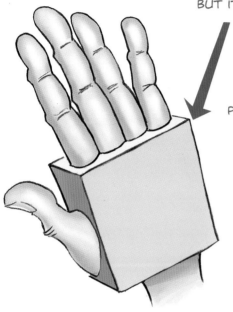

...VISUALIZING THE PALM AS THREE OVAL SHAPES THAT MIRROR THE THREE PALM PADS IS MORE ACCURATE AND FLEXIBLE

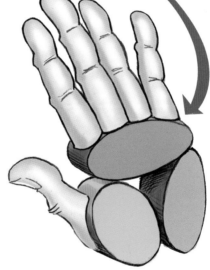

Palming the ace. The palm of the hand is tremendously flexible and versatile. It can spread out, cup itself, roll together, ball up into a fist—you name it. Thinking of it as made up of several movable elements is best.

THE HANDS ARE VERY FLEXIBLE, THEY CAN ROLL IN ON THEMSELVES

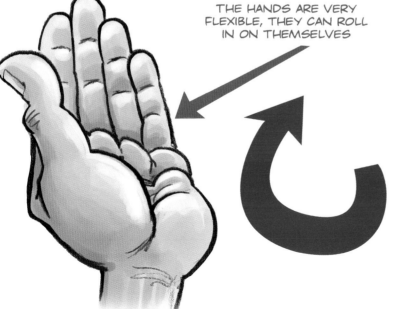

The Palm

This is the area on the interior surface of the hand between the fingers and the wrist, bordered by the thumb and the outside heel of the hand. The palm is an often misunderstood area. Roughly square to rectangular in shape, it has asymmetrical curved sides and is made up of three major elements: the thumb pad, the outer pad, and the upper pad. Many drawing books want you to think of the hand as a rectangular block from which the fingers and thumb protrude, but that idea lays the groundwork for many wrong assumptions about—and poor drawings of—the hand. You must think of the hand as flexible and curved, and think of the pads as three separate elements that combine to make that cupped hollow of the hand. They can roll against one another to create a pocket or spread out to be almost flat.

Fingernails

Though often glossed over in life-drawing classes, the fingernails deserve a closer look. Each one has a curved, narrow base, straight sides that fan out as they approach the tip of the finger, and (usually) a very curved outer edge. Women's nails are often grown out past the end of the fingertip, and can, of course, be manicured, painted, or even bejeweled in any number of ways. When viewed from the side, they are slightly recessed as they grow out from under the skin.

FINGERNAIL IS RECESSED AT BASE, GROWS OUT FROM UNDERNEATH THE SKIN OF THE FINGER

THINK OF FINGERNAIL AS SIMPLE "SHIELD" SHAPE

What to Look for When Drawing Hands

Trying to describe how to draw a hand in every imaginable position would be an impossible task. There are too many configurations, and hands themselves have different shapes and sizes from person to person. Fortunately you are never far away from a perfect reference for any hand position . . . just check the end of your arms. I keep a small mirror near my drawing table just so I can view different angles of my hands when I am struggling to draw a certain hand position. Still, there are a number of things that I would suggest anyone pay attention to when drawing hands.

Curves

I said it earlier, but I cannot emphasize that word enough. Curves, curves, curves. Knuckles curve when the hand is open or when it's in a fist. Looking at a fist from the knuckles, you see that the act of making a fist curves the back of the hand from thumb to pinky. Hands that are reaching or gesturing also have a thumb-to-pinky curve. Curves far outnumber straight lines on the topography of the hand. Hands drawn with more than just a few straight lines will appear stiff and unnatural.

Finger Interaction

Remember that the fingers are different lengths, but the action of the hand also changes the way fingers relate to one another. Fingers are rarely ever neatly pressed side by side (unless someone is imitating a robot). They tend to overlap and stagger their positions. When you hold a curved object like a bottle, for example, observe how your fingers overlap and how your pointer tends to be back farther than the other three fingers, which crowd together. Look for that when you decide how to pose your hands. Nothing looks less natural than four perfectly parallel fingers. Even in a relaxed state, your fingers will not be parallel. Look at a

sleeping person's fingers—they naturally separate and crowd one another in random ways. The pinky tends to separate from the other fingers most often, but that is far from a hard rule.

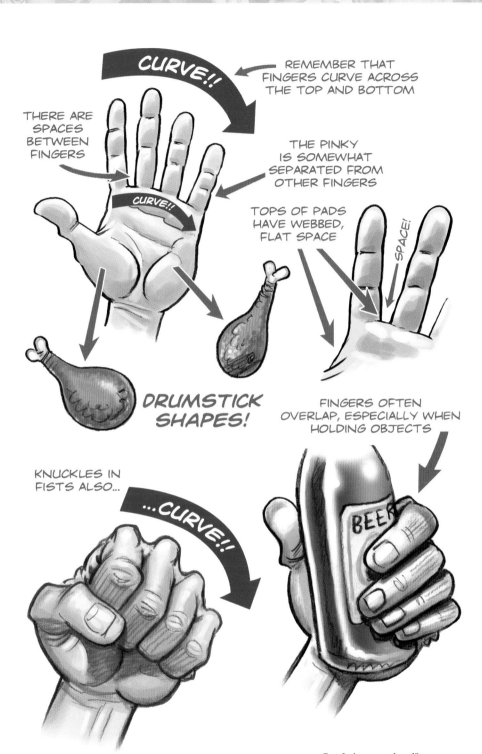

Can I give you a hand?
Here are a few tips on drawing hands. Remember you always have a perfect source of reference with hands—right at the end of your arm. Use a mirror or collect a photo album of hand poses you like to use.

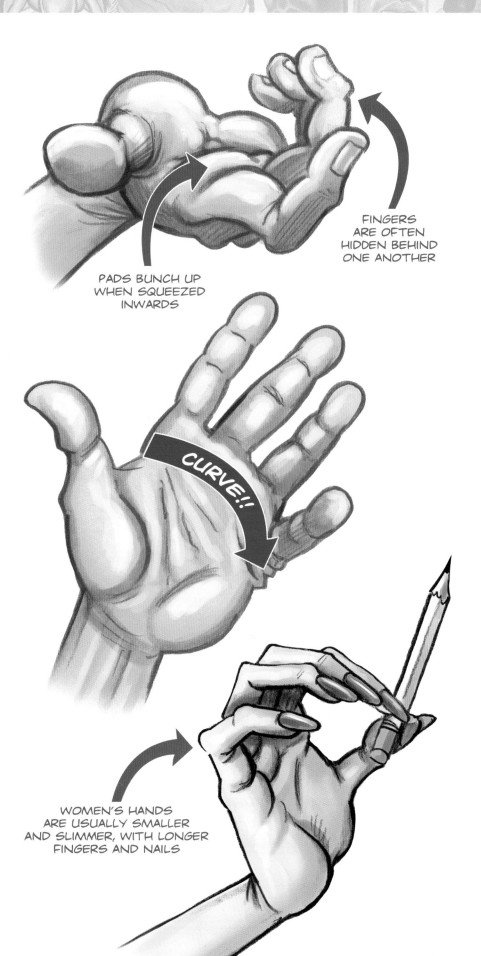

PADS BUNCH UP
WHEN SQUEEZED
INWARDS

FINGERS
ARE OFTEN
HIDDEN BEHIND
ONE ANOTHER

CURVE!!

WOMEN'S HANDS
ARE USUALLY SMALLER
AND SLIMMER, WITH LONGER
FINGERS AND NAILS

Remember the Meat!

That sounds graphic, but there's truth to it—your hands are made up of a lot of meaty muscle and padding. When they squeeze or clench or cup, all that meat pinches and gathers in ways that produce a lot of creases, wrinkles, and lumps. Remember the three important pads of the palm: the thumb and outer pads stay roughly in that drumstick shape, but the upper pad does a lot more curving and bending, and it bulges up a lot as the fingers move toward the thumb. Hands tend to be thickest across the lower palm.

Men's versus Women's Hands

Put simply, men's hands are thicker, with bigger fingers and a meatier palm, whereas women's hands are slimmer, with thinner fingers and palm. Women typically have smaller hands than men. Women's nails, if they are long, can create difficulties when it comes to drawing fingertips. I often just give women pointy fingertips, suggesting the nail rather than trying to articulate the ends of the fingers—unless I'm drawing a close-up of the hand, in which case I have to draw the whole thing.

People hate hearing this, but learning to draw hands is all about practicing. If you want to be able to draw something convincingly without relying on exact reference, you need to develop an instinct for drawing that thing—and that means drawing it over and over again. As I said before, you have the perfect reference located at the end of your wrist. Spend some time observing your hands. Place the fingers and thumb of one hand on the other and move that hand around so you can feel the muscles and bones beneath. Observe how the basic elements of the hand we have discussed move, rotate, flex, and relax with different movements. It's funny, but the hands people draw often end up resembling their own hands. They no doubt use their own hands for reference sometimes, but—even if they are not purposely doing so—they have also been staring at their hands for their entire lives and so that's probably what hands look like

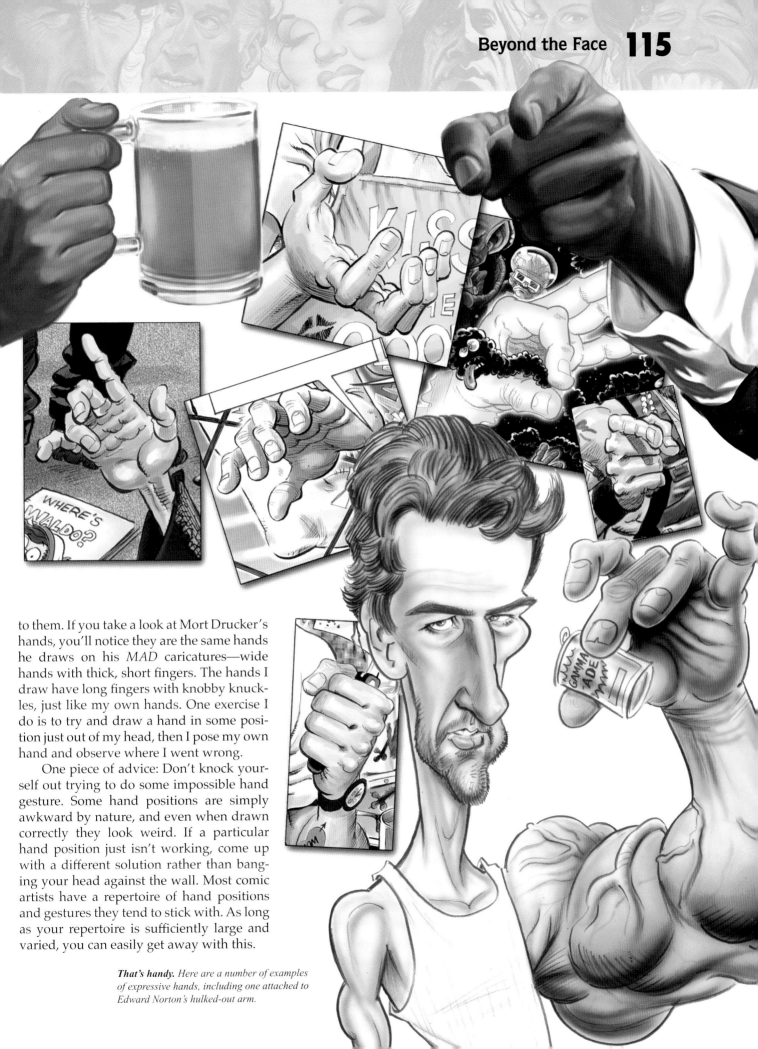

to them. If you take a look at Mort Drucker's hands, you'll notice they are the same hands he draws on his *MAD* caricatures—wide hands with thick, short fingers. The hands I draw have long fingers with knobby knuckles, just like my own hands. One exercise I do is to try and draw a hand in some position just out of my head, then I pose my own hand and observe where I went wrong.

One piece of advice: Don't knock yourself out trying to do some impossible hand gesture. Some hand positions are simply awkward by nature, and even when drawn correctly they look weird. If a particular hand position just isn't working, come up with a different solution rather than banging your head against the wall. Most comic artists have a repertoire of hand positions and gestures they tend to stick with. As long as your repertoire is sufficiently large and varied, you can easily get away with this.

That's handy. *Here are a number of examples of expressive hands, including one attached to Edward Norton's hulked-out arm.*

CARICATURE AND THE SEXES

One of the most common complaints I hear from other caricaturists is that women are harder to draw than men. Many struggle to make their caricatures of women look feminine and often feel their end result makes female subjects look like drag queens. There is definitely a difference in approach to caricaturing men versus women.

I think it's a myth that women, particularly beautiful women, are harder to caricature than men. Women have the same set of features that men have, but the need to differentiate the masculine from the feminine forces the caricaturist to modify his or her approach (in most cases—there are certainly exceptions, which we will examine shortly). This doesn't mean that it's more difficult to draw one sex than it is to draw the other, but you do have to keep the masculine-feminine difference in mind if you want to avoid the drag-queen look that can sometimes result.

One element that is often considered representational of classic feminine appearance is the "heart shaped" face. The combination of prominent but softly curved cheekbones and a small and slender chin can create a basic heart shape in a female's lower face. This face shape is often associated with classic female beauty—movie stars like Marilyn Monroe, Audrey Hepburn, and many other famous beauties have this type of face shape (see opposite page). Of course not all, or even most, women's faces have this type of shape. It's just one of those things caricaturists can look for and, if they observe that it applies to their subject, incorporate into their caricature. It can even be exaggerated. In fact, those attributes that make men and women look masculine and feminine are elements a caricaturist can always look to exaggerate.

While many of the differences between men and women's faces are surface features and, to a certain extent, superficial, the real differences lie under the skin, in the bones and the skull. The human brain is able to differentiate between a typical male and

Sex and the pity. Beautiful people are still caricaturable! Clockwise from top left: actresses Megan Fox, Kim Basinger, Spencer Grammer, and Amy Adams.

THE HEART SHAPED FACE

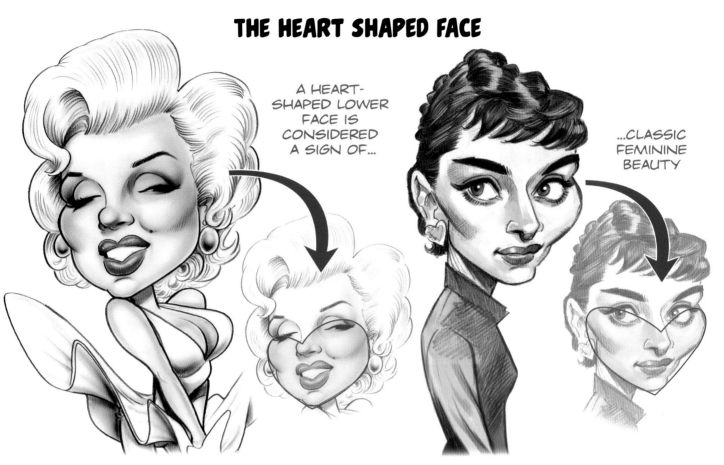

A HEART-SHAPED LOWER FACE IS CONSIDERED A SIGN OF...

...CLASSIC FEMININE BEAUTY

female face based on indicators that are more than skin deep. Hence, a drawing of a face that has male physiognomy in its underlying structure—regardless of how many "feminine" features one adds to the surface—will end up looking like a man wearing makeup.

Skeletal differences between the sexes have been well documented. The high levels of testosterone at puberty help enlarge the bones of males, while the high levels of progesterone help develop male characteristics like greater height and a narrower pelvic bone. The differences also extend to the skull, which is actually the second-easiest bone for forensic scientists to use in determining the probable sex of a skeleton, the pelvis being the first (I learned that on *NCIS!*). Examiners can judge the sex of a skeleton with a 90% accuracy rate based on the mandible alone.

The female skull is generally smaller and lighter than the male's. Bony elements like the brow ridge and mandible are usually less pronounced. The female skull tends to be wider than the male's, which helps give the features a softer look, owing to the more prominent cheekbones and less prominent jawline. The areas above the eye sockets in men tend to be more blunt and the brow itself is more pronounced, but in women that same upper eye socket area is sharper (something eye shadow accentuates) while the brow protrudes less.

The jaw is actually a key element to the masculine or feminine look of a subject. The combination of the wider skull, the less developed mandible, and the smaller, pointier female chin makes the female jaw distinct from the male jaw. In men, the upper (top part of the) chin is wider and higher vertically, while a female's is shorter and more rounded. The male chin is generally larger in every dimension, so big, square jaws inevitably read as masculine, and small, narrow, pointed ones read as feminine.

Have some heart.
Legendary beauties Marilyn Monroe and Audrey Hepburn demonstrate the classic heart-shaped face in action.

Features themselves are also different for men and women, often as a result of the skull structure but sometimes due to other developmental factors. Female noses, for example, are generally less angular and have a smaller, softer tip. Similar to their chins, women's noses have a tendency to be pointier, narrower, and vertically shorter (closer to the eyes) than men's noses.

So, what does all this mean in terms of a caricature? Since caricature is all about exaggeration, it makes sense that if you want a subject to be more feminine you should downplay the things that make a face masculine and play up those things that make it feminine. But wait—this sounds like distortion, or the exaggeration of features based not on the what the subject's features demand but on some other preconceived notion (which I constantly preach against), doesn't it?

Some rules to drawing faces do apply in order for the end result to be read as what you intended it to be. Drawing kids has certain rules you cannot break (or must break in only the most demanding of cases) if you expect your caricature to look like a kid and not some weirdly deformed adult. The same thing applies to drawing women. While it's true that some women's faces bend and even break some of these "rules," knowing them will allow the observer to understand their meaning and look for instances where they apply. If you are drawing a woman with an enormous square jaw you can't just ignore it, but you can look for the other typical female attributes and call attention to them to balance things—or, if you choose, you can just exaggerate that enormous jaw and know your caricature is going to end up looking like Jessie Ventura in a wig. Hey, if the subject looks like Jessie Ventura in a wig you can't do much about that. At least you will know why the caricature doesn't look feminine. You break the rules at your own risk, but you do have to break them when the situation calls for it.

Boys and Girls, clubbed. Clockwise from lower left: With his sleepy lids and long, dark lashes, Elvis Presley had very girly eyes—but his manly chin and head shape compensated; Jackie O was another classic, heart-shaped beauty; Terminator: The Sarah Connor Chronicles' Lena Heady and Shirley Manson both break a few rules regarding drawing women—Heady has a very angular face and strong jaw, while Manson's big forehead and fleshy lower face is not particularly feminine.

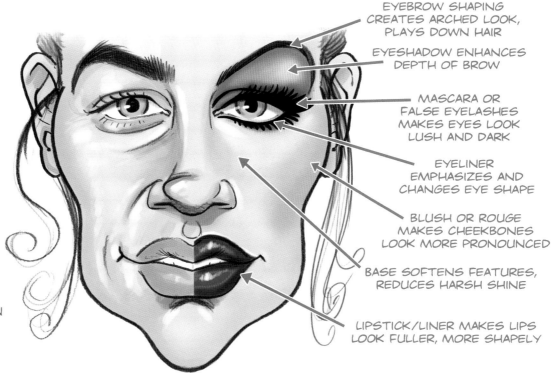

EYEBROW SHAPING
CREATES ARCHED LOOK,
PLAYS DOWN HAIR

EYESHADOW ENHANCES
DEPTH OF BROW

MASCARA OR
FALSE EYELASHES
MAKES EYES LOOK
LUSH AND DARK

EYELINER
EMPHASIZES AND
CHANGES EYE SHAPE

BLUSH OR ROUGE
MAKES CHEEKBONES
LOOK MORE PRONOUNCED

BASE SOFTENS FEATURES,
REDUCES HARSH SHINE

LIPSTICK/LINER MAKES LIPS
LOOK FULLER, MORE SHAPELY

OBSERVING THE MAKEUP RULE IN ACTION

HOW WOMEN APPLY COSMETICS, AND THE EFFECT IT HAS ON THEIR APPEARANCE, CAN BOTH TELL US A GREAT DEAL ABOUT HOW PEOPLE PERCEIVE FEMININITY, AND HOW TO EXPECT OUR CARICATURES OF WOMEN TO FOLLOW SUIT

The Makeup Rule

So, what are some other rules for making a caricature of a woman look feminine? The obvious thing is stay away from making the jaw, brow ridge, and chin bigger or more pronounced in a woman's caricature, and, if the situation calls for it, you might even make these elements a little smaller.

When considering surface features, elements like thick eyelashes, full red lips, soft complexion, high cheekbones, and curved, thin eyebrows are all features that are distinctly "feminine." You may notice these items have one thing in common: they are all features that women traditionally use makeup to accentuate or to create. Many women who don't have these features naturally use makeup to create them or to emphasize what they do possess. Take your cues from what makeup artists do, and play up the kinds of features that say "female" (and, conversely, avoid playing up these features on a man to prevent him from looking too feminine). If I am drawing a man who happens to have thick, long eyelashes (as many do) I will play that down in many

cases to accentuate the masculine aspects of the drawing.

Let's take a closer look at makeup, and, specifically, how women use it to enhance their femininity. Think about where and how women apply cosmetics to their face. The entire purpose of makeup is to emphasize the features that make a woman look feminine and downplay those that make her look masculine. So, when you are trying to emphasize femininity, play up those features that makeup is meant to enhance:

- **Sharper areas in the corners of the brows (eyeshadow)**
- **Higher and more curved eyebrows (eyebrow pencil)**
- **Fuller lips, especially the upper lip (lipstick)**
- **Longer, thicker, darker eyelashes (mascara and eyeliner)**
- **Higher, more pronounced cheekbones (blush or rouge)**
- **Less prominent nose (shine-reducing powder or base)**

Personally, I always strive to make a woman's face softer than a man's. I stay away from harsh, angular lines and features in a woman's caricature and use softer, more rounded lines and forms to define the face. I try to use fewer lines or elements that define edges of features. In a line drawing, the more lines you use in the face the more masculine (and older) the subject looks, generally speaking. If I want my subject to look more feminine, I will seek to define the features with as few lines as possible. Filmmakers use softer light and keep the camera slightly out of focus (that old Vaseline-smeared lens trick) on close-ups of women to create a dreamy and sultry—that is, feminine—look. This trick works on the same principle: it eliminates the hard edges of features.

Caricaturing a subject is, as always, defined by the demands of the subject's features and persona as perceived by the artist. However, that does not mean the caricaturist cannot approach a subject a little differently and look for specific things they might expect to see, based on factors like the age or sex of the subject. Understanding human perceptions and what's behind them, with respect to male versus female or old versus young, only brings another source of observational power to the artist.

Going co-ed. *A few examples of various men and women's caricatures—from left to right on this page: Nicole Richie has the right face shape . . . now about that nose; Entourage's Jeremy Piven has a classic male head shape; Park and Recreation's Amy Poehler has a very round head but quite feminine eyes; actor David Caruso has strongly masculine features.*

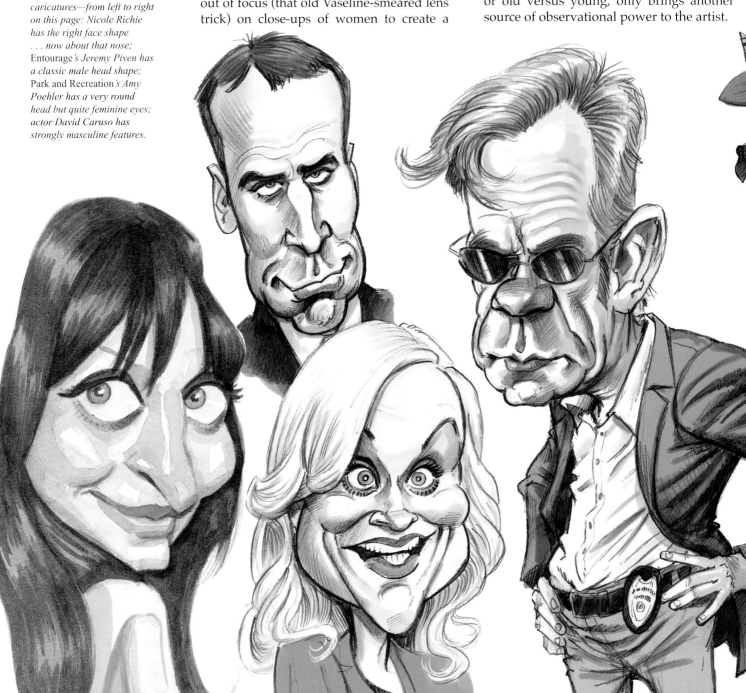

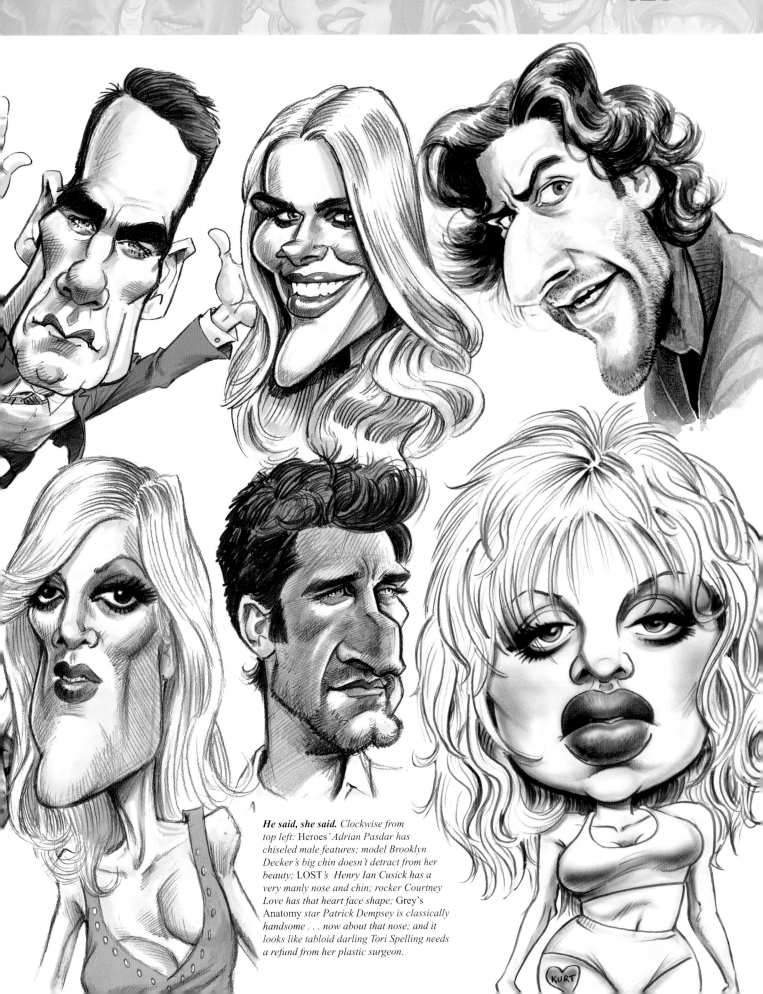

He said, she said. *Clockwise from top left:* Heroes' *Adrian Pasdar has chiseled male features; model Brooklyn Decker's big chin doesn't detract from her beauty;* LOST's *Henry Ian Cusick has a very manly nose and chin; rocker Courtney Love has that heart face shape; Grey's* Anatomy *star Patrick Dempsey is classically handsome . . . now about that nose; and it looks like tabloid darling Tori Spelling needs a refund from her plastic surgeon.*

7 DRAWING LIVE CARICATURES

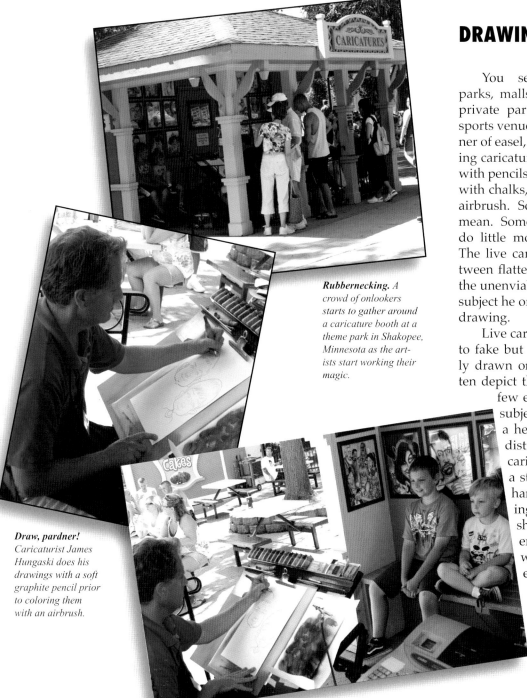

DRAWING A CROWD

You see them everywhere—theme parks, malls, state fairs, company picnics, private parties, nightclubs, casinos, zoos, sports venues—artists set up with any manner of easel, table, or lap board busily drawing caricatures . . . and a crowd. They draw with pencils, markers, or pastels. They color with chalks, conte crayons, color stix or the airbrush. Some draw funny. Some draw mean. Some really exaggerate and some do little more than a cartoonish portrait. The live caricaturist walks a tightrope between flattery and insult, as that artist has the unenviable task of caricaturing the very subject he or she is trying to please with the drawing.

Live caricature is a relatively easy thing to fake but a tough thing to master. Poorly drawn ones have little likeness and often depict the same basic face with only a few elements that are specific to the subject, relying on funny bodies or a heavy stylistic look to satisfy (or distract) the customer. A good live caricaturist, however, can capture a strong likeness and wield a deft hand with exaggeration, producing a great caricature in such a short amount of time that onlookers can hardly believe they just watched it happen before their eyes.

Rubbernecking. A crowd of onlookers starts to gather around a caricature booth at a theme park in Shakopee, Minnesota as the artists start working their magic.

Draw, pardner! Caricaturist James Hungaski does his drawings with a soft graphite pencil prior to coloring them with an airbrush.

Getting tooned up. Two young customers take a break from roller coasters and corn dogs to get their caricature drawn by James.

I paid my way through college drawing caricatures, drawing at the theme park during the summer and in nightclubs and bars and at holiday events during the school year. The following tips and techniques are an amalgamation of my personal philosophies and those I've learned from other artists whom I have worked with over the past twenty years.

THE CHALLENGES OF LIVE CARICATURE

All of the concepts in the previous chapters can apply to drawing live caricatures as easily as they can to more illustrative drawings. However, drawing live caricatures presents several challenges that drawing in the quiet and cozy confines of an art studio does not.

Time

Some live caricaturists are faster than others, but all must draw at a relatively fast pace. In the studio you have as much time as you need to do studies or preliminary sketches and figure out what is working and what is not before embarking on your final caricature. When working live, you are racing to get as many done as you can, whether it's for a client paying you to draw their guests or for the paying customers who are waiting in line. You don't have the luxury of sketching about—it's one shot, hit or miss.

Audience

Live caricatures are not drawn in an atmosphere of peace and solitude. They are produced in a fishbowl environment where large crowds watch your every move. Some cheer. Some jeer. It is not a job for the shy or faint of heart. At its best, live caricature can be a captivating performance art, and its most successful practitioners are as good at banter and showmanship as they are at drawing.

Smile, you're on Candid Pencil! *Caricaturist Wade Collins works on coaxing a grin out of his customer.*

Toons in the dunes. *That's me just starting a caricature of a U.S. soldier, one of many I drew while on a USO cartoonists tour in Kandahar, Afghanistan.*

Volume

You would think that drawing dozens upon dozens of faces over a short period of time would be of great benefit to artists, providing them with loads of practice and helping them develop their eye. Not necessarily. The sheer volume of faces that the live caricaturist is confronted with can make anyone lose objectivity and focus, and sooner or later they all unknowingly slip into the trap of drawing the same basic features on everybody. It takes a lot of concentration and effort to stay fresh and approach each face as if it was the first one of the day.

While at first glance the hurdles placed before the live caricaturist may seem insurmountable, they are in fact challenges that, once overcome, can make you a much better caricaturist—not just at drawing live but also at any form of caricature.

SOME BASICS

No Sketching

Drawing live caricatures is an exercise in reactive drawing. The artist does not have the time to noodle around on an under-sketch trying to visually search for a solution to the enigmatic face before him or her. Reactive drawing means that you draw in direct and immediate reaction to what you are looking at. There is no time for intense analyzing or contemplation. You see. You draw. End of story.

That seems harsh, but it is a crucial lesson for the live caricaturist. This type of caricature is a little like doing gestural life drawing. As an art student, I never liked the quick, 30-second gestural drawings of the live model our instructor insisted we do a great deal of. In retrospect, I understand why that type of figure drawing is so important to develop an artist's skills. During a long pose, the artist has plenty of time to sketch, erase, and build a drawing that is convincing and strong. That is analytical drawing, done through long periods of thought and experimentation. Gestural drawing demands that artists draw reactively, forcing them to develop not just their understanding of anatomy or detail but also their instincts with the figure—their ability to capture weight, movement, and life-like qualities of the figure that no amount of erasing and resketching could accomplish.

Live caricature is like producing a gestural drawing of an exaggerated face. Being forced to draw reactively and to commit to decisions with permanent line develops a caricaturist's instincts for likeness, expression, exaggeration, and composition. It's an exercise in spontaneity, confidence . . . and fearlessness.

So, no sketching. Put your eraser away. Do your quick "sketch" in your head using some of the theories and concepts in the earlier chapters. Force yourself to draw spontaneously and quickly, with bold, confident lines. At first your results may be wanting,

and you will realize that your caricatures will turn out better if you do just a little bit of sketching first. Resist this. Do a few (or many) bad ones, and let your instincts develop. Live caricature is like riding a bike, and sketching is a set of training wheels. It may help you get from point A to point B without falling over, but you'll never learn to race that way. Now, the artists who are willing to crash a few times, skin their knees, and fall behind—these artists will leave Mr. Training Wheels in the dust once they "get it" and are really riding.

Tools of the Trade

As mentioned, there are a nearly infinite variety of styles with respect to drawing live caricatures. However, most of them rely on some form of a line drawing as their base. What the artist uses to draw those lines is a matter of personal preference and comfort. Some like to use bold, black markers (which definitely discourage sketching), others might use a charcoal stick, and some may prefer a colored pencil. The techniques put forth here are largely independent of the type of drawing utensil used. For the record, I like to draw with a 3mm 4b or 6b graphite stick in a mechanical clutch-adapter leadholder and use a #8 blending stump for some shading effects. I use these tools for no other reason than they were what I was taught to use, and I've grown comfortable with them. To color live caricature work I use the airbrush. I like the effect of the softer graphite lines combined with the airbrush paint, as opposed to the look you get with the harsher line of a marker.

A Word about Generic Caricature

One of the principal dangers of live caricature (besides drawing a large angry-looking biker's girlfriend too ugly) is developing the habit of doing generic caricatures.

No two people, even identical twins, have exactly the same features. Yet, some caricaturists end up drawing the same

features on everybody, adding only slight variation here and there. This is a function of carelessness, convenience, or simply bad habits. The techniques of live caricature lend themselves to convention and the paths of least resistance, so falling into the trap of generic caricature is an easy thing to do.

When practicing the techniques spelled out in this chapter, remember they do not all apply specifically to what you are drawing, but rather they help show you how and when to draw it. Try to treat each face as a fresh puzzle or a new song on a radio station. Really look at the face and try to see what makes it unique, and then apply these live drawing concepts to execute those observations on the paper.

APPROACHING A LIVE CARICATURE

Since we are not allowed to sketch, we must do our thinking in our heads and not on the paper. Here is where those earlier caricature theories come into play.

Applying Our Caricature Theories

The first thing I do is study the face for a few seconds and think about how to apply some of those basic caricature theories we discussed in chapters 2 and 3—things like the Five Shapes, the T-Shape, the Law of Constant Mass, visual weight, and so on. Boiling the face down to its most basic elements is even more important when doing live caricature, where simplification means not only a more effective caricature but also one achieved in less time. Remember, it all starts with head shape. If necessary, go back and review those chapters before starting a live caricature session. On the right you can see the difference between tentative sketching and bold, live caricature.

Have I mentioned NO SKETCHING? You have to visualize first—that is do all "sketching" in your head, not on paper.

WHY NO SKETCHING?

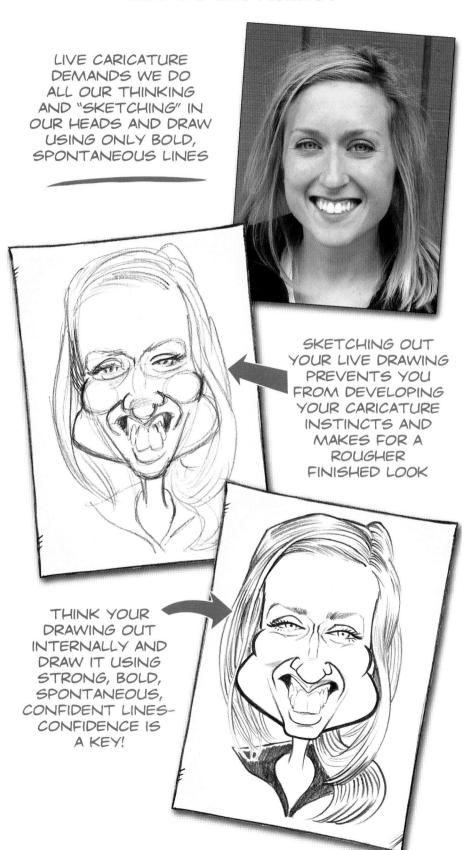

LIVE CARICATURE DEMANDS WE DO ALL OUR THINKING AND "SKETCHING" IN OUR HEADS AND DRAW USING ONLY BOLD, SPONTANEOUS LINES

SKETCHING OUT YOUR LIVE DRAWING PREVENTS YOU FROM DEVELOPING YOUR CARICATURE INSTINCTS AND MAKES FOR A ROUGHER FINISHED LOOK

THINK YOUR DRAWING OUT INTERNALLY AND DRAW IT USING STRONG, BOLD, SPONTANEOUS, CONFIDENT LINES—CONFIDENCE IS A KEY!

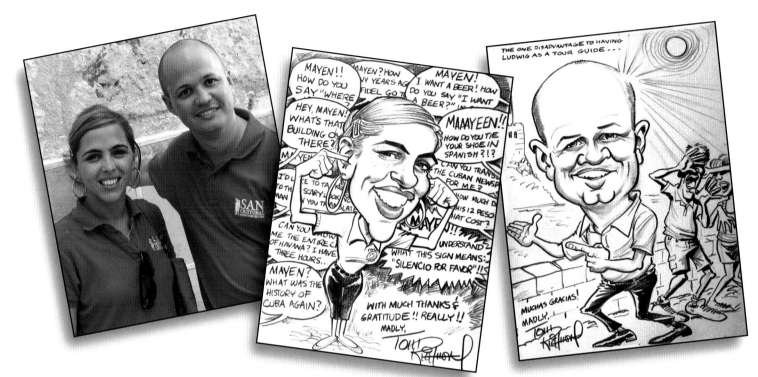

Castro Oil. *Mayen and Ludwig were tour guides for a group of cartoonists (including yours truly) on a U.S. government-sanctioned cultural exchange tour in Havana, Cuba. I did these drawings while sitting in the lobby of our hotel and gave them to Mayen and Ludwig as thank yous for being great guides.*

I make my observations, visualize the face in as simplistic a manner as I can with my one or two ideas for exaggeration incorporated, and then begin my actual drawing.

One other important point: working from life is different than working from photos. Photographs don't change expression on you a dozen times in the first minute. Before you commit to your drawing, you need to decide on the expression you are going to capture. Since the shapes of the eyes, the mouth, and, to a lesser extent, the rest of the Five Shapes are very much dependent on the expression, you should have this in mind before starting. Just be careful you don't draw the eyes in a neutral position and then make the mouth into a gigantic toothy smile . . . in a drawing like this, your model will look like they need an emergency trip to the bathroom.

Working Inside Out

There are many different techniques to live caricature. Some philosophies insist on drawing the face from the outside in, starting with the head shape and then moving on to the interior features. There is nothing wrong with this technique, but I prefer to work the opposite way, from the inside out.

Working from the inside out can be a tougher way to do the drawing, because if you aren't careful the drawing can quickly get out of control in terms of size and the relationships you exaggerate. In a way, compared to my thought process, I'm doing the drawing in reverse—I think from the outside in (observing the head shape and the rest of the Five Shapes first), but I draw starting with the interior features. This method allows for more adjustment on the fly; if you are drawing from the outside in, then once you draw the head shape you are locked into that relationship for all the rest of the features. Working from the inside out, if you find you drew the eyes a little closer together than you wanted, you can always make the head a little smaller to compensate. It does require more visualization of the basic caricature before and during the drawing, but to me the results always seem to have more life and energy. However, your mileage may vary.

THE SEQUENCING TECHNIQUE

You do not achieve more speed in live caricature by drawing faster lines. You achieve this by spending less time not drawing. To that end, drawing each of the facial features in the same order, known as sequencing, is a good way to make yourself draw more efficiently and therefore more quickly. The artist who practices this technique, especially once it becomes ingrained in his or her process, will spend less time wondering what to draw next and more time actually observing and drawing.

Sequencing is not a technique that dictates how you draw the features, it merely lays out when you draw them and with what specific lines. The relationships of the features and their individual shapes and characteristics will be different with every single face you draw, and what you define with these lines will depend on the individual subject's face. Draw what you see according to your observations, your decisions on exaggerating their relationships, and the way things really look . . . just get used to doing it in the same order and with the same basic line structure every time. I'm not going to discuss the specifics of drawing the features themselves here (chapters 4 and 5 cover that), but I do point out a few particular points of interest.

Pictured is Tony, and he will be our victim . . . er . . . subject for this demonstration of my drawing sequence when working live. Below Tony's photo is my visualization of his basic caricature—which is to say Tony's T-shape and Five Shapes according to my observations. Tony has a very wide, oval face, with extremely close-set eyes. He has a narrow, pointy, downturned nose and a small chin that is close to his mouth, giving him a correspondingly small lower face mass. His mouth is also very close to his nose, further diminishing that lower face mass. Therefore, the Law of Constant Mass demands I give him a larger upper head. The concept of The Force also tells me that, because I am moving his eyes close together

PREPARING TO DRAW LIVE

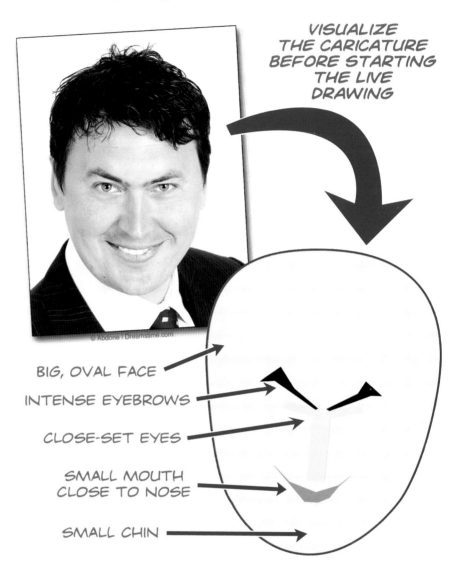

VISUALIZE THE CARICATURE BEFORE STARTING THE LIVE DRAWING

© Abdone | Dreamstime.com

BIG, OVAL FACE

INTENSE EYEBROWS

CLOSE-SET EYES

SMALL MOUTH CLOSE TO NOSE

SMALL CHIN

but do not wish to also make his nose and face long, I have to push that force outward and expand that oval face shape. Tony has very distinctive, close-set eyebrows that angle downward from the outside to inside. The negative space I see between the bottom of the eyebrows and upper eyelids shows the eyebrows are very close to the inside corners of the eyes and then angle away sharply. Finally, his eyes are different shapes, with the eye on the right smaller and more closed than the left one.

Ready to get faced?
Since I am not going to do any sketching prior to diving in to my live drawing of Tony, I need to do all the sketching, or visualizing, in my head. I take a good look at my subject and try to apply the various concepts we went over in the previous chapters. I need a visual blueprint that I will keep in my mind as I draw my caricature.

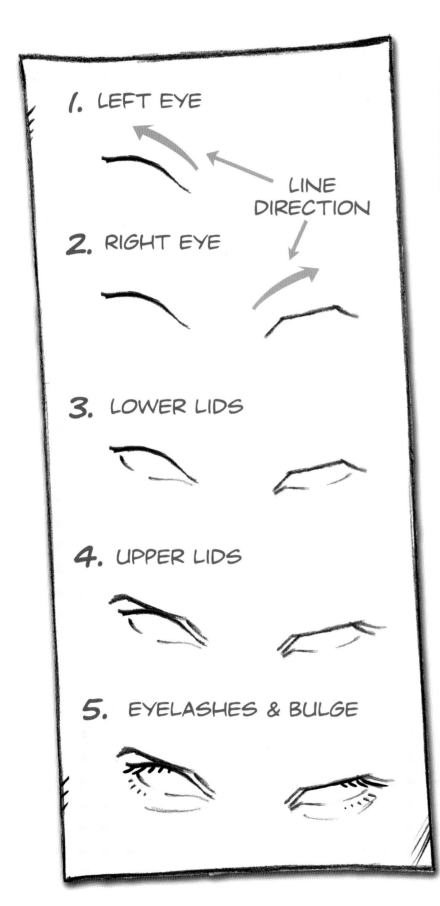

1. LEFT EYE

LINE DIRECTION

2. RIGHT EYE

3. LOWER LIDS

4. UPPER LIDS

5. EYELASHES & BULGE

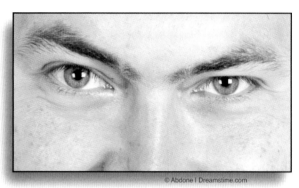

Start with the Eyes

Start at the inside corner of the eye on the left (1) and draw a line representing the upper lid line (the one with the eyelashes on it). I always start with the feature or side of the feature on the left and then work on the corresponding line on the right side. This is because I am right handed. If I did the right eye line first, then that line would be hidden under my hand while I drew the one on the left. It's tough to judge the relationships of the features if one of them is obscured. A lefty would do the opposite and begin on the right. Remember, I am thinking of that basic shape in my visualization as I draw lines to define these shapes on the paper.

Draw the corresponding eyelash line on the right eye (2). It doesn't seem like I've done much yet, but I have already established a great deal. I have drawn half of the shape of the eyes, and I have established the relationship between them. In Tony's case they are close together, but in another model they might be very far apart.

Draw the left and then right lower lid lines (3). Now the eye shapes are complete. Do not draw the iris or pupil yet, nor any ancillary lines like wrinkles, bulges, or other details. That all comes later. We are establishing our base caricature first.

Draw the upper eyelid lines (4), those that define the shape between the eyelash line and the folds of the upper lids.

Add some eyelashes, paying attention to how prominent they are on the subject. I also add the bulge of the eyeball at this point (5).

On to the Nose

The next two lines define the bottom of the nose. Draw the outside of the wing (ala) of the left nostril (6), then the corresponding line on the right (7). With these two lines, I have defined the bottom of the T-Shape and have established the width, length, and relative size of the nose compared to the eyes. I have essentially committed to three out of the Five Shapes, about 20 seconds into my drawing.

Now connect the two nostril sides to complete the underside of the nose (8). You can accomplish this with a single line in the case of a downturned nose like Tony's or, if your subject's nose is upturned, you'll need multiple lines to define the full underside of the nose including nostrils, septum, and where the septum connects to the top of the philtrum. Do not draw the upper area of the nose yet.

© Abdone | Dreamstime.com

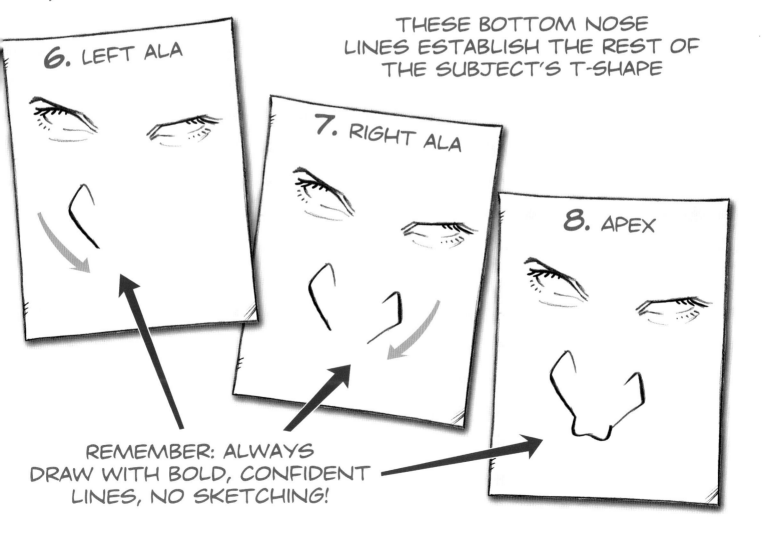

THESE BOTTOM NOSE LINES ESTABLISH THE REST OF THE SUBJECT'S T-SHAPE

6. LEFT ALA

7. RIGHT ALA

8. APEX

REMEMBER: ALWAYS DRAW WITH BOLD, CONFIDENT LINES, NO SKETCHING!

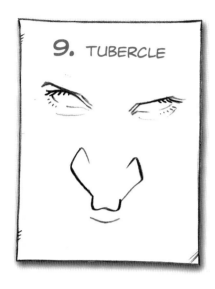

9. TUBERCLE

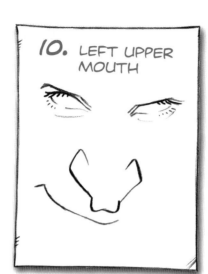

10. LEFT UPPER MOUTH

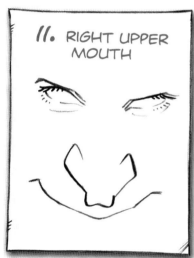

11. RIGHT UPPER MOUTH

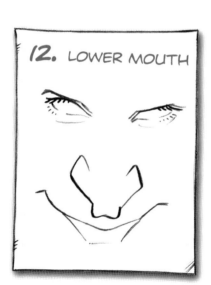

12. LOWER MOUTH

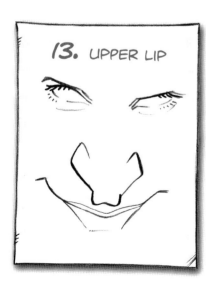

13. UPPER LIP

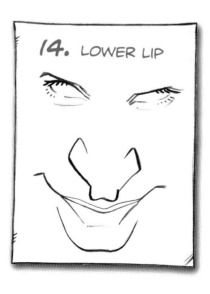

14. LOWER LIP

Next, the Mouth

The shape of the mouth is defined by the lines of the underside of the upper lip and the top of the lower lip, which meet at the corners. Working again from left to right (or vice versa if you're a lefty), start in the center of the upper lip (the tubercle). I will draw this first (9), then continue my line from behind it to the left corner of the mouth (10). I then draw the corresponding line to the right (11). I have just established the beginning of my mouth shape and its relationship to the T-Shape of the eyes and nose.

Next, I complete the mouth shape by drawing the lower lip line (12). This frames in the area where you will eventually draw the dental structure, but for now let's leave that until later. This shape is crucial, as it works with the eyes to establish a great deal of the model's expression.

Now I complete the upper lip. You can draw a line from the center of the upper lip to meet the line that defines the bottom of the upper lip, or simply draw a line from one side, across the center, to the other. If our subject has a strong philtrum, I start by drawing that shallow U or more angular V-shape directly above the tubercle. One line then extends from the top of that U to the left, and then another line to the right. In Tony's case, not only does he not have a noticeable philtrum, he barely has an upper lip. I draw one thin line all the way across, paying attention to the shape of the upper lip (13). Finally, the lower lip line (14).

We have already completed four of the Five Shapes! A great deal of the heavy lifting is done. Hopefully you remembered how vital it is to keep your original visualized basic caricature in mind as you drew these simple shapes, not only getting the shapes right but also laying out their relationships as you decided to exaggerate them. Likeness is already being established thanks to our accurate interpretation of the simple shapes. Fortunately, those shapes are sitting only a few feet away throughout your drawing, so drawing them accurately is only a matter of referring back to your model's face for direction.

The Chin

Now finish establishing the lower part of the face by placing the chin line. Look carefully at the specific shape of the chin and its relationship to the four shapes above as well as your visualization of the final head shape. Tony's chin is kind of pointy and quite small so I have placed it close to the mouth (15), in keeping with my mental "sketch" of his Five Shapes.

The Nose Bridge and the Brow

The area between the eyes, which contains the nose bridge, is next. I establish this with four different lines. The first two define the front plane of the bridge. They begin above the eye just to the outside of the caruncula. These lines emanate from the brow and then curve downward and head towards the end of the nose. They often contain a slight (or in some cases pronounced) bump as they pass over the ridge of the nasal bone, tapering out as the nose changes from bone to cartilage. I draw the left and right bridge lines (16).

The next two lines in this area serve two purposes. First, they indicate the inner curve of the orbit, or eye socket, creating the connection between the bridge and the eye itself (17). Then, as the lines continue down and follow the rims of the orbits, their curvature changes and begins to define the fleshy upper cheek area.

Next, draw the brow as defined by the eyebrows. Here I allow for a small degree of predrawing. Remember how the negative-space shape of the area between the upper eyelid and the bottom of the eyebrow is important in capturing the expression and feel of the eyebrow itself. Here I will draw a single line from the inside end of the eyebrow over to the outside end, establishing both the bottom of the eyebrow and the negative space I mentioned (18).

Finish off the eyebrows by drawing simplified directional lines to indicate the shape of the eyebrows themselves (19) as detailed on page 90.

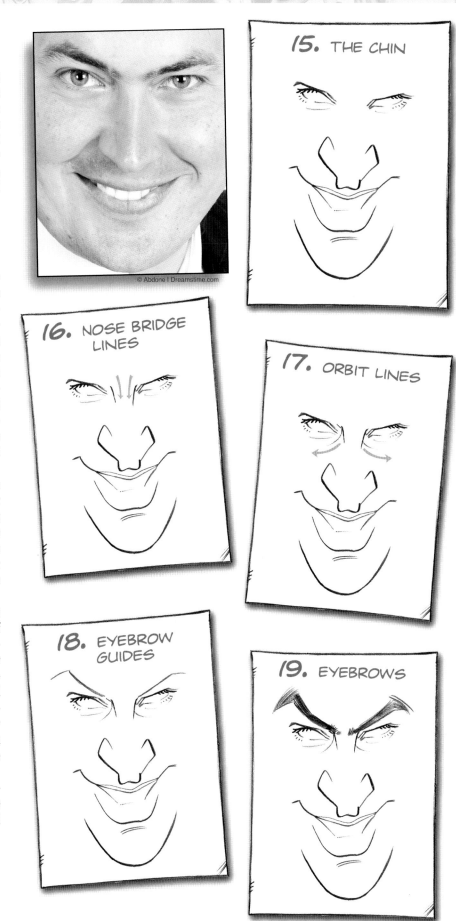

© Abdone I Dreamstime.com

15. THE CHIN

16. NOSE BRIDGE LINES

17. ORBIT LINES

18. EYEBROW GUIDES

19. EYEBROWS

© Abdone | Dreamstime.com

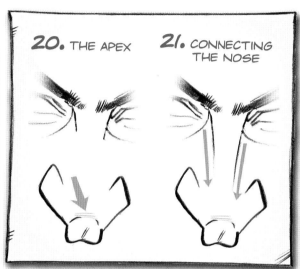

20. THE APEX

21. CONNECTING THE NOSE

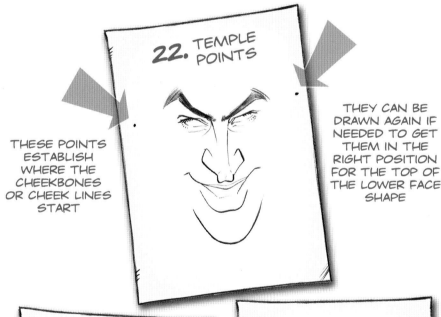

22. TEMPLE POINTS

THESE POINTS ESTABLISH WHERE THE CHEEKBONES OR CHEEK LINES START

THEY CAN BE DRAWN AGAIN IF NEEDED TO GET THEM IN THE RIGHT POSITION FOR THE TOP OF THE LOWER FACE SHAPE

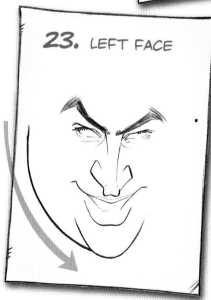

23. LEFT FACE

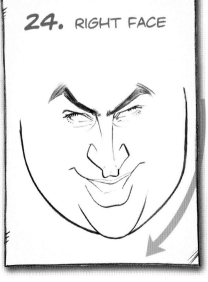

24. RIGHT FACE

Finishing Off the Nose

Now we need to connect the nose bridge to the bottom of the nose.

It's time to draw the end, or apex, of the nose. This can be tough to represent from a straight-on view. I usually define the apex with a series of lines establishing the top, bottom, and sides of the appropriate apex shape (20).

The lines that connect the bridge of the nose to the apex are basically a continuation of the tapering bridge line. They never connect all the way in a frontal view (21).

The Cheekbones and Jawline

Now let's go back to the temple area and get ready to define the rest of the bottom of the head shape. I've still got my original visualization firmly planted in my mind.

Using our idea of the whole head shape, it's now time to begin drawing the outline of the head. Here's where I allow for another tiny bit of "sketching" (but not really). At this point I place a small dot at the top of each cheekbone (22). This sets my starting points for the outside of the face contour. I sit back for a second and see if I have placed these dots in the appropriate places, reflecting good symmetry and following my original head shape observations. If I am off a little, I just continue making dots until I get it right.

Starting at the dot on the left, we can draw one of three different types of lines: a cheekbone line (for a face with cheekbones), a more rounded cheek line (for a face with some flesh but with cheekbones that are still visible), or a single line all the way to the chin, or under it (for a heavy face or a younger kid's face). Tony's round face gets that last option. First I draw the left side (23), then the right (24).

If Tony had a less rounded face with visible cheekbones, I would draw one line for the cheekbone or cheek, and then a second one coming from behind that line to define the jawline to the chin.

Ears

Next, draw the ears. Remember the shape and placement are the most important things to consider. For each ear, the first line you make will establish both those things (25). Sometimes, like in Tony's case, the ears are partially obscured by the hair. I just draw whatever parts of the contour of the ear I can see.

To finish the ears, you have to also draw what you notice about the inside of them. I use the fewest lines I can get away with here, just suggesting the basic form of the ear's interior, unless there are some unusually prominent things going on there (26).

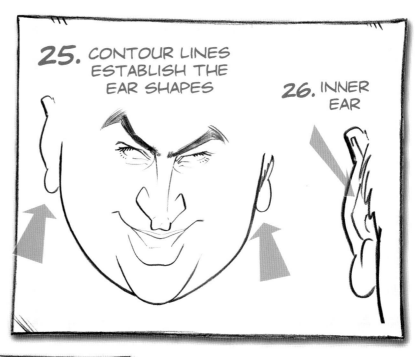

25. CONTOUR LINES ESTABLISH THE EAR SHAPES

26. INNER EAR

27. LEFT SIDE OF FOREHEAD

28. HAIRLINE

29. RIGHT SIDE OF FOREHEAD

30. HAIR CONTOUR

The Forehead and Hair

The head shape is now halfway complete. All that remains is the top half, which will be defined by the lines that make up the forehead and the hair.

The shape of the forehead, which is the negative space between the hairline and the eyebrows, is your new target shape. Where to start to draw depends on your subject, since hairlines vary so greatly. If the subject has a widow's peak in the center of their hairline, I start there. If not, I start at any point where there is a definite part in the hair or where a hair shape hangs down into the forehead area. In Tony's case, I will start at the upper left corner of his roughly rectangular forehead shape, and then move down to the left ear (27). I then go back and continue that line (actually a series of loose, fluid lines) along the hairline to the left (28), and then down to the ear (29).

Now you can move to the outer contour of the hair. Since hair can be of almost any variety, the lines must suggest the style while defining the basic shape and mass, finishing off the head shape (30).

Hair we go again. It's important to keep your lines loose and bouncy when drawing hair. Remember, you are trying to draw the feel of hair, not individual hairs. Simplify and represent the shapes and style.

31. NASO-LABIAL FURROW LINES

32. TOP OF CHIN

33. CREASES AND DIMPLES

34. TOPS OF CHEEKS

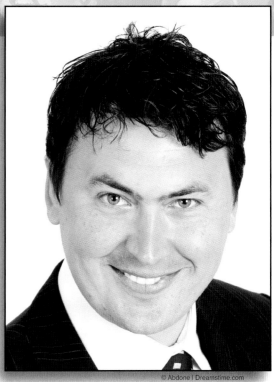

Connections and Filling In

Now you should go back and finish up the connections between and around the features. Be conscious of accidentally aging your model here. Numerous lines around the eyes, the corners of the mouth, and in the interior of the face will add years to the subject.

Drawing the nasolabial furrow lines, to the right and left of the mouth (31), establishes the bottoms of the cheeks and connects the mouth to the nose. Now is also the time to indicate the philtrum if you haven't already.

Add the top of the chin (32), noting how far it should be from the bottom lip compared to the bottom of the chin.

If needed, add lines that establish creases in the cheek area (33). Your model might have clearly defined creases from the cheekbones down or just slight visual echoes of the lines in the corners of the mouth. In Tony's case, he has some slight creases to each side of his mouth.

Place any necessary lines in and around the eyes, like the top of a bulging, smiling cheek (34). Again, be wary of aging your subject with unnecessary lines.

Finally, add any lines that might be warranted in the forehead area. A cave-man brow needs an upper defining line or two. Tony has a fairly smooth forehead.

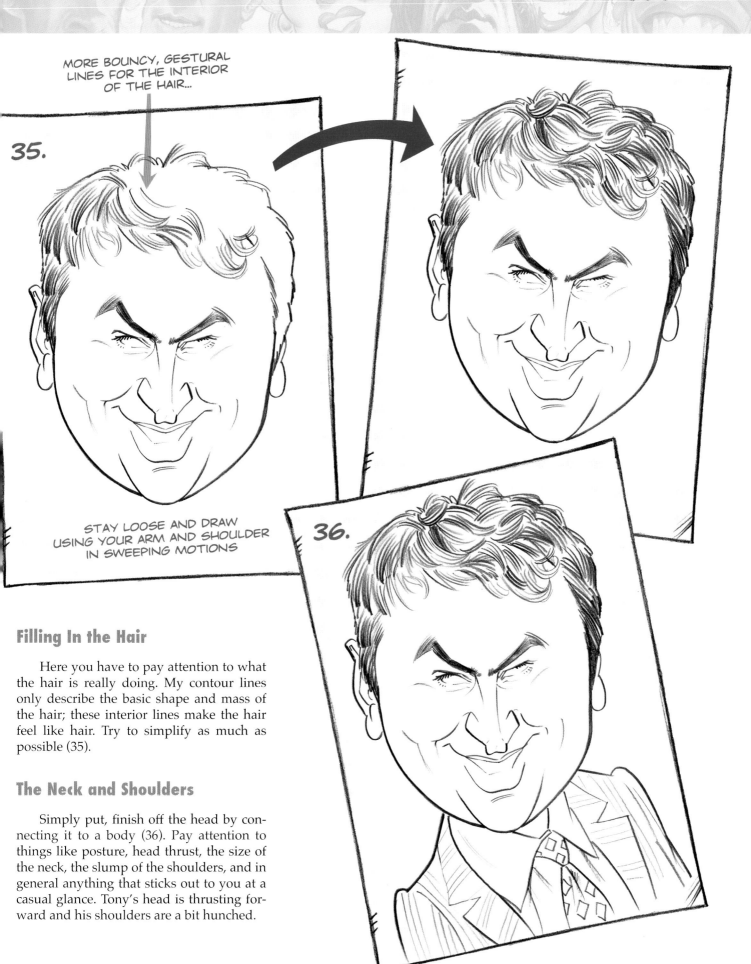

MORE BOUNCY, GESTURAL
LINES FOR THE INTERIOR
OF THE HAIR...

35.

STAY LOOSE AND DRAW
USING YOUR ARM AND SHOULDER
IN SWEEPING MOTIONS

36.

Filling In the Hair

Here you have to pay attention to what the hair is really doing. My contour lines only describe the basic shape and mass of the hair; these interior lines make the hair feel like hair. Try to simplify as much as possible (35).

The Neck and Shoulders

Simply put, finish off the head by connecting it to a body (36). Pay attention to things like posture, head thrust, the size of the neck, the slump of the shoulders, and in general anything that sticks out to you at a casual glance. Tony's head is thrusting forward and his shoulders are a bit hunched.

What about the Eyes and Teeth?

Okay, okay! It's time to wrap it up by drawing the interior of the eyes and the mouth shape. There is a reason I wait until the end to add these elements, and it's not because it really annoys the people watching me draw (well, not entirely because of that). Because I draw with a soft lead, I must be very conscious of the condition of my graphite's point. The lines I draw to represent the interior of the hair and the neck and shoulders are generally the boldest, heaviest lines in the drawing. As a result, by the time I finish these lines I have a very defined chisel point on my graphite, giving me a sharp edge for this more delicate area.

The Inner Eye

When drawing the interior of the eye, first draw the edge of the iris (37), followed by the edge of the pupil, usually broken by a highlight "notch" (38). You can then take your time doing a neat fill of the pupil so it is dark and black (39).

The Teeth

Now you're ready to add teeth. I draw these in three stages: First, I define whatever gum line is visible with a series of scalloped lines (40). Then I draw the corresponding bottoms of each visible tooth (41). Finally, I imply the separation between the teeth with lines that almost connect the gum points to the bottoms of the teeth (42).

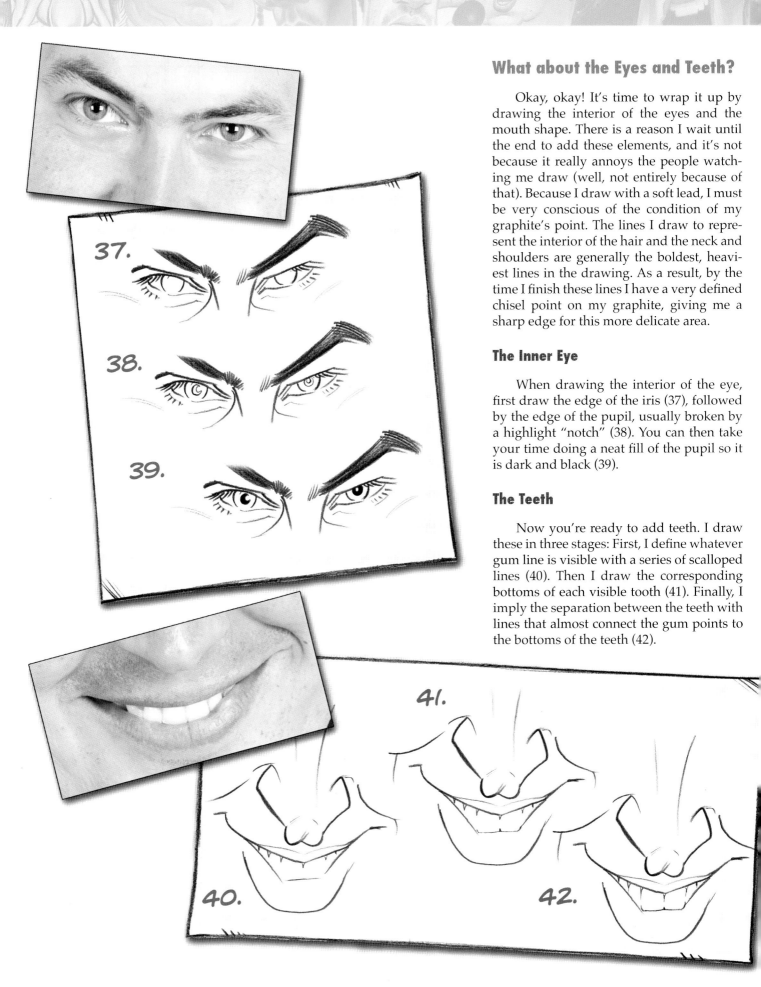

37.

38.

39.

41.

40.

42.

The final step is . . . whatever your live technique calls for. This drawing was done using a 4B graphite lead, and I finish it off by doing a little shading with a blending stomp to add some values and some three-dimensional qualities. Pictured is the finished drawing, done in about five to seven minutes (and in only 42 easy steps!)— and I'm a slowpoke compared to many.

Again, this sequencing technique is merely an established order of drawing for efficiency and speed, and the predetermined series of lines I mention in this walk-through can be used to describe almost any face. True, some faces will require you to ignore some of the lines in this example or diverge from certain steps in this approach, in order to better capture the likeness. There are plenty of unique circumstances and exceptions. The beauty of exceptions is that, by nature, they are what make a given face unique, so embrace them and use them for exaggeration.

© Abdone | Dreamstime.com

Drawing la vida loca. *Live caricatures are necessarily loose, spontaneous, and drawn without a safety net. They can be intimidating to the new caricaturist, but it's exactly that demand for immediate and urgent decisions and execution that makes drawing live so invaluable an experience. The live caricaturist must be fearless, developing a confidence and trust in themselves that carries over into more meticulous studio work. There is no better way to train your instincts for caricaturing the face than to draw a few thousand live caricatures.*

USING LINE WIDTHS TO CREATE VOLUME AND INTEREST

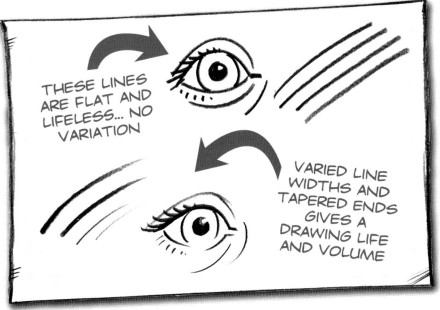

THESE LINES ARE FLAT AND LIFELESS... NO VARIATION

VARIED LINE WIDTHS AND TAPERED ENDS GIVES A DRAWING LIFE AND VOLUME

LINE WIDTH IN ACTION!

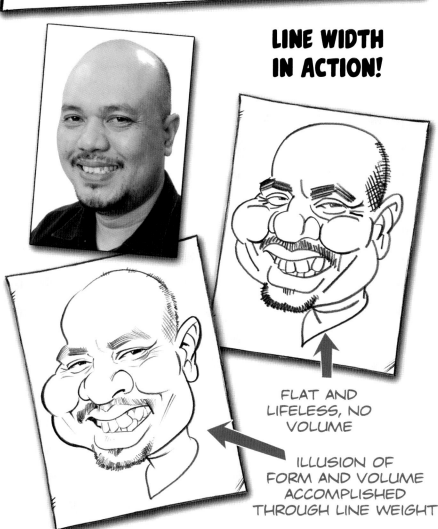

FLAT AND LIFELESS, NO VOLUME

ILLUSION OF FORM AND VOLUME ACCOMPLISHED THROUGH LINE WEIGHT

DRAWING WITH LINE

As I mentioned, most live caricaturists use a line-based style of drawing for their work, be it in pencil, marker, or any other medium. Drawing with line can be difficult, because lines are powerful things. Describing something with a line makes it a definitive element, and overusing lines can make a subject look significantly older and weather-beaten—or make a drawing flat and lifeless.

There are a number of tricks and techniques that can help a live caricaturist take the two-dimensional starkness of line and make it more energetic and lifelike.

Line Weight Variation

Line weight is the key to making a line drawing interesting and full of life. Inkers in the comic and cartoon industries use the weight of their lines to add a feeling of dimension and movement to their work. Line variation in a caricature will accomplish the same thing. Here are two versions of the same drawing, one with uniform line weight and the other with varied line weight. Quite a difference, isn't there? One is flat and lifeless, the other much more kinetic.

When doing a live caricature, remember the lines that define strong edges and definite changes of plane require the boldest strokes. In a live caricature, the lines around the contour of the head shape, the hair and eyebrows (if dark), and the neck and shoulders are the most bold and powerful.

Looking at linework from boldest to lightest, the next level of line strength would be present in the upper eyelid (because the mass of the eyelashes causes this line to be darker), the edges of the nostrils, the wings of the outer nostrils, the interior lines that define the mouth shape, the interior of the ear, and the bottom of the lip.

Lines that are a bit thinner would be used for the upper lip, the nasiolabial furrow, the eyelid crease above the eye shape, the nose bridge and orbital area, the gum lines, and the bottom line of the eye shape.

Even a little thinner and less pronounced would be the lines around the bottom edges of the teeth and lines used for any noticeable creases or dimples in the cheeks.

Finally, the thinnest and most delicate lines in the face would indicate the small creases or wrinkles around the corners of the mouth, those under the eyes, the lines between the teeth, and other subtle elements like freckles.

Using line weight in an effective way, even the quickest live caricaturist can make a two-dimensional line drawing come to life.

Implied Line

I have mentioned this concept already, but it's time to discuss it in more detail. Implied line, as the term states, is a technique in which an artist does not draw a line but simply implies that a line is there. This is useful for areas where a line seems needed but can't be drawn because even the thinnest of lines would read as too strong. This is accomplished by drawing two lines that taper toward each other and look like they are going to connect but do not actually do so.

The viewer reads this as a single line, but the treatment is subtle enough that it can be used where an actual line would be too heavy. I often use implied line for the lower lid line of the eye and between the teeth.

The eye is wet and glistens, making the lower lid line indistinct. An implied line creates the feel of a wet eye.

Teeth are not blocky but rounded—and also wet. The separation between them is too subtle for a harsh line, which would read as a definite space between the teeth. Using implied line here creates a better feel for the teeth.

In a frontal view, the line connecting the bridge of the nose to the apex cannot be a full line, since the nose is a rounded, soft mass with no real edges from this angle. Letting the nose bridge line taper away as it approaches the apex helps soften the nose but still suggests the mass and protrusion there.

USING IMPLIED LINE TO COMPLETE DELICATE FORMS

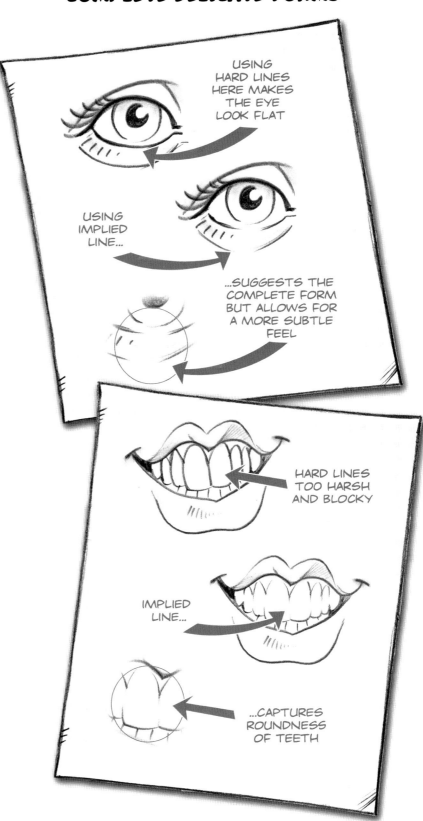

USING HARD LINES HERE MAKES THE EYE LOOK FLAT

USING IMPLIED LINE...

...SUGGESTS THE COMPLETE FORM BUT ALLOWS FOR A MORE SUBTLE FEEL

HARD LINES TOO HARSH AND BLOCKY

IMPLIED LINE...

...CAPTURES ROUNDNESS OF TEETH

SOME LIVE CARICATURE EXAMPLES

Here are a few different subjects and their live-style caricature drawings, along with the T-shape and a few observations for each face.

OBSERVATIONS:

-LONG, NARROW FACE
-CLOSE-SET EYES & NOSE
-LONG CHIN & JAW
-TINY TEETH WITH LOTS
OF GUM AREA
-HEAVY EYEBROWS

OBSERVATIONS:

-ROUND, CHERUB-CHEEKED LOWER FACE
-CLOSE-SET EYES, NOSE, AND MOUTH
-MORE FOREHEAD MASS THAN JAW
-SMALL, SLIGHTLY UPTURNED NOSE
-DARK, DISTINCTIVE EYEBROWS

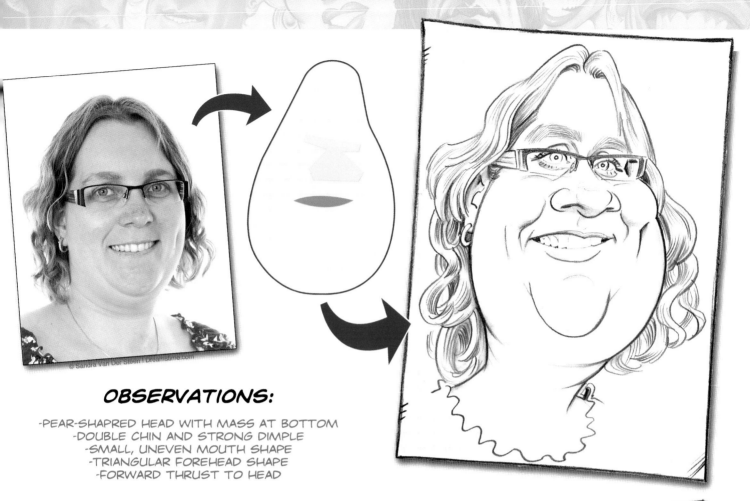

OBSERVATIONS:

-PEAR-SHAPED HEAD WITH MASS AT BOTTOM
-DOUBLE CHIN AND STRONG DIMPLE
-SMALL, UNEVEN MOUTH SHAPE
-TRIANGULAR FOREHEAD SHAPE
-FORWARD THRUST TO HEAD

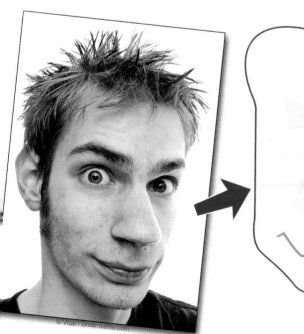

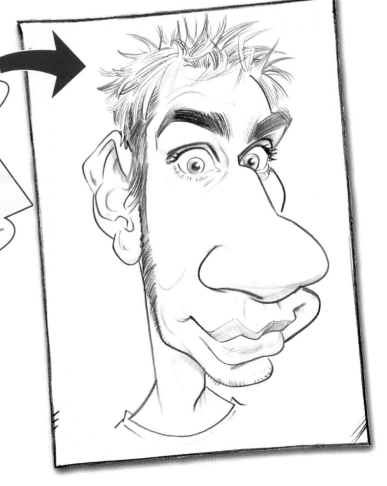

OBSERVATIONS:

-WHERE DO I START??
-HARD, HEAVY, EXPRESSIVE EYEBROWS
-NARROW NOSE BRIDGE, VERY WIDE END
-LARGE, ANGULAR EARS SET HIGH ON HEAD
-SMALL FOREHEAD WITH LONG FACE AREA
-LONG SIDEBURNS

8 CARICATURE IN ILLUSTRATION

The ability to do good caricature illustration leads to many opportunities in the world of publication and multimedia. Most news and feature articles, films, TV shows, stories, and other forms of communication and entertainment are about *people*—what they do, who they are, and what makes them interesting. Even product advertising, in the form of endorsements, features people and their likenesses. Art directors, editors, producers, and others in charge of presenting these stories to the world need visuals to go along with whatever information they are communicating. Caricature is a unique way to represent the people who are the subject matter of these various narratives—and that makes for a nearly endless list of potential freelance clients. Caricature is highly versatile and can range from extremely critical to simply amusing and anywhere in between. Politicians, actors, musicians, newsmakers, athletes—anyone who a client wants a reader or viewer to recognize in a humorous or satirical way is ripe for depiction in caricature. That requires an illustrator who can do caricatures.

Tooth or Dare. A spot illustration of Julia Roberts for TIME Digital Magazine. Watercolor and mixed media.

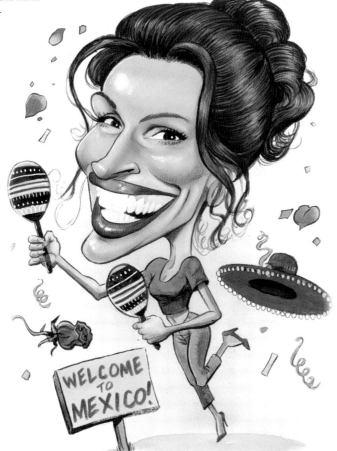

WELCOME TO MEXICO!

NARRATIVE IN CARICATURE ILLUSTRATION

All of the concepts we've discussed in this book apply to caricature illustration. Learning how to exaggerate rather than distort, how to create strong recognizability, how to incorporate statement in a caricature—these skills are important regardless of the application of the work. Good caricature is good caricature, whether the end result hangs framed in someone's living room or graces the cover of *TIME*. That said, there are some unique elements to doing caricature illustration for publication or other media, and most involve the operative word *illustration*.

You may have noticed I said "an illustrator who can do caricatures" in this chapter's first paragraph as opposed to "a caricaturist." This is because when you are doing caricatures for publication (and for brevity I use the term *publication* to represent all

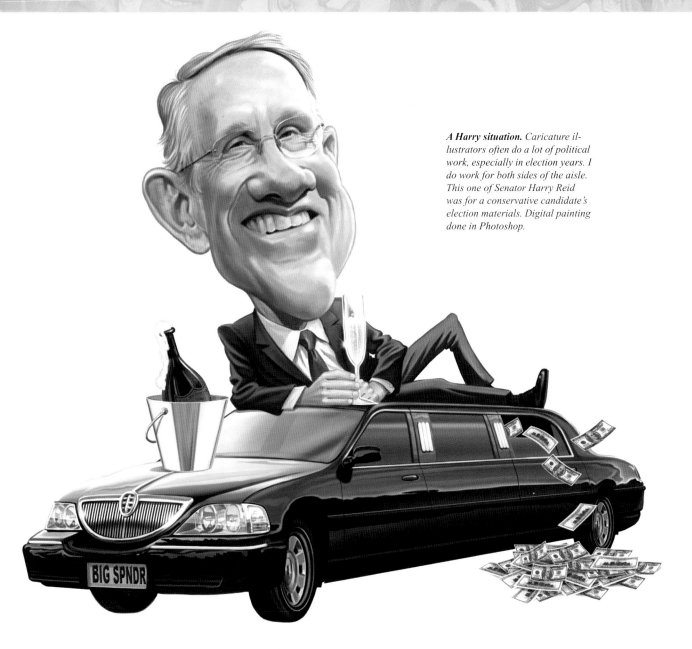

A Harry situation. Caricature illustrators often do a lot of political work, especially in election years. I do work for both sides of the aisle. This one of Senator Harry Reid was for a conservative candidate's election materials. Digital painting done in Photoshop.

media markets for freelance illustration), the caricature itself is only one element of the project as a whole. The artist is no longer doing just a caricature, he or she is doing an illustration that features caricature as a central element.

That may seem like simple semantics, but it isn't. Most caricature illustrations have a larger purpose beyond simply depicting the subject's features in a funny or critical way. A magazine article has a story to tell about the subject, and it's the job of the illustrator to help tell that story visually. This adds the all-important *narrative*

element to caricature illustration. Narrative is the message the client needs an illustrator to describe visually with the art. In the case of a caricature illustration, this can sometimes be accomplished with the statement of the caricature, or sometimes the illustrator includes an environment, or setting, for the caricature to help present the narrative. Illustrators must be storytellers, using visuals to tell a particular story. Caricature illustrators are no exception, and must use their set of skills with a particular message (the client's message) in mind.

One year too many. The Minneapolis Star Tribune *newspaper had me do this full-page illustration for the front of their sports section. It was for a feature story wondering which Brett Farve the Minnesota Vikings would get that year—the good or the bad? Pen and ink with digital color.*

AVOIDING LCD

This leads us to one of the pitfalls of live caricature, one of the biggest reasons some very talented artists who make their living drawing live caricatures aren't successful doing caricature illustration: the dreaded affliction I call *Live Caricaturist's Disease* (LCD).

LCD isn't really a disease, of course. It's a condition many live caricaturists develop that unfortunately limits their ability to parlay their skills at exaggerating the face of a live model into publication work. Basically it's the belief that the universe begins at the top of the head and ends just below the neck. I've known some live caricaturists who are incredible at capturing exaggerated likenesses, whose skill at drawing the face is absolutely spectacular. However, when confronted with the challenge of drawing a car, or a building, or a toaster, they are flummoxed. Moreover, the narrative aspect of illustration escapes them. Why? Because live caricature usually *does* end at the neck, and things like figure work, environment, and narrative are distant concerns in the typical live caricaturist's workday. When you draw 10,000 five-minute caricatures a year with big heads and little throwaway bodies, it's hard *not* to focus completely on the face. This single-minded focus, to the exclusion of the rest of the world, tends to atrophy the skills one needs to be an illustrator, skills one will also need when considering other platforms for caricature art.

Caricaturists who want to apply their abilities to publication illustration need to broaden their horizons beyond the head and embrace caricaturing the world itself . . . no easy task. The only way to accomplish this is to spend as much time and effort developing your ability to draw cars, buildings, toasters, and everything else as you do developing your ability to exaggerate the face.

It's also important to make sure the other elements in your illustrations have a look that is cohesive with your caricatures, especially when it comes to other human

characters that do not represent specific people. In fact, you need to present the viewer with a cohesive and believable universe in which your caricatures look like they belong. Nick Meglin, long time editor of *MAD* Magazine and an illustrator himself, once explained this to me using the great Jack Davis as an example: "A Jack Davis caricature is instantly recognizable as a Jack Davis drawing, but when Jack draws a chair, or a boat, or a foot—they are also instantly recognizable as a Jack Davis drawing." Davis creates a universe in which everything he draws, including his caricatures, looks like it belongs in that universe. A caricature illustrator needs to be able to caricature both the human target and the rest of the world with equal success.

CARICATURE ILLUSTRATION AND STYLE

One of the great things about caricature is that, as an art form, it can include virtually any method of drawing or rendering, and still these disparately produced pieces will be instantly recognizable as caricatures. Whether a caricature is done with the cartoony linework of Mort Drucker, the lavish painting of Sebastian Krüger, the elegant lines of Al Hirschfeld, the graphic design and color of David Cowles, or with any one of an infinite number of other techniques, the end result is still unmistakably a caricature. These different techniques and forms of visual communication are referred to as the artist's individual style.

Style, by my definition anyway, is a combination of two things: an artist's natural visual sensibilities and the technique he or she uses to actually create the finished art. The latter is basically mechanical and within the control of the artist. It's not too terribly hard to switch to new mediums and explore different techniques in order to appeal to a different set of clients, but to change the fundamental way in which you draw and see the world is not quite so feasible. Therefore,

in some ways an artist's style is within his or her control, and in some ways it is not.

Artistically speaking, a caricature's success or lack thereof is independent of style. Whether the caricature is painted, drawn, inked, wildly or mildly exaggerated, sculpted, frescoed on the ceiling of a renaissance cathedral, or scrawled on a cave wall with crushed berry paste by torchlight, it's either a good caricature or it isn't. The style of the artist doesn't matter a bit in that respect. When an art director is weighing the commercial application of caricature for publication, however, the impact of style can matter a great deal.

There is certainly no one style that is commercially applicable above all others. There are many illustrators known for their caricatures, and they work in styles that are

Definitely a sour apple.
This spot illustration was done for Penthouse Magazine *to accompany a new feature column by rocker Dave Navarro, giving out advice on your love life. Pen and ink using a colored line style with digital color.*

Singing the blues. *This half-page illustration was done for one of the Scholastic publications, to accompany a story about the TV show* High School Musical. *Pen and ink with digital color.*

very different from one another. The works of C. F. Payne, John Kascht, and Steve Brodner, just to name a few, are often seen in major publications, and each is commercially successful, yet their styles are all diametrically opposed. Are all styles equally in demand in publishing? Certainly not, as some styles are more commercially accepted than others. However, there is room for a great many styles of caricature in publishing and advertising. In fact, it could be argued that there is room for *all* styles of caricature commercially—it's just that it's easier to find commercial applications for some styles over others.

Commercially, the appeal and viability of a given style hinges on a number of factors:

1. *The final result or effect the art director is looking for:* Each project is a little different, and what the art director might envision for a given job will dictate the style of art he or she is looking for. Smart art directors will then look for an artist whose style fits the look they are seeking. If they want a crazy, exaggerated style, they'll call an artist who fits the bill.

2. *The demographic and tastes of the overall target audience:* This falls somewhat under the umbrella of the first factor, but it has a much broader context than a single art director or single project. Each established publication has a certain visual "identity," and they won't stray far from that identity regardless of the needs of any given project. Some magazines won't use cartoony or whimsical artwork but prefer their illustrations to be more artsy and avant garde. Others prefer a more subtle, realistic approach to their illustrations, while still others might want the high-energy, loud cartoon look. Obviously, the audience that the publication is meant to appeal to and the subject matter they usually cover dictate some of that visual identity. A magazine for kids will use cartoon artwork and zany, energetic styles while one for the film industry might want something more daring or cutting edge. To a large extent, the preferences of the current art directors of a publication also help define its look. I have seen magazines that were known for using a certain style of art suddenly drop those illustrators once a new art director was hired, even though the target audience or subject matter for that magazine remained the same.

3. *What is "hot" at the moment:* As with any aspect of pop culture, there are certain trends in illustration, and styles that are greatly in demand for a few years might suddenly be deemed outdated or passé. Some styles have staying power, but many are subject to the fickleness of current trends. For a long time many of the big entertainment magazines were using artsy wash-style spot caricatures with wavy lines and blocky colors to illustrate their sidebars and short pieces—now, that caricature style has all but disappeared from those publications. The graphic, design-like look of Cowles' work was huge for a while but has cooled off quite a bit in the last few years. When a style is "hot," an artist like Cowles and maybe one or two others will define the style, and as that style saturates the market it will mean work for a lot of knock-off or similar but lesser-known illustrators. Then, when the popularity of the style cools, all those ancillary artists will stop getting that type of work but the defining artists will still get what remains of the demand. In that way, a few top artists can always make a living doing a certain style independent of current trends, while those who were riding the popularity wave will struggle to find work in that same style once that wave has washed out.

Some styles are timeless and will never fall out of fashion. Having a unique style is important to establish your identity as an illustrator, but unless your style is one of those timeless ones, or it appeals to a large enough base of potential clients that you will find continuous work with it, it's hard to make a long-term living as an illustrator if you are unwilling or unable to vary your work. I know many illustrators who have developed secondary or alternate styles in order to pursue work from a different set of clients. It's important to have a consistent and identifiable style as an illustrator so your clients know what to expect, and know they can come to you to get it, but there is nothing wrong with applying different techniques of rendering and execution to your natural way of drawing that might appeal to other potential clients. I've known some

illustrators who develop a radically different style of illustration and actually market themselves under a different name with that look.

Developing a style of caricature illustration with the intention of commercial success is difficult for several reasons. You cannot be sure what will be appealing to a large market at any given time, nor can you predict how long a particular style will be in demand. The most difficult aspect of all is that an illustrator doesn't usually find a style—a style finds the illustrator.

Dems da breaks. Fade In *Magazine* had me do this full-pager of 2004 Democratic Presidential candidate John Kerry and a few of his (at the time) hopeful choices for a Vice-Presidential running mate. Pen and ink with digital color.

SOME EXAMPLES OF CARICATURE ILLUSTRATION

BILL CLINTON: CHARACTER DESIGN

Enough about you. *(above) This caricature of reality TV star Kim Kardashian was done for the cover of the* UTNE Reader *to illustrate an article about our narcissistic society. Colored line and digital color.*

Take ten of these and call me in the morning. *(right) The cover of* Contingencies Magazine, *a publication for the insurance industry, concerning health care and the 2008 Presidential primary candidates. Digital painting.*

BARACK OBAMA- CHARACTER DESIGN- NEUTRAL

RONALD REAGAN- CHARACTER DESIGN

Some real characters. *(above) These are three examples from the dozens of designs I did of animated characters for the R.G. Entertainment film* I Want Your Money. *These were turned into CG characters for several animated segments of the movie. Pencil and digital color.*

Can't we all just drink a beer? *(right) A parody of a UFC fight poster featuring Barack Obama, Henry Gates, and Sgt. James Crowely at the "Beer Summit," done for* MAD *Magazine's "20 Dumbest People, Places and Things of 2008." Digital painting.*

The right gun for the job. This illustration was used in another R.G. Entertainment film called Super Capers (2009); it was meant to spoof an oil-painted portrait of a big-game hunter, as portrayed by actor Michael Rooker. Digital painting.

A one-ah and a two-ah and a . . . This illustration was used as a wrap-around CD cover and on promotional materials for Gordon Goodwin's Big Phat Band on their album The Phat Pack. Pen and ink and digital color.

MAD modeling. This was the cover of the cartooning industry magazine Stay Tooned, *done for a special issue featuring profiles of several artists from* MAD *Magazine. Colored line and digital color.*

Now open up and say "OWWWWWWWW!" *Another cover for* Contingencies *Magazine, this time showing 2004 Presidential opponents John Kerry and George W. Bush squaring off on health care issues. Digital painting.*

Wait 'til they get a load of me. *Jack Nicholson for film industry publication* Fade In *Magazine. Pen and ink, digital wash.*

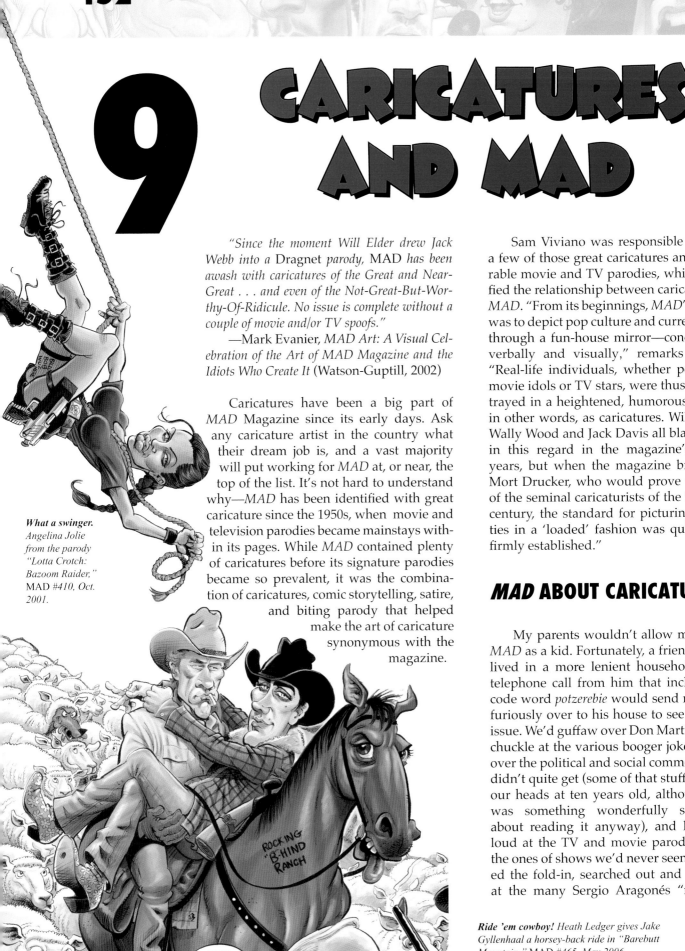

9 CARICATURES AND MAD

"Since the moment Will Elder drew Jack Webb into a Dragnet *parody,* MAD *has been awash with caricatures of the Great and Near-Great . . . and even of the Not-Great-But-Worthy-Of-Ridicule. No issue is complete without a couple of movie and/or TV spoofs."*
—Mark Evanier, *MAD Art: A Visual Celebration of the Art of MAD Magazine and the Idiots Who Create It* (Watson-Guptill, 2002)

Caricatures have been a big part of *MAD* Magazine since its early days. Ask any caricature artist in the country what their dream job is, and a vast majority will put working for *MAD* at, or near, the top of the list. It's not hard to understand why—*MAD* has been identified with great caricature since the 1950s, when movie and television parodies became mainstays within its pages. While *MAD* contained plenty of caricatures before its signature parodies became so prevalent, it was the combination of caricatures, comic storytelling, satire, and biting parody that helped make the art of caricature synonymous with the magazine.

What a swinger. Angelina Jolie from the parody "Lotta Crotch: Bazoom Raider," MAD #410, Oct. 2001.

Sam Viviano was responsible for quite a few of those great caricatures and memorable movie and TV parodies, which solidified the relationship between caricature and *MAD*. "From its beginnings, *MAD*'s mission was to depict pop culture and current events through a fun-house mirror—conceptually, verbally and visually," remarks Viviano. "Real-life individuals, whether politicians, movie idols or TV stars, were thus best portrayed in a heightened, humorous manner; in other words, as caricatures. Willie Elder, Wally Wood and Jack Davis all blazed trails in this regard in the magazine's earliest years, but when the magazine brought in Mort Drucker, who would prove to be one of the seminal caricaturists of the twentieth century, the standard for picturing celebrities in a 'loaded' fashion was quickly and firmly established."

MAD ABOUT CARICATURE

My parents wouldn't allow me to read *MAD* as a kid. Fortunately, a friend of mine lived in a more lenient household, and a telephone call from him that included the code word *potzerebie* would send me biking furiously over to his house to see the latest issue. We'd guffaw over Don Martin's work, chuckle at the various booger jokes, puzzle over the political and social commentary we didn't quite get (some of that stuff was over our heads at ten years old, although there was something wonderfully subversive about reading it anyway), and laugh out loud at the TV and movie parodies—even the ones of shows we'd never seen. We folded the fold-in, searched out and snickered at the many Sergio Aragonés "marginal"

Ride 'em cowboy! Heath Ledger gives Jake Gyllenhaal a horsey-back ride in "Barebutt Mountain," MAD #465, May 2006.

ROCKING "B'HIND RANCH

DON'T SHOOT! I'M A REPUBLICAN!

cartoons, and thoroughly thumbed through every issue from cover to cover. We even tried to draw our own parodies of our favorite comic books, TV shows, and films (I recall doing a scathing spoof of *The Apple Dumpling Gang*, which *MAD* somehow missed lampooning themselves). My friend and I enjoyed every page.

Then that stupid kid moved away . . . I didn't read another *MAD* for nine years.

When I was nineteen I got that job doing caricatures at a theme park near Chicago. I worked with five or six other caricaturists, and most of them had copies of *MAD* spilling out of their backpacks and littered about the apartment we shared. Picking one up for the first time in nearly a decade, I was immediately floored by the incredible artwork and brilliant caricatures. Were the pictures this amazing back when I read this at ten years old?—Yes, they were. I just wasn't looking at them with an artist's perspective at that age.

The caricatures in *MAD* all share a certain approach. Most of them are deeply rooted in likeness, and the exaggerations are often not as pushed as caricatures you might see in other venues. These *MAD* caricatures had a fantastic balance of likeness, exaggeration, and life. They didn't just sit on the page looking goofy. They *acted*. They *spoke*. They moved and sang and danced. It was like animation captured on the page, and they did it all without ever losing recognizability. Great caricaturists like Jack Davis, Mort Drucker, Angelo Torres, Harry North, and Sam Viviano set the standard for comic-art caricature by which all others today are inevitably judged.

Through caricature and visual storytelling, combined with the writers' wit and commentary, *MAD* creates a visual movie or TV review that mercilessly points out all the absurdities, flaws, and shortcomings of its subject amid a sea of great comic art, caricature, jokes, and background gags. Roger Ebert once said he learned to be a film critic by reading *MAD* Magazine. Many caricaturists learned to be critical of people's faces the same way.

CARICATURES AND *MAD* PARODIES

The *MAD* staff refers to their parodies of movies and TV shows as *continuities*. Unlike most feature pieces in the magazine, which consist of single gag panels or spot illustrations, continuities feature storytelling in the traditional comic book sense. This creates a number of unique challenges with respect to the art and, especially, the caricatures.

Illustrating a continuity piece for *MAD* has been compared to juggling—you have a lot of balls to keep up in the air at once. Here are some of the principal elements a *MAD* artist needs to stay on top of when doing a continuity piece . . .

Storytelling: As with any comic book project, the artist must strive for good storytelling. This means moving the reader's eye across the page, describing the action or scene effectively, formulating page and panel layout, varying "camera" angles and perspectives, and making the characters "act"—basically making sure the story flows in an engaging way and does not confuse the reader. This task is made harder by the fact that the word boxes and dialogue are all set and (mostly) immovable, necessitating careful planning in placing talking figures, especially in the all-important splash page (the large introductory page usually featuring all the main characters of the piece).

Feeling Il. Kim Jong Il from "MAD's 20 Dumbest People, Events and Things of 2006: Kim City," MAD #473, Jan. 2007.

Schoolhouse schlock. Jack Black lectures his class off in "Fools of Rock," MAD #438, Feb. 2004.

Holy auto glass claim, Batman! Looks like Gary Oldman's "Commissioner Boredom" fails his "behind-the-wheel" exam in the parody "The Dork Knight," MAD #495, Nov. 2008.

Selling the Gag: It's the artist's job to reinforce and sell the jokes the writer has written in each panel. This means paying attention to the writer's intent and figuring out ways to make the written joke clearer or stronger.

Background Gags: Will Elder called his practice of cramming nearly every available space in a panel with some kind of visual joke or gag the "chicken fat" technique, because adding chicken fat to soup enhances the flavor and makes it more filling—much like Elder's extra drawings enhanced the story. Adding these kinds of gags is one of my favorite parts of doing continuity pieces. It adds extra layers of humor to each parody, so readers who give the parody a second look will often find things they missed the first time through.

And finally . . .

Caricatures: Obviously, this is crucial. A *MAD* parody absolutely requires convincing caricatures of the actors involved. However, there is a lot more to it than that. *MAD* artists must caricature the same person over and over, sometimes a dozen or more times. Moreover, the same actors have to be drawn with a number of different expressions. The caricatures are "acting," and so they need to emote and otherwise be convincing in whatever moment they are in. The same character may have to be drawn shocked, angry, yelling, sobbing, smitten, mortified . . . you name it.

It would be almost impossible to assemble a collection of reference images of a person with all the specific expressions and emotions that might be needed in a *MAD* parody. If, when looking for reference for a specific actor, I happen across a picture of that person yelling, or crying, or looking surprised, I'll grab it. However, even in such cases it's unlikely that photo will be facing the way the panel requires or have the exact expression needed. Expecting to find a perfect reference for each individual face in every panel would be unrealistic. Therefore, I need to be able to draw these faces without specific reference.

References used for caricatures, or for any illustration job, are meant to provide assistance, not be a crutch. If I cannot create an illustration of something without a photograph showing me the exact image, angle, and lighting I am looking for, my effectiveness as an illustrator would certainly be in question. I use references to see how things work, to pick up details and aspects I might not otherwise realize existed, and to help make my drawing more convincing. I do not use them as the exact basis for everything I draw. It's a little how like writer's use a dictionary or thesaurus to find a word or do research to learn about the subject they are writing about. The stories they write are their creations, but they might look at reference material so that they can write more convincingly about a given topic. If I need to draw a building, I might refer to some pictures of buildings to see how the windows, trim, stonework, and such might look so I can draw it with more authority, but I shouldn't need to find the exact angle and view of every building I want to draw. In fact, I will often change things even from a direct photo reference in order to vary the composition or enhance the effectiveness of what I am trying to achieve with the illustration.

The same goes for caricatures. If I have several pictures of a subject from various different angles, I can use these references not just for specific drawings but to learn what is important about his or her face—which in turn helps me caricature that person from almost any angle. When it comes to expressions, faces all have the same basic muscles

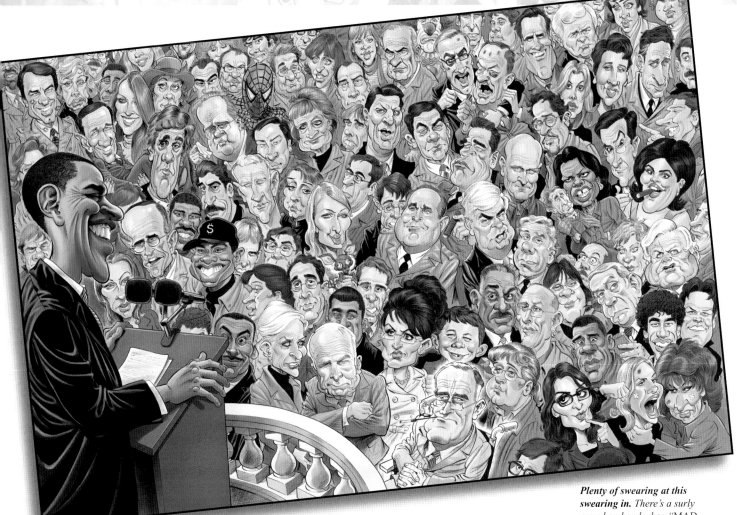

Plenty of swearing at this swearing in. There's a surly crowd on hand when "MAD Exposes Who's Thinking What at the Obama Inauguration," MAD #498, Feb. 2009.

and tend to have the same reactions with respect to emotions and expression. So, by combining what I learn from the references with what I know about facial expressions, I can draw the same face with different emotions and still maintain a cohesive likeness, or at least the illusion of it, throughout the story.

With respect to a *MAD* parody, my approach to doing all this is twofold:

Finding Face Keys

First, I need to find several important features that are "keys" to the specific face I will be doing multiple drawings of, and then I make sure I carry them through each different caricature even as I take liberties with the expressions. It might be heavy eyebrows, the squareness of a chin, a distinct head shape, or many such things that make a particular face unique. These become *face keys* that make the viewer believe they are looking at the same character in each panel. Usually, the crazier the expression I am drawing, the more I have to rely on these keys to keep the illusion cohesive and maintain the recognizability of the caricature. The reader sees these keys and recognizes the caricature as the same person from previous panels.

Establishing Keystones

The second part of the equation involves what I call *keystones*. At several points throughout the parody, I incorporate a more exacting caricature of a subject, based heavily on a specific photo reference. These caricatures are always more detailed and have the strongest likenesses

Whoa, Bundy? Ed O'Neill looks none to happy about appearing in "Muddled Family," MAD #509, June 2011.

of the lot. These keystones are always found on the splash page (those being the "intro" keystones), and then they crop up here and there throughout the rest of the parody. They act as supports that bridge the gap between the caricatures where I am more or less "faking it" with expressions and angles I don't have specific references for. *MAD* legend Jack Davis used this technique all the time in his *MAD* parodies, except he'd often just do the one keystone caricature on the splash and then do a simpler cartoon representation of the character for the rest of the parody. I'm not Jack Davis, so I rely on more than one keystone. I pepper them throughout the parody, wherever I think I need an anchor point.

A *MAD* JOB FROM START TO FINISH

The process of doing a continuity piece for *MAD* is quite involved, and caricatures are only part of the equation. The following is a synopsis of how a continuity job for *MAD* typically goes, with a focus on the caricature aspect. The example we are going to look at is a parody of the AMC television show *Mad Men* that appeared in *MAD* #508, March 2011.

Soul searching.
Gwyneth Paltrow steals Robert Downey Jr.'s heart—and maybe his liver—in the parody "Ironic, Man," MAD #492, Aug. 2008.

The Layout and Script

The first thing I get from the gang at *MAD* is a copy of the written script and a layout of the piece.

The artist is always the last stop before the piece goes to *MAD*'s in-house art department for final production and then to the printer. Before I get this layout, the writer has written and submitted a script to the editors, who have gone over it, argued and came to blows or called each other hurtful names a few times about it, and then finally agreed on any changes like rewording or cutting gags, rearranging story points, and reducing the number of panels or pages. The art department then assembles and lays out the text and word balloons, panel placement, headers, and department text, creating the final layout. That's a great deal of time and effort people have put in before I even see the job.

The restriction of the balloon placement complicates matters, making the splash page and, to a lesser extent, the rest of the job into a kind of visual puzzle. I have to place the characters so that the word balloons make sense sequentially, without the balloon "tails" crossing or doing anything too confusing within the environment set up by the story, while doing (hopefully) convincing caricatures of several actors and actresses with many different expressions and from many different angles throughout the story, while simultaneously paying attention to storytelling design, panel layout, and camera angles to advance the eye along the page, while at the same time "selling the gag" and adding visual gags of my own in the panel backgrounds to add a second layer of humor, all while trying to draw funny in the first place. Whew! That is a lot of work— I am exhausted just writing that sentence.

Photo Reference and Research

In the case of a movie, my first step, if at all possible, is to see the film. If, like in this case, it's a TV show, I set the old DVR to record some episodes and watch several. It's important to get a good feel for

THE LAYOUT

the movie or TV show before trying to do a parody of it, and this especially helps me do good caricatures of the characters. Notice I said *characters* and not *actors*. This is one of the chief differences between *MAD* parody caricatures and plain old caricatures—in the *MAD* continuity I am caricaturing the character, not the actor. The character an actor portrays will have their own unique mannerisms, look, and personality that affects the statement of the caricature. In our example, actor Jon Hamm's character of Don Draper looks and acts differently than Jon Hamm the private person. While I am drawing Hamm's features, I am trying to capture Draper in my caricature's *statement*.

The little details are what make for a good lampooning, and it's impossible to capture the little things without first having a solid familiarity with the show. I will often tap friends or relatives who regularly watch a TV show and ask them about what to look for (a neighbor pointed out that one of the designers in the show *Trading Spaces* was

always barefoot when she did her work, so I gave her stinky, dirty feet throughout the continuity). Information like that makes the statement of the caricatures stronger and helps me capture the character, not just the features of the actor.

After getting familiar with the show, I start digging up photo reference. Even though I am trying to draw the characters, I still have to start with the features of the actors involved, so good pictures at multiple angles are important. Naturally, the internet is great for that. If there's a good book out about the movie or show, I'll go buy it (that's tax deductible, you know!), and I have subscriptions to all the mindless celebrity-chasing entertainment magazines so I can clip pictures out of them as well. If an actor or actress I'm drawing was recently in a film or TV show that's out on DVD, I may rent that and do some screen captures to use as reference, but I primarily farm the

The initial layout of the two-page splash from "Sad Men" as designed and assembled by the MAD staff. Splash pages are almost always introductory scenes featuring virtually all the important characters in the continuity. Every caricature here must be a strong keystone, establishing the recognizability that will carry though the rest of the parody.

I draw the rough pencils directly on the layouts, plotting the positions of the characters and their inter-action based on the place-ment of their word balloons. Notice how I indicated that I'd like to move some of the floating word boxes to leave more central room for the artwork. Splash pages are like puzzles.

internet for pictures. I assemble them on 13×19-inch sheets and print them out so they are handy. With my references, script, and my layouts in hand, I am ready to get started.

The Roughs

I always rough out my story pages directly on the layouts sent to me by *MAD*, at the size they will be printed. Later I en-large them for final pencils and inks, but drawing the roughs at print size helps me get a grasp of the scale as well as how the storytelling is flowing. I print them on a sheet of decent drawing paper, as there will be a considerable amount of erasing at this stage and copy paper would be too fragile.

I "rough in" the basic action, design, and layout of the art and start thinking about the caricatures. I use my reference

loosely at this point, and I don't knock myself out trying to do any involved caricatures. My goal here is to get the basics down quickly, just to be able to get the idea across to the editors back at *MAD*. This is where I demonstrate how I am "selling the gags," how the storytelling elements will flow, and what kind of sight gags I am adding. With respect to caricature, I will plot out where I am going to place my keystones and sketch a quick carica-ture based on the photo reference. If I miss them, I don't go back and sweat over it . . . that's for the final pencil stage. Surprisingly, the quick and gestural nature of this loose drawing stage will often yield some very workable rough caricatures. Certainly while I am working on the roughs I am studying the characters involved and searching for the face keys to each.

Roughing out my art layouts is where the heavy thinking goes into the job. I have to consider what the writer is trying to say in each panel and make sure the art is backing that up—and, if possible, making it clearer.

Splash pages are always the most difficult. They involve title graphics and usually multiple characters talking to the viewer. Since you can't have balloon tails overlapping one another, the position of each speaking character is basically established already. Couple that with the need to stage these characters in an appropriate scene, adding gags and the like, and the splash page becomes a tricky road to navigate.

Once the roughs are complete I scan and e-mail them back to *MAD*. The editors and art staff review the art and get back to me with comments and direction. Most of these I ignore, unless they come up with something boring but useful—like pointing out I gave someone six fingers or neglected to draw someone's pants or something. All kidding aside, the editors and art staff at *MAD* really know their business, and when they do make changes they are always for the better. I've learned a great deal working for *MAD*. One thing I've learned is that there

is no such thing as a free lunch, so don't bother asking. Another thing I learned is to cash my paycheck as quickly as possible.

Final Pencils

Once the pencil roughs are approved, I can move on to the final pencils. This is the stage where the serious drawing occurs. The first thing I do is transfer the roughs onto the final, large bristol boards. I blow up my scans of the roughs to 200% original size and then print them on 11×17 paper. Drawing at double the print size is larger than most comic book art originals are done (typically comic artists work at 130% to 150% of print

A few other pencil roughs. Page three (left) and page six. Some of the drawings can be quite loose at this stage—little more than scribbles sometimes. I'll even just do circles for heads like in the last panel. For the purpose of review, the likenesses are not important. The storytelling, design, and narrative flow are the primary focus here.

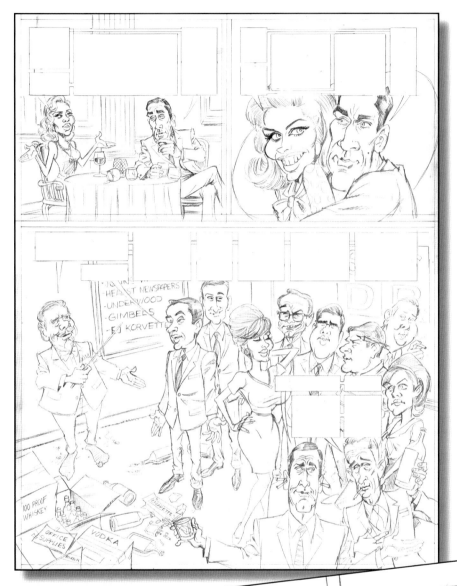

Examples of the final pencils. In page six (above) and a detail from the splash page of Elisabeth Moss and Jon Hamm (right), the caricatures are fully worked out, drawn at 200% print size on bristol board. I try to stay somewhat loose with the caricatures, even at this stage, to leave some room for inking.

size), but this has been the tradition at *MAD* since the very beginning—and if it ain't broke, don't fix it. I have to print the splash page image in quarters, then trim and tape them together. With the story pages, a typical row of panels fits an 11×17 page and so I print each row separately. I then use a large, homemade light table to redraw the roughs onto the final boards. I do very quick, light sketches on the boards to get the basic shapes and panel layouts.

I have my reference printouts strewn all around me as I dig into the final pencils with a mechanical leadholder and an HB or F 2mm lead. At this stage I need to work out the drawings fully, including backgrounds, caricatures, gags, and other elements. How long this takes depends on how I am drawing at the time—sometimes everything just flows off the pencil and it's almost effortless, and sometimes I get stuck on something and it drives me crazy. It's not unusual to find that some of the actor's caricatures come very easily while one or two may put up a mighty struggle. This usually turns out to be because I am focusing on a face key that is either incorrect or not important enough to be a true key.

Typically I will have to draw the lead characters in a parody between six and a dozen times, using the aforementioned face keys and keystones to make the caricatures more convincing. If I blow the keystones, the whole house of cards falls down, so I spend the most time on those. For important characters I will have at least one keystone per page, sometimes more. Close-up shots are ideal for keystones, because they naturally call for more detail and it makes sense for these drawings to be more complex. In between the keystones I keep in mind the face keys I have observed and keep them consistent even (and especially) when I'm portraying extreme expression or crazy action.

I work my pencil drawings up to provide a good base for inking, but I don't add every fingernail and hair follicle . . . some detail needs to be left for

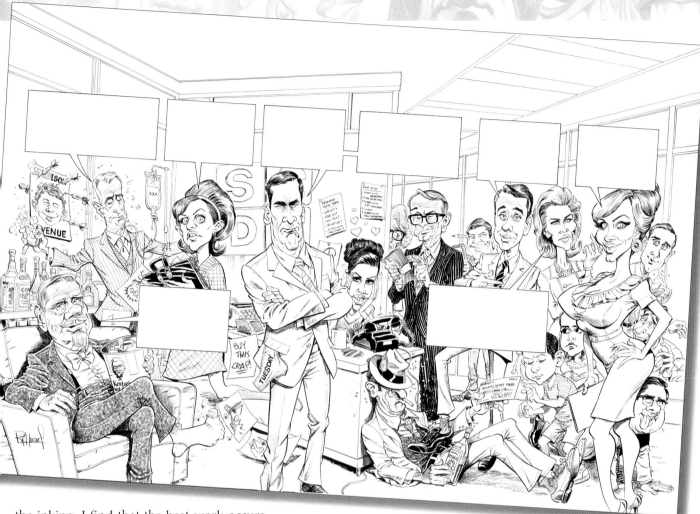

the inking. I find that the best work occurs when the inker actually draws with the ink rather than simply trying to duplicate the line qualities of the pencil drawing.

On very rare occasions *MAD* wants me to send them parts of the final pencils that might need review . . . usually only if we changed something drastically from the roughs at the first review stage. If everything is a "go," then it's on to the inking!

Inking

Inking has always been the toughest part for me. Many of the comic artists I know feel their inked work never seems as effective as their pencils, and you can count me among them. No matter how much I've done it, I always begin an inking job with trepidation and a certain amount of nervousness. Over the years I've learned to trust myself a bit more, but I still wouldn't say it comes easy. To get started, I take out a #3 (.80) Rapidio-

graph pen and rule the balloons and tails, bleed, and panel edges. That's the easy part. Then comes the real inking.

Inking is about drawing, not just tracing your lines. You have to follow the pencil work you've drawn but not be a slave to it. This is especially true for caricatures, as they will lose likeness and life if you aren't *drawing* with your ink. In order to do this, I look at the same reference I used to draw the pencils when I ink. Essentially, I am drawing it all over again, just in ink this time. Now I must be more conscious of line weights, using black areas to create shadows and contrast and trying to imply depth of field. Because I know this work is going to be colored, I don't have to work that hard to lay down a lot of black areas, define forms with hard shadows, or work up many values with crosshatching. All the value work can be done with the color. However, I have always felt the work looks best if the inks

The finished inks of the splash page. Even though I have already worked out the caricatures in the final pencil stage, I ink with my photo reference in hand. Just drawing over your pencil lines will cause your art to lose life and energy. I have avoided using any large black areas because the show has a very distinct, bright color palette that is evocative of the 1960s.

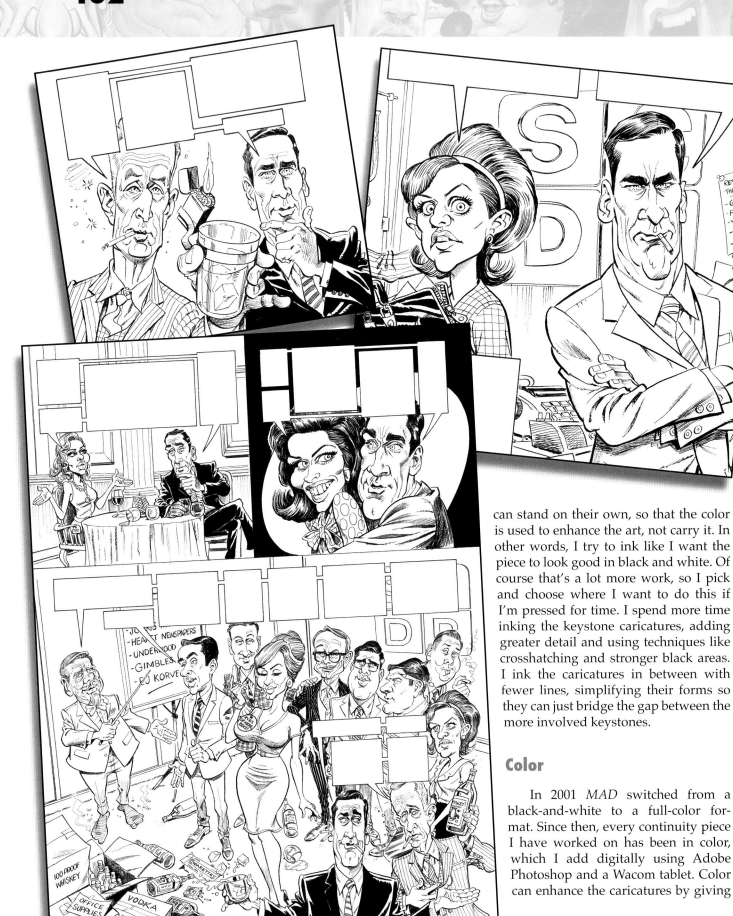

can stand on their own, so that the color is used to enhance the art, not carry it. In other words, I try to ink like I want the piece to look good in black and white. Of course that's a lot more work, so I pick and choose where I want to do this if I'm pressed for time. I spend more time inking the keystone caricatures, adding greater detail and using techniques like crosshatching and stronger black areas. I ink the caricatures in between with fewer lines, simplifying their forms so they can just bridge the gap between the more involved keystones.

Color

In 2001 *MAD* switched from a black-and-white to a full-color format. Since then, every continuity piece I have worked on has been in color, which I add digitally using Adobe Photoshop and a Wacom tablet. Color can enhance the caricatures by giving

*A few more samples of
the final inked artwork.*

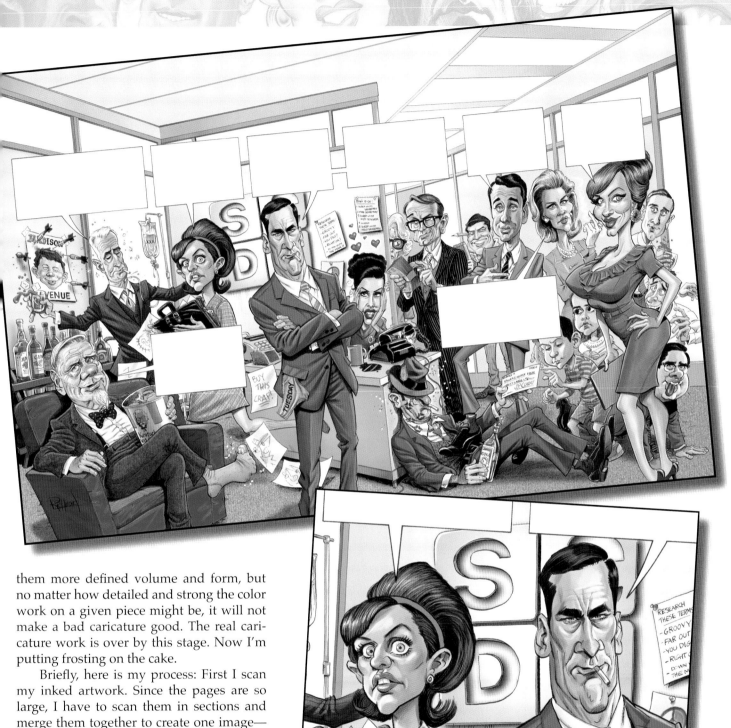

them more defined volume and form, but no matter how detailed and strong the color work on a given piece might be, it will not make a bad caricature good. The real caricature work is over by this stage. Now I'm putting frosting on the cake.

Briefly, here is my process: First I scan my inked artwork. Since the pages are so large, I have to scan them in sections and merge them together to create one image— either a full-page or a two-page spread in the case of a big opening splash. I scan the art in as grayscale because I like the subtle line values this mode picks up as opposed to the starkness of a bitmap (black and white) scan. With this accomplished, I clean up the line work digitally, erasing mistakes I may have missed before and sometimes fixing areas that didn't register properly when the separate scans were stitched together.

Examples of the digitally colored artwork.

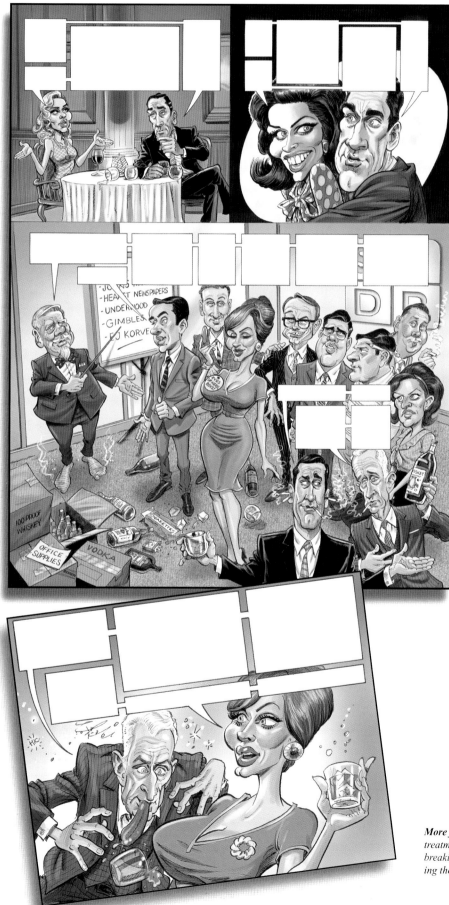

Next, I separate my line art onto its own layer. This can be done a few different ways—it depends on the program you are using.

This is the process I use in PhotoShop:

1. Scan line art as grayscale image.
2. Create a new blank layer, rename it "Inks."
3. Go to the "Channels" palette (there is only one channel called "Gray").
4. At the bottom of the channels palette, click the "dashed circle" icon titled "Load Channel as Selection."
5. In "Select" drop-down menu, select "Inverse."
6. Go to your "Inks" layer.
7. Press "D" on your keyboard to reset swatches so full black is the active color.
8. Press "Option" + "Delete" to fill the selection with black.
9. On background layer, press "Command" + "A" to select everything and then "Delete" to delete line art on that layer.
10. Convert to RGB or CMYK.

You now have a layer with all your inked lines on a transparent background.

I apply the color under the lines, similar to how an animation cell is painted. My goal is to create a hand-painted feel, so I use the pressure-sensitive pen tablet and the regular brush tool to add layers of washes over a base mid-tone color. In this way I build up values and colors to make the end result look like a watercolor painting. I avoid using the airbrush tool or too many filter effects to keep a non-digital feel.

Some color effects can add to the impact of the caricatures. For example, the dark-haired Don Draper character usually has a very noticeable five o'clock shadow, and I exaggerate that by adding a blue-green wash to his beard area.

Once the color is finished, the artwork is sent to *MAD* for final production in the magazine.

More finished color art. Note the monochromatic treatment of the top right panel of page six (top), breaking up the constant full-color panels and giving the viewer's eye a break.

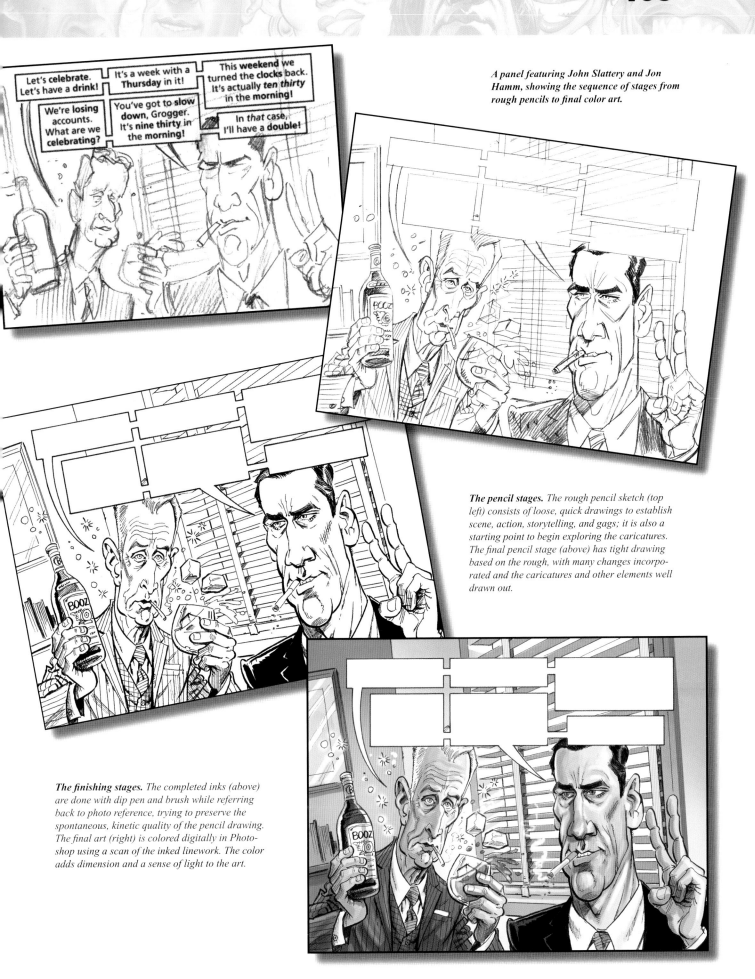

A panel featuring John Slattery and Jon Hamm, showing the sequence of stages from rough pencils to final color art.

The pencil stages. *The rough pencil sketch (top left) consists of loose, quick drawings to establish scene, action, storytelling, and gags; it is also a starting point to begin exploring the caricatures. The final pencil stage (above) has tight drawing based on the rough, with many changes incorporated and the caricatures and other elements well drawn out.*

The finishing stages. *The completed inks (above) are done with dip pen and brush while referring back to photo reference, trying to preserve the spontaneous, kinetic quality of the pencil drawing. The final art (right) is colored digitally in Photoshop using a scan of the inked linework. The color adds dimension and a sense of light to the art.*

CONCLUSION

Now you've read the whole book and maybe you're energized, maybe you're deflated, or maybe you're overwhelmed with thoughts of the Five Shapes, the Law of Constant Mass, hairy caterpillar eyebrows, and countless muscle groups and bony structures, with their unpronounceable scientific names, all swirling around in your head . . . sorry about that if you are the latter. Regardless, I wanted to end with a word about self-confidence and work ethic. Remember that there's no book, no lesson, no magic formula that will automatically transform someone into the artist he or she aspires to be. And a complicated art form like caricature is not something that anyone can master in a steady, predictable learning curve. Indeed, once you find yourself brimming with pride because you *think* you've mastered some aspect of the art form, think again.

Looking back, I feel there were two moments that really helped define me as an illustrator and a caricaturist. Both involved the complete crushing of my self-confidence as an artist.

The first was that job drawing live caricatures for Fasen Arts in 1985. I was a young kid from a tiny Minnesota town, and, as young kids tend to be, I was fully confident in my skills when I packed up my bags and moved to a suburb of Chicago to work at the nearby theme park. Once I got a look at the work Steve and Gary Fasen and their group were doing, I realized that I had a long, LONG way to go if I ever wanted to be a professional illustrator. Rather than let myself be defeated by this, I put my nose to the grindstone and worked my fingers to the bone drawing and drawing and drawing. I watched the others draw. I studied the work of caricaturists I admired. Most importantly, I was never afraid to attempt anything set before me, no matter how many times I ended up failing miserably at it. Eventually I became a manager and trainer for Fasen Arts, and then an owner and operator of my own caricature concessions, all the while embarking on a freelance career. My self-confidence in my skills was coming back . . . for a while.

In 1998 I joined an organization called the National Caricaturists' Network (since rebranded as the International Society of Caricature Artists), which is a group of professional live caricature artists who hold an annual convention and competition featuring a special guest speaker. The 1998 convention was set to be in Las Vegas and the guest speaker was going to be the great Mort Drucker. I eagerly went to Vegas, figuring I would take home a few awards, maybe even the "Golden Nosey," which was what they called the big award for Caricaturist of the Year. The convention didn't go as I'd planned. First, Mort had to cancel because of some family obligations, so I missed out on meeting him. Second, and far more demoralizing, was another decimation of my confidence as a caricaturist. This convention was attended by some of the most brilliant and talented caricaturists I had ever seen, and I had worked with some pretty good

ones over the previous 13 years. The competition hall was a giant room, the walls of which were covered in hundreds upon hundreds of caricatures in every conceivable style by the end of the competition. Looking at the mind-boggling caricature art that was being produced live and on the spot there, I went from thinking I'd be winning multiple awards to hoping I'd get to sit next to someone who won one so I could at least get a peek at what the statuettes looked like. Confidence shattered—again.

As it happened, I actually did win some awards that year, including, to my surprise, the Golden Nosey. It was a big honor, but I did not leave that convention feeling validated. Rather, I felt like I was back at square one, with a lot of work to do. The drop in self-confidence brought on by seeing all those amazing caricature artists was another jump-start that got me focused on improving myself as an artist.

Unlike that first wake up call in 1985, this second one never wore off. I live by the philosophy that, while you can be satisfied where you are today as an artist, you should not be satisfied to be in the same place tomorrow. Growth needs determination, desire, and—yes—just a little dose of insecurity.

Aim high in your work. Don't believe you have ever reached the limits of your skills or talent, because the moment you do believe that, you have. Always reach for that little bit extra in everything you do, and be fearless in the face of failure. That is where learning truly begins.

AFTERWORD

BY SAM VIVIANO

You, sir or madam, are a very fortunate individual, because you've just finished reading a remarkable book . . . unless you're someone who likes to read the afterword of a book first, and save the rest for later. Hey, that's okay, no judgments here: I've been known to do that myself. This book, however, is too important for you to waste your time reading my blather, and since this blather depends on you having actually read the book, I recommend that you go back and do so. Right now. Go ahead, I'll wait here patiently until you're finished.

There—aren't you glad you took my advice and read Tom Richmond's inspiring prose before coming back here to my little debriefing station at the end of the book? For now you have everything you need to know to become a great caricaturist, offered in loving detail by someone who knows what he's talking about. The only thing left for you to do is to actually sit down and start doing it. Get out those pencils, pens, brushes and Wacom tablets and make great art.

Or at least make a good start. The one thing Tom does not point out enough in these pages (he could say it in big boldface type on every single page and it wouldn't be enough) is that no amount of reading will turn you into a great artist. The only way to become an artist is to pick up the tools and start making pictures. A much wiser artist than I once told me that the road to one good drawing is paved with thousands of bad drawings. It's a long road, but the experience of traveling on it can be exhilarating.

And what a tour guide you have in Tom Richmond! Not only is his knowledge of the art broad and his advice well worth heeding, but he himself is a perfect role model for the aspiring caricaturist. Tom understands quite well that talent alone is not enough, and all the tips culled from the writings of others are only useful if you put them into practice. You've got to roll up your sleeves and get to work. And that's what has always impressed me the most about Tom — not his undeniable talent or his indisputable intelligence, but rather his awe-inspiring work ethic.

When I first met Tom in 1999, shortly after I became Art Director of *MAD*, he expressed an interest in illustrating for the magazine and showed me his work. It was very good even then, but, to be honest, not quite good enough for *MAD*, and I told him so. If I recall correctly, I offered some constructive criticism and suggested he keep in touch with me. About a year later, our paths crossed a second time, and once again he shared his recent work with me. What I saw was so impressive that I knew then and there that his art would soon be gracing the pages of *MAD*. What was the reason for this incredible leap forward in such a short time? I don't think Tom magically became more talented over the preceding year, nor did he acquire a vast repository of secret tips and useful shortcuts (there aren't any) . . . but he did put in an awful lot of work. Thousands and thousands of drawings, I would guess. And it got him where he wanted to go.

Now, I won't guarantee that if you work as hard as Tom does that you will become as good an artist as Tom. Talent does play a part in the equation, after all. But I do guarantee that you will be a better artist than you are today, and you will have a terrific time on the journey. So what are you waiting for? Pick up a pencil and start drawing!

Sam Viviano
Longtime artist for, and current
Art Director of, MAD *Magazine*

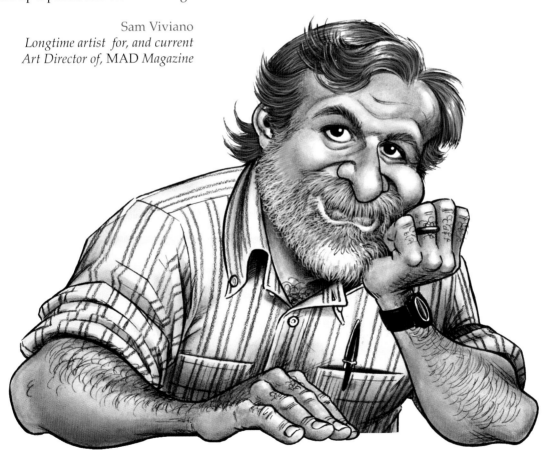

© Art by Sam Viviano

THE END